TINTORETTO

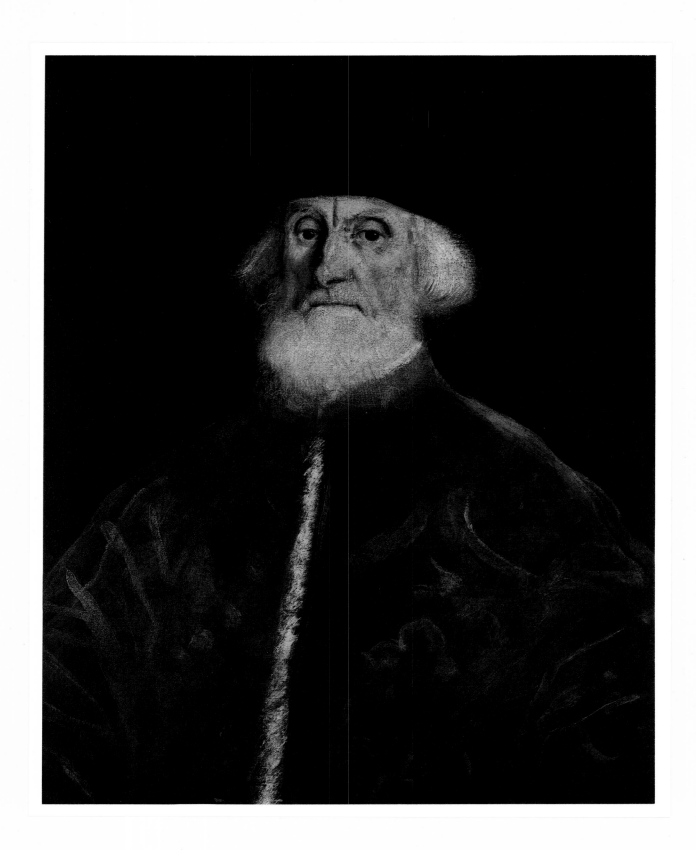

LIFT COLORPLATE FOR TITLE AND COMMENTARY

TINTORETTO

TEXT BY

FRANCESCO VALCANOVER

DIRECTOR, SUPERINTENDENCY OF THE HISTORICAL
AND ARTISTIC TREASURES OF VENICE

AND

TERISIO PIGNATTI

PROFESSOR OF MODERN ART, UNIVERSITY OF VENICE

TRANSLATED FROM THE ITALIAN BY
ROBERT ERICH WOLF

THE LIBRARY OF GREAT PAINTERS

HARRY N. ABRAMS, INC., *Publishers*, NEW YORK

DESIGNER: CAROL ROBSON

Library of Congress Cataloging in Publication Data
Valcanover, Francesco.
 Tintoretto.

 (The Library of great painters)
 Bibliography: p.
 Includes index.
 1. Tintoretto, 1512–1594. 2. Painters—Italy—
Biography. I. Tintoretto, 1512–1594. II. Pignatti,
Terisio, 1920– . III. Title. IV. Series.
ND623.T6V28 1984 759.5 83-12214
ISBN 0-8109-1650-9

Text copyright © 1985 Francesco Valcanover and Terisio Pignatti

Illustrations copyright © 1985 Harry N. Abrams, Inc.

Color printed in Italy
Black-and-white printing and binding in Japan

CONTENTS

COLORPLATES

Commentaries by Francesco Valcanover

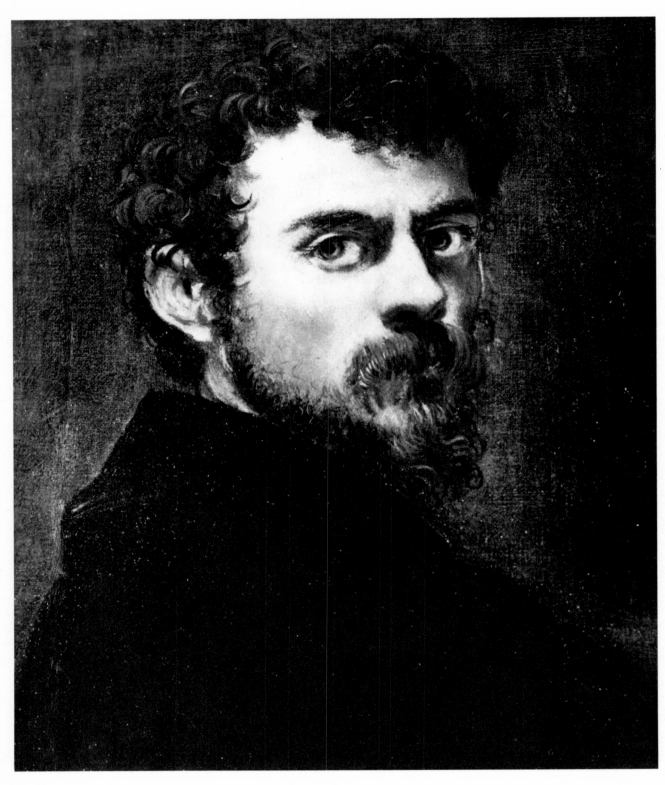

1. SELF-PORTRAIT. c. 1548.
Oil on canvas, 17⅜ × 15″. *Ascoli Collection, New York*

LIFE AND WORKS

THE DEMON PAINTER

Among all the artists of Venice throughout its history the one who has impelled the historians and critics to represent him with the most brooding, superhuman aura of *peintre maudit* has been Tintoretto. Yet perhaps the truth was the contrary. No doubt much of the misrepresentation is due to his own character, which was anything but easy to understand. Viewed superficially, he was an artist who sought the more difficult paths and would not bow to tradition. For proof of this one may look at the immensely famous *Miraculous Rescue of a Christian Slave by Saint Mark* (see colorplate 6) finished in 1548 when he was only twenty-nine years old (fig. 1). It is undeniably an early work but one in which he unabashedly rejected all the usual models for the kind of religious painting he could have learned from a Palma, a Bonifazio, or a Paris Bordone. Taking apart certain elements of the scene and recomposing and highlighting them, after his own fashion, with unexpected and surprising intensity, he showed himself straight off to have a sense of the theatrical with roots more in the world of the architects and designers of stage scenery than in the essentially Venetian tradition of a painterly use of color. In this particular painting, depicting the miracle of Saint Mark, the young artist denied and surpassed the great Titian himself, supreme master and unchallenged head of the Venetian school (fig. 2). This was so because it was no secret in Venice that the young upstart had learned this revolutionary new *maniera* not from his fellow citizens but from Tuscans and Romans like Giorgio Vasari, Francesco Salviati, and Giuseppe Salviati, or from the Emilians and their emissaries such as Andrea Schiavone, or from Mantua, where the art of Giulio Romano still held sway. His true masters were Michelangelo, Raphael, Parmigianino—the inspirers of the new style. Although others had already ventured on that new path timidly, Tintoretto affirmed it, like the sudden blast of a trumpet, in his *Miraculous Rescue of a Christian Slave by Saint Mark*.

To defend that work from the charge of excessive innovation, the famous contemporary critic Pietro Aretino certified that "there is not a man with a modicum of initiation into the qualities of draftsmanship [*disegno*] who is not dumb-founded" at sight of it, and—he promptly added, apostrophizing the painter himself—"blessed be your name if you would just channel the skillful swiftness [*prestezza*] of what you do into comparable patience in doing it." He brought his peroration to a close by calling on the wisdom of maturity to "restrain the headlong rush of carelessness with which eager and swift-acting youth thinks it can get by." But there was a side effect to that eulogy. In it Aretino set forth an idea that was to become an important element of the anomalous myth of Tintoretto: speed of execution, inspiration tolerating no restraints, genius in the throes of possession. It was a first step toward the notion of the demon painter, the diabolical artist.

It needed only Vasari to fan the flame, in the second edition of his *Lives* (1568): ". . . in matters of painting, extravagant, capricious, swift and determined, and the most awesome brain [*il più terribile cervello*] that painting ever had." Vasari went on to divulge the reason for his substantially negative judgment of Tintoretto's paintings: they are "different, and not at all like what other painters do."

It may seem odd that Vasari, self-appointed champion of the *maniera*, did not recognize an ideal fellow spirit in the young Tintoretto, who would prove himself the most fully committed standard-bearer of mannerism. Vasari should have realized that it was precisely because of his "differentness" that Tintoretto had to put up with a certain ostracism from the Titian clique, who deemed themselves the custodians of the sacred Venetian tradition. Perhaps Vasari in his own way was not all that wrong in detecting in Tintoretto an irregular, one difficult to confine and in many respects less predictable than painters such as Paolo Veronese or Jacopo Bassano, who were then following similar careers. What struck Tintoretto's contemporaries, and frightened them, was this extraordinary determination to be independent. Was it only in that sense that he possessed an "awesome brain"? Yet the myth was launched and would be inflated, and the man and the artist would take on an aura of severity, of someone possessed, with a tinge of sorcery.

In the footsteps of Vasari, Carlo Ridolfi in 1648 charged Tintoretto with aiming to appear the "rashest painter in the

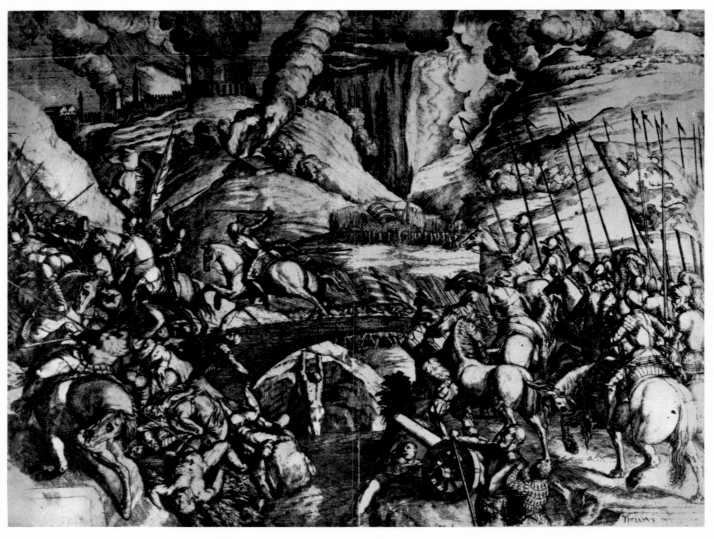

2. Giulio Fontana. THE BATTLE OF CADORE. Engraving. 1569
(after Titian's painting of 1513–38 in the Sala del Maggior Consiglio, Palazzo Ducale, Venice, burned 1577).
17⅛ × 22″. *Gabinetto Nazionale delle Stampe, Rome*

world.'' Twelve years later, in 1660, the fanciful and eminently baroque Marco Boschini gave full expression to the myth in his own rather special Venetian idiom:

> *Che gran stupor, che cose tremende,*
> *Che pensieroni pregni e che fierezze!*
> *Tuto bulega e salta come frezze;*
> *No' fu visto in virtù cose più orende.*
> *Qua se ferma el mercurio, e le montagne*
> *Se fa svolar, per arte e per virtù.*
> *Negromanzia de tal valor mai fu,*
> *Che suga i fiumi e alaga le campagne.*

Which might be rendered: "What great wonder, what tremendous works, what great thoughts ripe with meaning, and what great deeds of daring! Everything swarms and soars like arrows; never has anything more horrendous been seen of the sort. There mercury ceases to roll and the mountains take flight through such art and excellence. Never before was there such brave black magic, which can drain the very rivers dry and flood the open fields."

From Boschini forward, through the many vicissitudes of cultural trends, the art of Tintoretto was also subject to shifts in taste, but the mythic substratum coloring all judgments of his character remained what it was: "innate ferocity" for Luigi Lanzi in 1795–96; concealing "a certain coarseness and barbarism" for Jacob Burckhardt in 1855; "impassioned furor" for Hippolyte Taine in 1866; victim of the "demonic presence" of the models of Michelangelo for Bernard Berenson in 1897; "destroyer of the classical formulas" for Heinrich Wölfflin in 1915.

Not until the 1920s was a more modern critical approach set forth, proposing to interpret the artist in terms of the aesthetics of expressionism, then in its major phase of development. Art historians such as Erich von der Bercken and August L. Mayer in 1923 and Mary Pittaluga in 1925 at last gave fair treatment to the poor man perfidiously accused of witchcraft when it was really a matter of instinctive creativity in language, of brilliant intuition regarding dynamic forms in space, of a vigorous and sanguine quest for a new expressiveness.

EARLY LIFE

The plain truth is presented in the few but precise biographical documents that have survived. Tintoretto was anything but demoniacal; in fact he was altogether a different type. His origins were modest. He was born Jacopo Robusti in 1519 (following the death certificate of 1594, which listed his age as seventy-five) to Giovanni Battista Robusti—a dyer (*tintore*) of silk cloth who had emigrated to Venice from Lucca—and he became known as Tintoretto because of his father's occupation. The young Robusti had a brief apprenticeship, with no noteworthy achievements and with no famous masters. There are no real grounds for the tradition of a period of study with Titian, brusquely terminated. It is more probable that his master was simply a modest picture maker, an adept draftsman without pretensions, perhaps one of those humble Veneto-Cretan fabricators of images of the Madonna, known as *Madonneri*, who were active in the first decades of the century, turning out paintings with enamel-like surfaces, with sharp contrasts in chiaroscuro, and often with gold highlights (as Tintoretto would do later). It was the same tradition that a generation later produced such an artist as El Greco.

Also surprising, considering the dubious tradition of the ferocious quality of his character, Tintoretto was not very impressive in physique. He was called small of stature by Vasari (1568) and "slight in flesh" by his writer-friend Andrea Calmo (1548), who, in a letter, hailed him also as "a grain of pepper" that "confounds, beats, and puts to rout ten bunches of [sleep-producing] poppies," a clear allusion to colleagues less rich in spirit and genius. In every sense he was a common man in his relations with other people, and he was also very much a family man. Not later than 1553 he married Faustina de' Vescovi (or, as sometimes written, Episcopi) and was the father of eight children, among whom Marietta (probably born 1554), Domenico (born 1560), and Marco (born 1561) later joined him as painters. Two other daughters, Perina (born 1572) and Altura, became nuns in the convent of Sant'Anna and were likewise gifted, reproducing in lace the masterworks of their father. Ottavia (born 1570) married a shopkeeper's assistant, Sebastiano Casser; nothing is known about his daughter Lanza or about the firstborn son, Giambattista, for whom even the birth dates are lacking.

Outgoing and certainly clever, Tintoretto must have been astute in what is now called public relations, doubtless with help from his wife, who had some influence as the daughter of the head of a major confraternity, the grand guardian of the Scuola Grande di San Marco. Tintoretto made a place for himself very early in the circuit of the *scuole maggiori* and the confraternities and took a major part in the work at the Doges' Palace (Palazzo Ducale), winning popularity and fame. He must have been generous in his relations with his painter-confreres, particularly with the younger ones if so many passed through his workshop—not only a number of Venetians like Palma Giovane, Vicentino (Andrea Michieli), Aliense (Antonio Vassilacchi), and Leonardo Corona but also such foreigners as Paolo Fiammingo (Pauwels Franck), Marten de Vos, and Pieter Vlerick. Even though he did not have family relations in high places and the spectacular private commissions that Titian and Veronese could boast, yet Tintoretto also was a man with strong cultural interests, whose friends, besides Aretino, included the writer Andrea Calmo, the printer and engraver Francesco Marcolini, and the musician Gioseffo Zarlino. This gives the lie to yet another of Ridolfi's unfounded tales, that the artist "loved solitude more than all things else." It is one more fable to be scrapped along with those about his *terribilità*, his awesome and even inhuman strength of character.

As for his working habits and techniques, the sources—once their exaggerated fictions intended to enhance the notion of a *pittore terribile* are excepted—do seem to suggest something that can be trusted. According to the detailed description by Ridolfi, Tintoretto set up a small room as a studio where he not only copied models from life or plaster casts but also studied the special effects achieved when working from artificial light. He constructed small stages with scenes laid out in perspective and placed in them wax figures either nude or dressed in scraps of cloth to get a better idea of drapery folds and the lighting effects derived from candles arranged in various positions. This practice was not unknown to other painters of the time—including Veronese, Bassano, Palma Giovane, and even Titian—who were particularly attentive to special effects of illumination and even to night scenes. Yet when Tintoretto involved himself with a mere painter's expedient, it promptly took on the odor of sulfur and brimstone. What could be more appropriate to such dubious goings-on than this candle-lit toy theater—where, by Ridolfi's account, Tintoretto practiced his art even using the skin of human cadavers—to prove the man was something of a necromancer possessed by demons.

Yet all the exasperations of the writers on art can do nothing to deny the authentic spirituality of Tintoretto, which unquestionably was more intense, more unabashed, than that of many of his colleagues, including the greatest such as Titian and Veronese. It was the spirituality of a son of the people, nourished by the sources of a renewed Christian religiosity in a time of reform while simultaneously linked with the most ingenuous but morally valid aspects of Protestantism.

Venice was affected in various ways by the Counter Reformation, particularly in the numerous trials for heresy conducted by the Tribunal of the Inquisition (see Anna Pallucchini,

THE FORMATIVE PERIOD

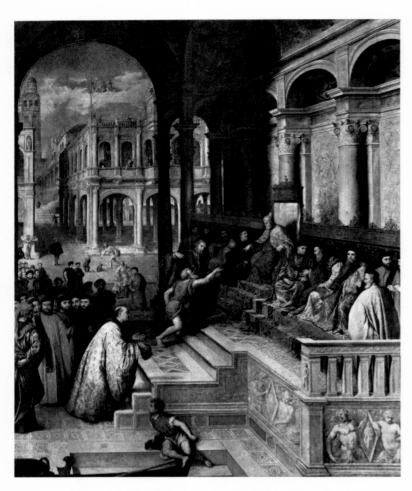

3. Paris Bordone. A FISHERMAN BRINGS THE RING
OF SAINT MARK TO THE DOGE. c. 1534.
Oil on canvas, 12′ 2″ × 9′ 10″. *Gallerie dell'Accademia, Venice*

Arte Veneta, 1969). If the ideological premises implicit in the great religious cycles realized by Tintoretto are considered, his work reveals a constant inspiration from a profound sense of faith typical of the common folk, one that expresses a tormented but confident hopefulness. The inspiration is evident from the time he first reached an artistic maturity truly his own right up to the end of his life—from the Saint Mark cycle begun in 1548 and completed in 1566 to the four scenes from Genesis painted between 1550 and 1553 for the Scuola della Trinità, from the work for the church of the Madonna dell'Orto between 1556 and 1564 to the great undertaking for the Scuola Grande di San Rocco that began in 1564 and continued for twenty-three years. The paintings of Tintoretto, far indeed from manifesting an obsessive egocentricity, gave form and voice to a collective religious sentiment that arose from the masses of suffering poor, sustained by a Catholic optimism that envisaged the end of the human ordeal as an otherworldly eternal happiness.

The first evidence of Tintoretto as painter is a document of May 22, 1539, which he signed as witness: "*mistro Giacomo depentor del Champo di San Chassan*" (Master Jacopo, painter, of Campo San Cassiano). Art historians of the twentieth century have assigned to the decade between that date and 1548—the year of the *Miraculous Rescue of a Christian Slave by Saint Mark*—many important works that constitute the catalogue of the younger years of the artist and enable us to grasp what his training and formation were. This critical evaluation is due especially to the research of Rodolfo Pallucchini (1950, 1967).

One may wonder why a painter gifted with such impetuous spontaneity should have required a formative period of almost a decade. But in Italy the years between 1539 and 1548 were extremely complex and their influence was decisive on the entire course of painting in Venice. They correspond to the period of major importance of the impetus of Tuscan-Emilian-Roman culture—in a word, of the impact of mannerism. There is still much debate about the particular character of mannerism as it evolved in the Veneto. Although some specialists insist that it is pointless to include Venice in this development (Briganti, 1945; Nicco Fasola, 1956), there does seem to be a clearer grasp now of the mannerist phenomenon in its Venetian guise, with a positive evaluation of its relationship with Emilian and Tuscan-Roman culture beginning around 1540 (Chastel, 1956; Hauser, 1964; Rodolfo Pallucchini, 1981). Tintoretto is, as one would expect, the Venetian most generally associated with the mannerist style.

Venetian culture had already shown, with a certain overt condescension, some interest before 1540 in the development of artistic idioms not based on mastery of color, on painterliness. In the 1520s Pordenone in his frescoes in Cremona Cathedral had sought some kind of modus vivendi with mannerist thinking. Also, the middle generation of Venetian painters—Bordone, Bonifazio dei Pitati (Bonifazio Veronese), Schiavone, and even Bassano (figs. 3–5, and see fig. 21)—offer allusions that prove their interest in Michelangelo, Raphael, Correggio, and Parmigianino. Even if there is no conclusive evidence in that period of a full awareness of a true antinaturalistic and anticlassical position, this Venetian proto-mannerism did break with the emphasis on tonality inherited from Giorgione but more and more watered down by his followers.

Another decisive factor was the presence in Venice of ever more important cultural emissaries from Rome and Florence. Among those who settled there after the sack of the Holy City by the imperial troops in 1527 were Pietro Aretino, militant critic and propagandist for Michelangelo's concept of *disegno*,

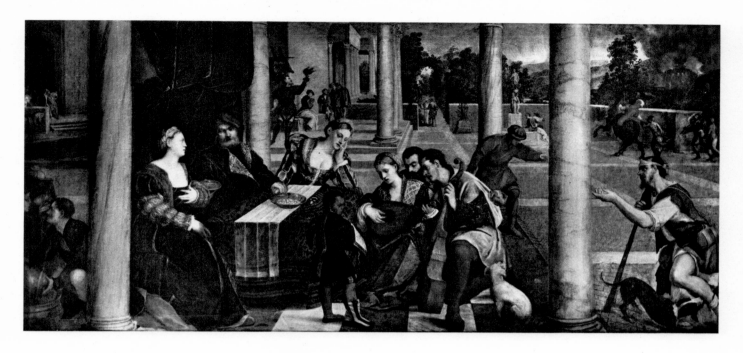

4. Bonifazio dei Pitati. THE BANQUET OF DIVES. c. 1540.
Oil on canvas, 6′ 9″ × 14′ 4″. *Gallerie dell'Accademia, Venice*

5. Andrea Schiavone. THE CONVERSION OF SAINT PAUL. c. 1544.
Oil on canvas, 6′ 9″ × 8′ 8″. *Pinacoteca Querini-Stampalia, Venice*

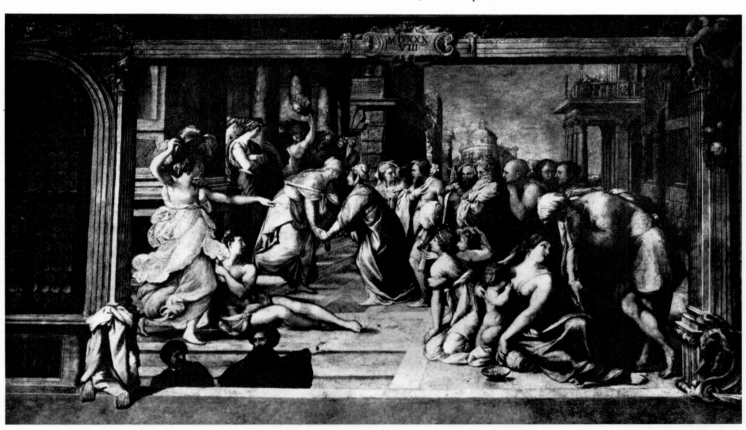

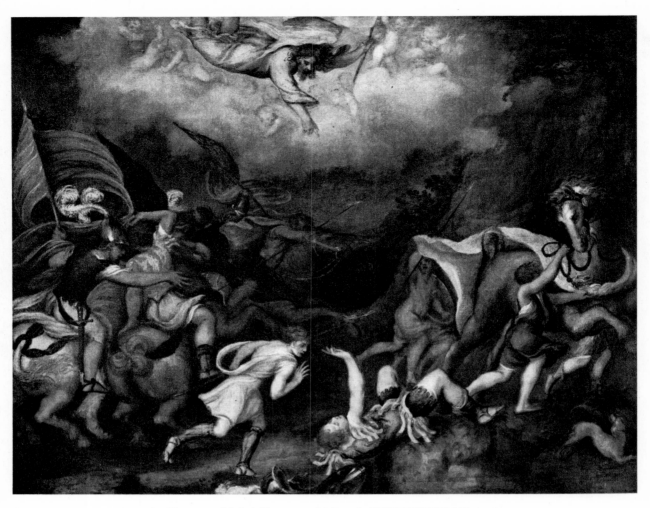

6. Francesco Salviati (Francesco de' Rossi). THE VISITATION. 1538.
Fresco. *San Giovanni Decollato, Rome*

7. Giuseppe Salviati (Giuseppe Porta).
Woodcut frontispiece of *Le Ingegnose Sorti di Francesco Marcolino,*
intitolato: Giardino dei pensieri (Venice, 1540)

and Jacopo Sansovino, sculptor and architect of the most modern persuasion. Eight years later Aretino begged from Michelangelo the drawings of the Medici tombs, which Tintoretto studied and copied in one drawing after another (see fig. 81). Then, between 1539 and 1541, the wealthy Grimani family summoned one of the major representatives of Roman mannerism, Francesco Salviati (fig. 6), to decorate the rooms of their palace in Campo Santa Maria Formosa. Vasari himself turned up in Venice in 1541–42 not only to stage the *Talanta*, Aretino's elaborate comedy, but also to decorate the Palazzo Corner-Spinelli with a ceiling painting in foreshortening, which would mark a turning point in the local art. Another arrival, in 1539, this one to settle permanently, was Giuseppe Salviati (fig. 7), a mediocre painter but highly active and singularly capable of transmitting the ideas of Michelangelo and Raphael to the young Venetians who were eager to master the new manner, which had by then become virtually a mode or a mania. Finally the prints after Parmigianino were introduced by Schiavone, who himself reworked them in a coloristic key; these, with their fascinating

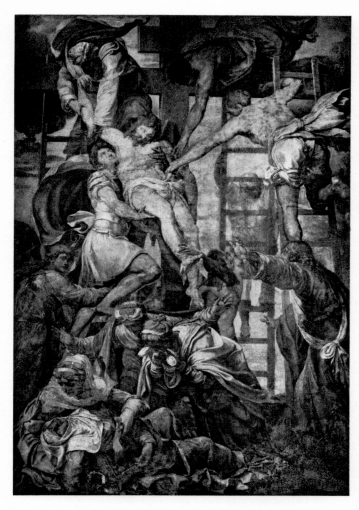

8. Daniele da Volterra. DESCENT FROM THE CROSS. 1541.
Detached fresco, approximately 13′ × 8′ 6″. *Santa Trinità dei Monti, Rome*

9. ALLEGORICAL FIGURE. c. 1541.
Detached fresco, 71 × 41⅜″. *Coiazzi Collection, Venice*

10. Antonio Maria Zanetti. AURORA.
Engraving after lost Tintoretto fresco for Palazzo Grimani,
Venice, in Zanetti's *Varie pitture a fresco de' principali maestri veneziani* (Venice, 1760)

and elegant dynamic, were destined for a sure success in those Venetian circles that prized formal refinement and a measured grace.

Clearly then, the crucial decade in the development of Tintoretto as an artist was so rich in new possibilities as to justify a long period of enthusiasms and changes. This meant, on the one hand, that he was slower in arriving at a firmly defined language, and, on the other, that he continued to absorb the ideas and motifs, disparate yet consistent with each other, of that revitalizing force that is referred to as mannerism (fig. 8).

It was the pro-Venetian theorist Paolo Pino who in 1548 wrote that if an artist were able to unite "the draftsmanship [*disegno*] of Michelangelo with the color of Titian . . . he would be the very god of painting." It was a motto that might have served more than one of the younger generation in Venice in the 1540s and 1550s but would best have fitted Tintoretto had this been what he was after. But between 1539 and 1548 that eager young man was avidly grasping at everything he could find a use for, without imposing limits on himself and standing under no other man's banner. Whatever he produced was entirely original, an idiom that burgeoned under his hands with increasing sureness (figs. 9, 10).

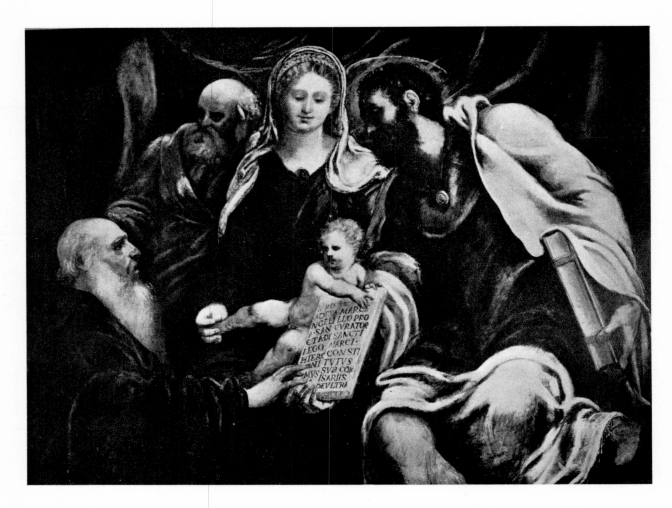

11. THE HOLY FAMILY WITH SAINT JEROME AND THE PROCURATOR GIROLAMO MARCELLO. c. 1537.
Oil on canvas, 4' 10" × 6' 4". Private collection, Lucerne

Perhaps the earliest work that can be attributed to Tintoretto with certainty is the *Holy Family with Saint Jerome and the Procurator Girolamo Marcello* (fig. 11). It was probably painted about 1537, since the election of Marcello to the post of procurator on June 17, 1537, is referred to in the pages of the book held out to him by Saint Jerome and to which the infant Jesus points. At the time Tintoretto was not yet twenty, yet the canvas with its life-size figures unmistakably heralds a new artist. Graceful and elegant as a figure by Parmigianino, the Virgin still has a touch of the archaic in both her type and pose, suggestive more of a Byzantine image of the empress Basilissa than of a stately Venetian model. More traditional, however, and more in the line of a donor by Bordone or Bonifazio, is the procurator fitted in at the margin, profiled by his snowy beard against the sumptuous red of his senatorial robe. But the surprising force of the young painter seems to have been concentrated in the Saint Jerome seated obliquely across the right half of the picture. He dominates the foreground, and the foreshortening of his pose distinguishes him from the other figures, makes them appear flattened against the background. A more

overt homage to the Michelangelo of the Sistine Chapel Prophets and the Medici tomb figures could not be imagined in the Venice of those years. This single figure, although given unexpected prominence that is not completely integrated within the painting, constitutes a truly exceptional poetic and cultural presence. A new painter had been born, and one can imagine the reactions of a contemporary faced with this picture, which seemed to demand its due by an almost insolent sureness and assertion of its own artistic authority.

Once the formula had been found, the young man clung to it for a few years at least—in the same way that the *Madonneri*, those artisan fabricators of Madonnas who may have been his masters, churned out infinite repetitions of models that were archaic and yet forever new. Signed and dated 1540, another *Holy Family with Saints* (fig. 12), now in a private collection in New York, would seem to be the first painting in which the artist finally worked out to his satisfaction the motif he had felicitously discovered. The figures, again life-size, are disposed with more measured harmony around the Virgin and balance each other in defined rhythms, with airy gestures that attenu-

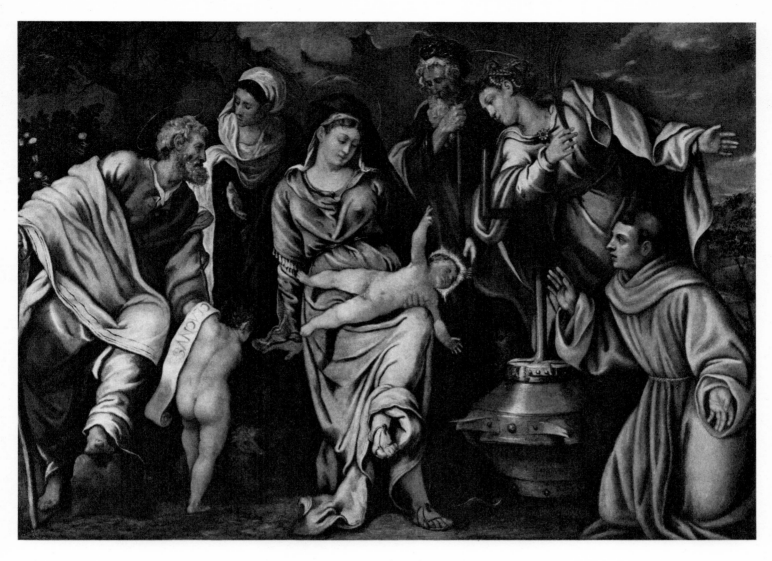

12. THE HOLY FAMILY WITH THE YOUNG JOHN THE BAPTIST
AND SAINTS JEROME(?), ANN, CATHERINE OF ALEXANDRIA, AND FRANCIS. 1540.
Oil on canvas, 5′ 7″ × 8′ . *Private collection, New York*

13. Michelangelo. THE MEDICI MADONNA. c. 1531.
Marble, height 7′ 5″. *Nuova Sagrestia, San Lorenzo, Florence*

ate the evident borrowings from Michelangelo (fig. 13) and
Raphael. The artist was making an ever more integral chro-
matic narrative, particularly through dynamic structural lines
defined by the use of light, but the timbres still verged on stri-
dencies, which were nevertheless typically fresh and youthful.

To the three years between these two paintings have been
assigned several other variations on the same theme that Tin-
toretto, drawn to new interests, soon renounced. Among the
finest of these studies of the Holy Family is one presently in the
Wallraf-Richartz-Museum in Cologne, a *Holy Family with
Saint Ann and Saint John the Baptist*, which is dense with pro-
found vibrations in the velvets and silks caught by a painter
familiar with the dyer's art; and there is the Madonna in
the Curtis Collection in Venice. There is also one in the
Boymans–van Beuningen Museum in Rotterdam in which the
attitude, reminiscent of Michelangelo, is given precise expres-
sion in the elegant stylization of the linear profiles.

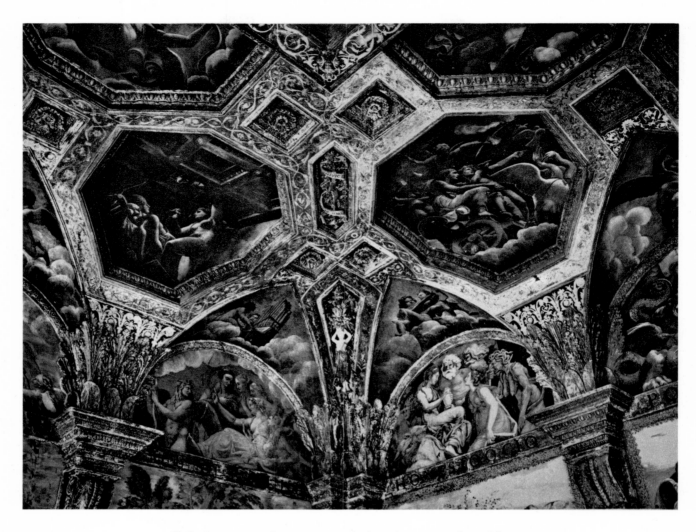

14. Giulio Romano. Ceiling Frescoes, Sala di Psiche. 1528. *Palazzo del Te, Mantua*

It has been variously proposed that Tintoretto may have been so drawn by a passion for the new Roman forms as to visit Mantua, setting off sometime around 1540 to discover for himself the frescoes of Giulio Romano (fig. 14). The first and most immediate results of that expedition may have been the fourteen octagons with mythological subjects done for the Palazzo Pisani in the former San Paterniano quarter and now in Modena (fig. 15). Daringly foreshortened forms, contorted and serpentine poses, disconcerting lighting effects often with dramatic illumination from behind, sophisticated connections between various figures in flight, all offer the clearest evidence—if one accepts the hypothesis of a visit to Mantua—of the violent impact the work of the older master had on a virtual beginner in his early twenties. Further consequences showed themselves in certain broadly conceived compositions such as the Milan *Dispute of the Boy Jesus in the Temple* (colorplate 2), a vivid work that recalls the noble compositional symmetry of the Stanze of Raphael, which the young artist could have known through prints.

Something different from the Roman influence appears in the six "Biblical Tales" now in Vienna (colorplate 3, fig. 16)—painted about the middle 1540s—in which the compositional framework and vivid chromaticism imply a new model, Andrea Schiavone. In reaction against the sculptural and ponderous excess of his Mantua-influenced figures, Tintoretto turned, in these six panels, to the fluid manner of the younger painter from Dalmatia, Schiavone, who was linked by a double thread, as engraver and painter, to the work of Parmigianino. The panels (probably cassone fronts) are beyond question among the greatest achievements of Tintoretto's younger years. They display an unprecedented taste for theatrical settings, exploiting perspective and emphasizing it at times by pavements with large marble squares or by rows of colonnades.

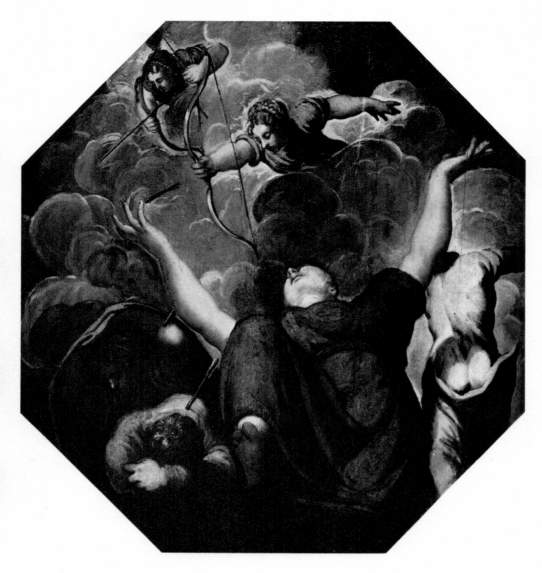

15. NIOBE AND HER CHILDREN. c. 1542.
Oil on canvas, 5' × 4' . *Galleria Estense, Modena*

16. THE PROPHET NATHAN PROMISES ETERNAL LIFE TO THE HOUSE OF DAVID. c. 1546.
Oil on canvas, 11⅜ × 60". *Kunsthistorisches Museum, Vienna*

17. Sebastiano Serlio. Setting for "LA SCENA TRAGICA." Woodcut, in Serlio's *Il secondo libro d'architettura*, p. 45v (Paris, 1545)

THE SCENOGRAPHIC SETTING

In the mid-1540s the painter seemed to be taking a new interest in the setting as such, and it was surely no coincidence that Sebastiano Serlio's book on theatrical architecture (fig. 17), published in Paris in 1545, circulated widely among the Venetian painters. While Tintoretto makes much of motifs drawn from Schiavone in several other narrow, horizontally oriented pictures—the finest of which are an *Apollo and Marsyas* (fig. 18) and the *Concert of the Muses* in Verona—at the same time he was developing a partiality for scenographic painting with broad and spacious architecture. The immediate result was a group of narrative paintings on biblical subjects, most often with life-size figures, including a *Visit of the Queen of Sheba to Solomon* (fig. 19), a *Christ and the Woman Taken in Adultery* (fig. 20), and other canvases on the latter subject now in Amsterdam, Prague, Milan, and Dresden. The common element in these works, after a suggestion in the rules laid down by Serlio, is the architectural framework. Within it the figures are disposed like dynamic elements of a stage presentation based particularly on skillful use of light, often with a natural source complemented by one that is artificial. More than being magical, as has so often been observed, the tendency is toward a verisimilitude of the stage setting, superimposing—sometimes even chaotically—effects of formal artifice on others which, in the gestures and attitudes of the figures, smack of the melodramatic. Clearly the artist was aiming more for poetic credibility than for veristic effect. The theatricalism Tintoretto arrived at had more in common with popular pantomime than with the noble solemnity of the *sacre rappresentazioni*, the religious spectacles still performed in his time.

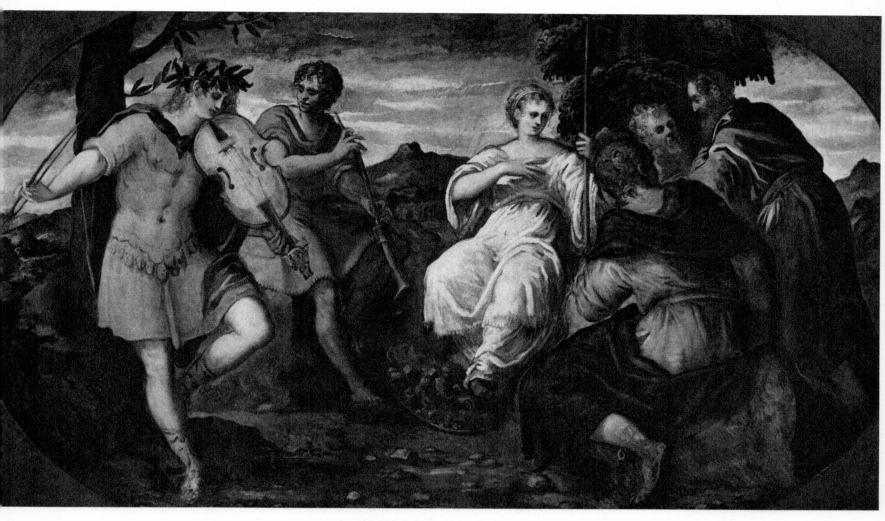

18. APOLLO AND MARSYAS. 1545.
Oil on canvas, 4' 6" × 7' 9". *Wadsworth Atheneum, Hartford, Connecticut. Ella Gallup Sumner and Mary Catlin Sumner Collection*

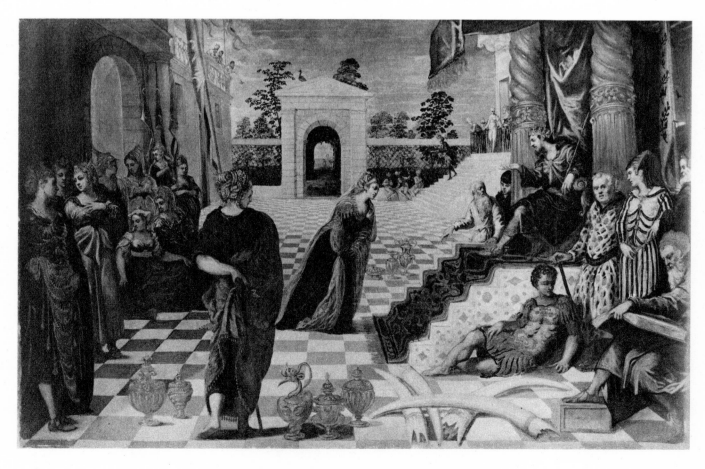

19. THE VISIT OF THE QUEEN OF SHEBA TO SOLOMON. c. 1546.
Oil on canvas, 4' 11" × 7'. *Bob Jones University Collection, Greenville, South Carolina*

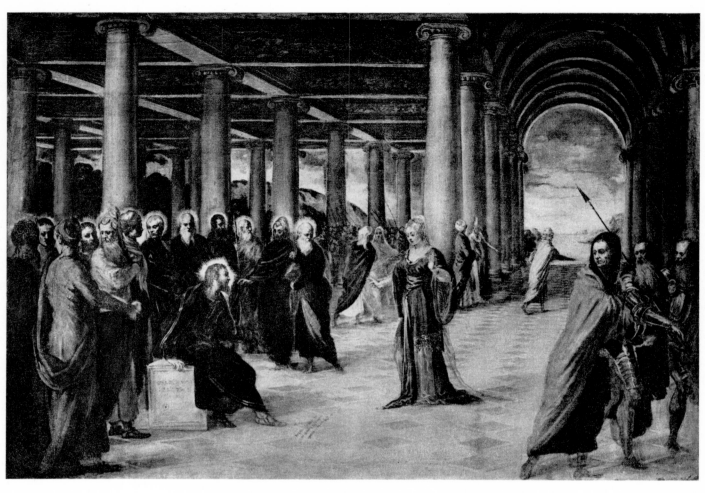

20. CHRIST AND THE WOMAN TAKEN IN ADULTERY. c. 1546.
Oil on canvas, 47 × 66½". *Galleria Nazionale, Rome*

21. Jacopo Bassano. THE LAST SUPPER. c. 1547.
Oil on canvas, 5′ 6″ × 8′ 10″. *Galleria Borghese, Rome*

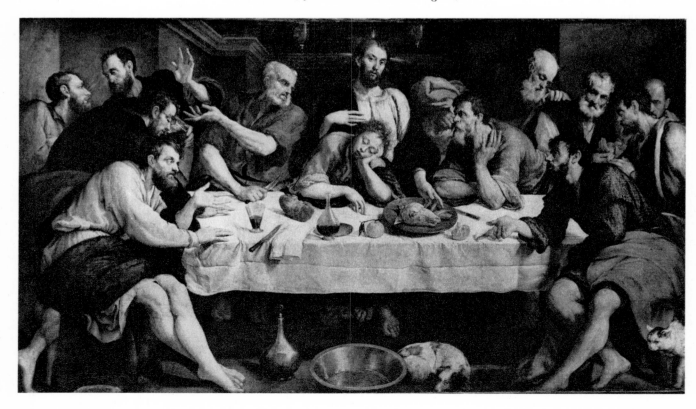

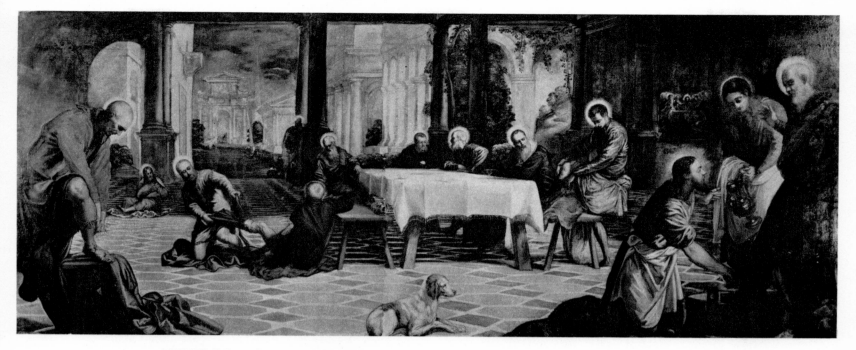

22. THE WASHING OF FEET. 1547. Oil on canvas, 7′ × 17′ 5½″. *Cathedral of Saint Nicholas, Newcastle-upon-Tyne*

It was in the paintings of 1547–48, works that rounded off his youthful period, that Tintoretto reached a truly high pitch of expressivity. In the *Last Supper* for the church of San Marcuola (fig. 23), inscribed with the date 1547, he inaugurated a new and grandiose format, with the very large dimensions that became typical of his work (figs. 22, 23). The usual long band of Apostles to either side of the Christ comprised a new and more picturesque grouping, and the impression that the same forms are repeated at the right and left in symmetrical positions is accentuated by the light that silhouettes the profiles against the background of a dark-green drapery. A mysterious aura thus infuses the most mysterious and secret act of the Passion of Christ and confers profound significance on this representation of the celebration of the Eucharist. The significance is furthered by the attention given to the Apostles, who, through their ex-

pressive gestures, reveal their awareness of the solemn rite taking place. In contrast, the two Virtues at either side, Faith and Charity, seem static and anonymous, and although they are treated seriously, they give the impression of two serving women passively observing the strange tableau.

As pendant to the *Last Supper*, probably in the same year, Tintoretto painted an even larger canvas, a *Washing of Feet* (fig. 22), which eventually made its way from San Marcuola to the Cathedral of Saint Nicholas at Newcastle-upon-Tyne in England. With a grandiose atrium of a classical villa and a backdrop painted according to the architectural prescriptions of Serlio, this painting differs in its scenic apparatus. Yet here too the biblical event is presented in its own rigorous simplicity, subdivided into distinct episodes that imprint on the narrative a slower but no less intense rhythm. While the other Apostles

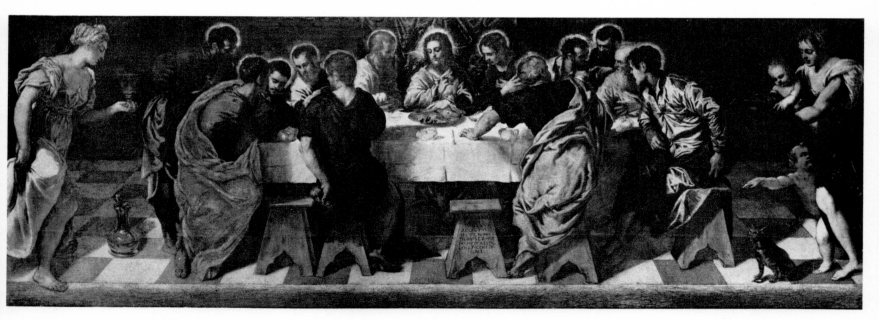

23. THE LAST SUPPER. 1547. Oil on canvas, 5′ 2″ × 14′ 6″. *San Marcuola, Venice*

24. PORTRAIT OF A NOBLEMAN. 1545.
Oil on canvas, 53½ × 41".
Her Majesty's Collections, Hampton Court Palace, Middlesex

remove their footgear for the ritual, Christ kneels to wash the feet of Simon Peter, whose melodramatic gesture accentuates his surprise and emotion. The sense of miracle is present in all its force, not as a formal effect so much as the direct expression of a sentiment accessible to the simple spirit of the believer.

Certainly the technical virtuosity of the composition, the surprising effect of color thinly applied and made iridescent by the light, the scrupulous treatment of human anatomy, and the evocative transparency of the background landscape, all contribute fundamentally to the true accomplishment of this work. That the theme as well as the approach to it were important to the artist is attested by the numerous other versions he painted, from the more elementary and perhaps earlier one in the Pembroke Collection at Wilton House in England to those in the Art Gallery of Ontario, Toronto, and the Prado, Madrid (colorplate 5). The Toronto canvas, more schematic in its architectural treatment, appears almost a dress rehearsal for the Newcastle-upon-Tyne version, while that in Madrid, although equivalent in the distribution of the figures, strikes one as of a later date and distinguished from the model by a greater harmony and chromatic fusion. This chromatic harmony, due to the use of lighter tones and a general brightening of the background, already forecasts the *Miraculous Rescue of a Christian Slave by Saint Mark* (colorplate 6), which would make it the

most advanced point to which the painter had so far carried this treatment of the ritual cleansing of the disciples' feet (see Rodolfo Pallucchini, 1976).

The highly accentuated mimetic and physiognomical characterization of Tintoretto's figures in historical or sacred scenes suggests that many are likenesses from life. From the outset he had to cope with portraiture true and proper, and it is typical of him that its formal genesis should be rooted in the close observation of human types in his larger compositions. The portraits in this earliest period extend in orderly sequence from the 1545 Hampton Court *Portrait of a Nobleman* (fig. 24) to the *Bearded Gentleman* in the Louvre, which is close to it in time, to the Kröller-Müller Museum *Gentleman in Furred Coat* of two years later and to the imposing *Portrait of Niccolò Priuli* (fig. 25), also attributed to 1574. A *Self-Portrait* in New York (see fig. 1), painted about 1548, when the artist was thirty—of which another version exists in the Victoria and Albert Museum in London—catches the impetuous and dramatic expression the young man may well have had. The *Portrait of Jacopo Sansovino* (fig. 27) of about the same year shows a more fully developed form, with the background opening onto architecture and landscape.

In these first examples, in which his ability to suggest character through physiognomical and psychological accents is proven, the artist seems to aim at a vision that is intensely expressive and faithful to life rather than at the definition of a social type as Titian did (see Rossi, 1974). Yet in the most important instances Tintoretto was not insensible to that great

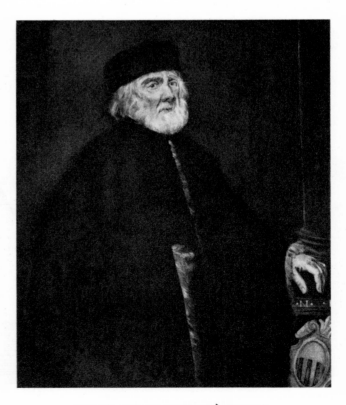

25. PORTRAIT OF NICCOLÒ PRIULI. c. 1547.
Oil on canvas, 49¼ × 41⅜". *Ca' d'Oro, Venice*

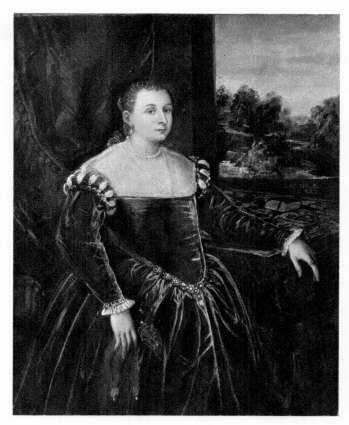

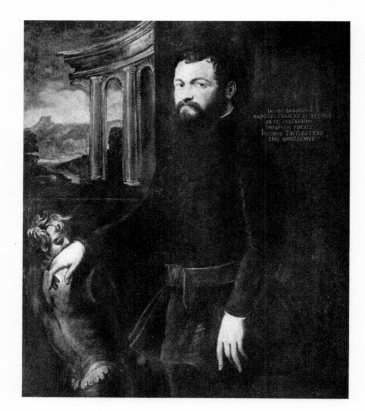

26. PORTRAIT OF A VENETIAN NOBLEWOMAN. c. 1550.
Oil on canvas, 58 × 47".
Institute of Arts, Minneapolis. William Hood Dunwoody Fund

27. PORTRAIT OF JACOPO SANSOVINO. c. 1547–48.
Oil on canvas, dimensions unavailable.
Formerly Bachstitz Collection, The Hague

model, and the results were not long in appearing in such works from about 1550 as the stately *Portrait of a Venetian Noblewoman* (fig. 26), the spiritual *Lady in Mourning* in Dresden, the *Procurator Jacopo Soranzo* in the Venice Accademia, and the monumental *Portrait of the Soranzo Family* in Milan (Frontispiece and fig. 28a, b) with no fewer than fifteen likenesses.

Although portraiture commanded his attention fairly regularly, the true vocation of Tintoretto was in works for public viewing, whether historical, sacred, or profane in subject. It is as if he understood almost from the start that he was destined to work on a grandiose scale, to create large works for a public that might be anonymous but was no less capable of participation, expressed by a faith that was simple and profoundly felt. Tintoretto was very much the man for miracles, an artist for whom the superhuman event fulfilled an unquestioning need for optimism.

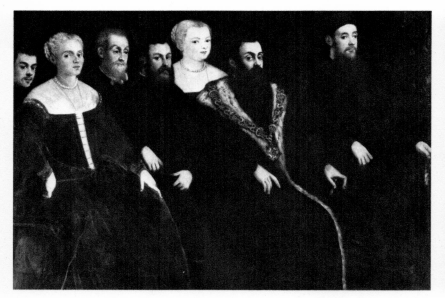

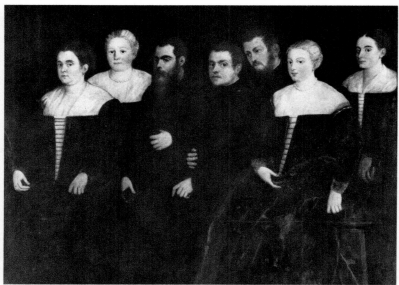

28. PORTRAIT OF THE SORANZO FAMILY. c. 1550.
Oil on canvas, each side 5' × 7'. *Castello Sforzesco, Milan*

THE VENETIAN *SCUOLE*

The natural environment for such miracle paintings was the *scuola*, the peculiarly Venetian institution in which laymen formed confraternities for works of religious devotion and charity and mutual aid (though not for education, as the name would seem to imply), with members drawn usually from the same craft or trade and, in cosmopolitan Venice, the same national stock. The *scuola* was the equilibrating organization par excellence of the Venetian social system: in fact, the Republic in its wisdom entrusted to the *scuole* a task of political moderation accomplished by both material beneficence and spiritual participation. Not unexpectedly, it was in the *scuole* that the popular legends best took root and grew and that the most-loved saints were honored, saints like Mark, protector of Venice, and Roch, deliverer from plague.

The *Miraculous Rescue of a Christian Slave by Saint Mark* (colorplate 6) was painted in 1548 for the major confraternity that bears the name of the saint honored in the painting—the Scuola Grande di San Marco—and in time it was joined by three others to form an ensemble. Center of the dynamic action and at the same time focal point of the viewer's awareness of the miracle, the saint plunges down from the skies, and his sole gesture suffices to shatter in the hands of the torturers the instruments of the martyrdom of the poor slave accused by his Turkish masters of practicing the Christian faith. Confronted with the sudden shattering of the axes and other instruments, the executioner turns in consternation toward the judge, himself dismayed, while the soldiers shrink back and the onlookers huddle together in disbelief. Around the prospective victim, stretched on the ground in marked foreshortening, is a void; clearly the painter's intention was that none of the Turks should perceive the saint in midair, plummeting like an eagle with tensely spread wings. The blinding explosion of light that haloes the head of Saint Mark, like lightning in a cloudless sky, slashes the shadow of the pergola beneath which the hideous judgment was about to be consummated. The impact that such an effect—ingenious but fairly elementary in its shock value—must have had on Tintoretto's contemporaries is difficult for the modern viewer to imagine since he is used to much greater marvels offered by present-day technicians and scientists, but a Venetian in the year 1548 had little precedent for it and must have gasped in wonderment (fig. 29).

As a final twist to the extraordinary, Tintoretto seems to have amused himself by inserting into the crowd portraits of three persons known to everyone in Venice and made conspicuous in the picture by their dark garments: the physician Tommaso Rangone, who was the promoter of the entire pictorial decoration of the confraternity headquarters, the critic Pietro Aretino, who immediately acclaimed the value of the work and even insisted on its great originality, and the artist himself, who looks on with evident satisfaction. All three—Rangone in the lower left corner, Aretino peering out between the columns, Tintoretto at the right margin—are clearly offstage, present like the saint but just as invisible, seeing but not being seen. This is perhaps more than simply a clever contrivance, it is a devout act of participation, a pledge of faith.

That so much unprecedented play of ideological, aesthetic, scenographic, and spiritual elements would unsettle anyone who had never before witnessed them in a painting was not unexpected. The reactions were predictable, especially among the traditionalists and promoters of the status quo, the supporters of special interests, and, not least, the rival painters. Someone even spoke—or pretended to—in the name of Titian, absent from the city in the service of the emperor. As a tradition handed down by various sixteenth-century writers has it, there were such clamorous protests that an indignant Tintoretto took the canvas back to his studio. With time the storm blew over, and Venice finally realized it could count another great master—"Iacopo Tentor," as he signed himself in a burst of pride on his new work.

The year 1548 therefore marks the true coming of age and the first real triumph of the artist after ten years of tests and trials and ever more frequent successes. The formulas for comparison devised by later writers—maniacal visionary, an awesome brain, a manneristic painter; Michelangelo's draftsmanship and Titian's color—do not explain the true poetic accomplishment of this canvas. More than an impressive technical virtuosity or innovation in form or an aggressive display of feeling, what Tintoretto took as his point of departure was a profound understanding of the human responses of simple people like the fishermen, workers, modest merchants, and artisans aided by the Scuola Grande or counted among its members. Compassion and rejoicing for a poor and unknown creature—a slave, a nobody in the social scheme—who in his final moment found a just avenger are genuine and simple sentiments. In this painting they are expressed as an utmost challenge, with dazzling colors and lights, grandiose forms, and unexpected brushwork, which, in its defiant sureness and intuitive swiftness, must, like the subject itself, have seemed a very special event.

Apparently not willing to rest on his laurels, Tintoretto soon returned to the theme of supernatural apparition in the *Saint Roch Ministering to the Plague Victims* (colorplate 7) for the church of San Rocco. An archive document of the adjacent Scuola Grande gives the date 1549, and there are indeed many

elements in common with the *Miraculous Rescue of a Christian Slave* of the previous year, most notably in its composition based on converging architectural side wings and in its chromatic conception with the dark interior of the *lazaretto* counterpointed by various strands of light. Here there is no grand artifice of a soaring saint invisible to the multitude, however; instead, a humble healer of souls and bodies alike walks among the unfortunates struck down by the grim contagion. No earlier depiction is known of the horrors of the pest-houses in time of plague, that most feared scourge of the age. Tintoretto's is the first, and its realistic fidelity is surprising, even if his motive seems to have been the compassionate piety of a Christian spirit rather than the aesthetic constraints of representing things as they were.

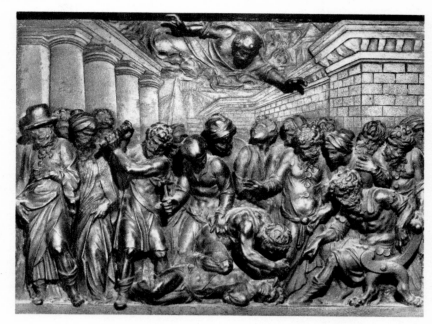

29. Jacopo Sansovino. SAINT MARK RESCUING A SLAVE. 1541–43. Bronze relief, 19⅝ × 23⅝″. *Basilica di San Marco, Venice*

NEW INTEREST IN TITIAN AND VERONESE

After such creations, which must have exhausted him through their anguished spiritual conception as much as their unprecedented creative realization of new forms, it would have been natural if Tintoretto had sought some way to catch his breath. Instead, in the first years of the 1550s, he began a new series of important pictures that involved stylistic innovation and demanded maximum creative tension. Most writers agree that in this period there are signs of a new interest in his major contemporaries, Titian and Veronese—not in terms of influence or imitation but as an undisguised ideological and stylistic confrontation, virtually a challenge on their own terrain.

The five episodes from Genesis painted between 1550 and 1553 for the Scuola della Trinità (later demolished to make way for Santa Maria della Salute) entered into direct competition with the purported mannerist expression of Titian. Certain works of the older master done in the 1540s—the *Christ Crowned with Thorns* of the Louvre, the *Saint John Baptist* of the Venice Accademia, and the *Cain Slaying Abel*, one of the canvases for the ceiling of Santo Spirito, now in Santa Maria della Salute (fig. 30)—seem to have been objects of the younger man's challenge; it suffices to note that the presence of the monumental nudes in both artists' works was derived from Michelangelo. But the flowing form of the bodies as well as the use of a serpentine movement to develop compositions along lines of force notably differentiate Tintoretto's results from those of Titian. What is missing, though, is that inescapable sense of classical form that made Titian, when he felt the need

for renewal, turn to antique sculpture rather than to the tormented manner of Michelangelo.

With Tintoretto the human body moves on a plane of tension and dynamism that seems to shake off the canons of the antique; with enhanced pathos, the figure steps into an insecure reality, which is profoundly tinged with the feel of mannerism. This is especially evident in the four of these biblical scenes that are extant (now in the Venice Accademia). In the *Fall of Man* (fig. 31, colorplate 10) the nude bodies are like forms vibrant in the glow of the earthly paradise, a warm light tremulous with hints of sorrow to come, while in the *Cain Slaying Abel* (fig. 32) the struggle reaches the acme of a drama whipped to exacerbation by the light slashing through forest foliage. This same well of quivering instability was responsible for a genuine masterpiece, the *Creation of the Animals* (colorplate 9). A furious whirlwind of lights and colors, resplendent as lightning in a sky still stormy with the throes of creation, is swept along by the gesture of the Creator.

In other canvases of the period the artist took up again, in a profane key, the formally fascinating motif of the nude he had tested in the Genesis scenes: the *Susanna and the Elders* of the Louvre with its stupendous female form delineated against the green carpet of an opulent garden, the *Leda and the Swan* formerly in the Contini-Bonacossi Collection, the Dresden *Liberation of Arsinoë*, but above all the Munich *Venus and Mars Surprised by Vulcan* (colorplate 11). The Munich painting is the most elaborate of the group, staged in an interior through whose

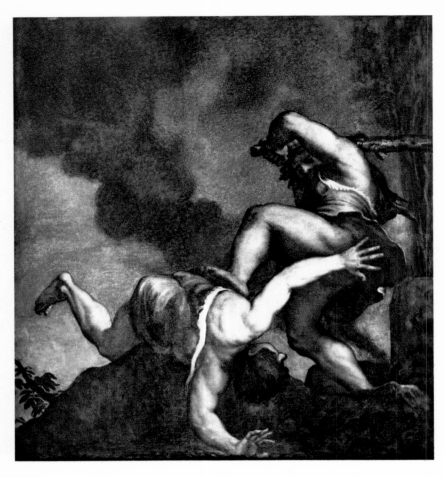

30. Titian. CAIN SLAYING ABEL. 1542.
Oil on canvas, 9' 2" square. *Santa Maria della Salute, Venice*

31. Paolo Farinati (after Tintoretto).
THE FALL OF MAN AND THE CREATION OF EVE. 1550–53.
Pen and brush, dark and light brown ink, 10 × 7¼".
Janos Scholz Collection, New York

bull's-eye glass windows intersecting rays of light sweep along the diagonal movements of the figures. The figures themselves are set into an off-balance composition full of scarcely restrained tension, just as the subject calls for.

Last perhaps in this series is the Vienna *Susanna and the Elders* (fig. 33, colorplate 16), which fills almost half of the scene with a relaxed and opulent image, emphasizing the contrast between the alabaster translucence of the flesh and the darkness of the hedge that separates but does not conceal the naked beauty from the prurient elders. Within this shady bower, cool and sheltered as a private interior, the painter disposes with consummate skill the treasures of his personal armamentarium of luminosity: limpid water, mirror, silver vase, lace, jewels, and pearl necklaces. All around, delicate small roses tremble beneath the gently grazing rays of an afternoon sun that evokes a soft and sensual warmth somewhat unusual with Tintoretto. For once, in subject matter at least, he let himself be tempted by Titian's sumptuous Venuses radiant at their toilette or taking their ease.

Conversely, the inspiration for the six "Biblical Tales" now in Madrid has often been said to come from Veronese. These canvases, among the most fascinating of Tintoretto's works, had the honor of being acquired by Velázquez during his visit to Venice in 1649. Each is dominated by a single full-bodied female figure with a strongly sensual expression. But the specific roles are different: sometimes she is in the scintillating garments of a heroine of antiquity, Judith, Esther, the pharaoh's daughter, or the queen of Sheba (fig. 34); elsewhere, as Potiphar's wife (colorplate 15) or Susanna, she is nude and provocative. If their date is not later than 1555, it is difficult to say what the point of contact with Veronese, that other bright star on the Venetian scene, could have been, although just before that time Veronese had produced for the Doges' Palace certain much-admired, sumptuous-bodied Junos (fig. 35) and Venuses and Virtues that were no less elegant, paintings promptly judged by the critic Francesco Sansovino in 1556 to be "work truly draftsmanlike and refined" ("*opera veramente di disegno et gentile*"). Yet it was not for outward splendor of trappings nor certainly for its sensual licentiousness (unthinkable for a man like Tintoretto) that the artist would have been interested in the work of the young Veronese, who had come suddenly to the fore and just as suddenly won the praise of those two powerful Venetians, Jacopo Sansovino and Titian, for his decoration of the Libreria Vecchia, completed in 1556. Rather, Tintoretto's alert and penetrating eye would have detected in his younger contemporary an original and valid interpretation of the *maniera* in the style peculiar to Parmigianino: skillfully sophisticated poses, elegant contortions of the figures, and a generally lightened palette supported by an almost transparent

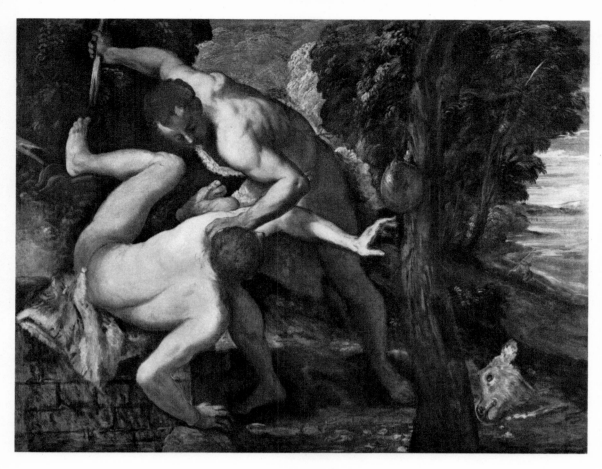

32. CAIN SLAYING ABEL. 1550–53.
Oil on canvas, 4′ 11″ × 6′ 5″. *Gallerie dell'Accademia, Venice*

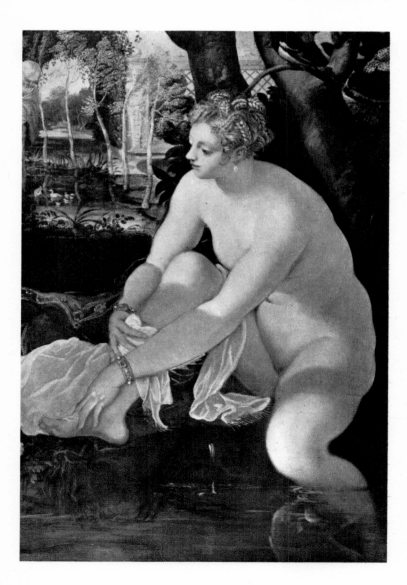

graphic definition (as in the paintings Veronese did for the sacristy of San Sebastiano in 1555). The influence of Veronese by no means weighed down the natural idiom of Tintoretto but, instead, helped to render his enamel-like chromatic textures lighter and more lucent.

If then the older painter looked to the example of the younger—whose work he could have seen perhaps as early as 1551 in San Francesco della Vigna—it was chiefly in terms of refinement of the blend of color and drawing, a factor that was always, virtually by instinct, weighty with Tintoretto. Traces of that influence are to be detected in other works from the early 1550s, such as the three canvases for the Palazzo dei Camerlenghi (all now in the Accademia): the *Saint Andrew and Saint Jerome* (fig. 36), the *Saint Louis of Toulouse and Saint George with the Princess* (colorplate 12), and the *Madonna and Child with Four Salt Magistrates*. Likewise the *Presentation of the Infant Jesus in the Temple* of the Accademia is very much a parallel to one on the same subject by Veronese for the organ case of San Sebastiano, which not only seems to have suggested the monumental motif of the woman in the immediate foreground but reveals other similarities in the flaming candles and in the typologies of the bearded priests swathed in garments rich in luminescent and chromatic effects.

33. SUSANNA AND THE ELDERS (detail). c. 1555.
Oil on canvas, overall 4′ × 6′ 4″.
Kunsthistorisches Museum, Vienna

34. THE VISIT OF THE QUEEN OF SHEBA TO SOLOMON. c. 1555. Oil on canvas, 23 × 81″. *Museo del Prado, Madrid*

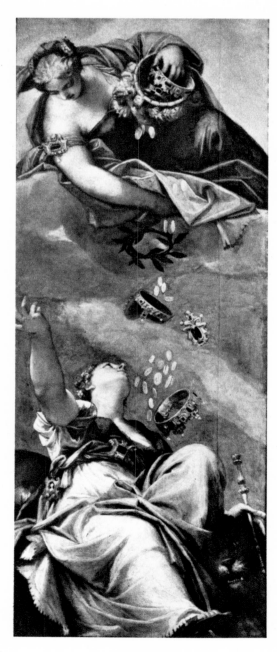

35. Paolo Veronese.
JUNO SHOWERING RICHES OVER VENICE. 1553–54.
Oil on canvas, 12′ × 4′ 10″
Palazzo Ducale, Venice

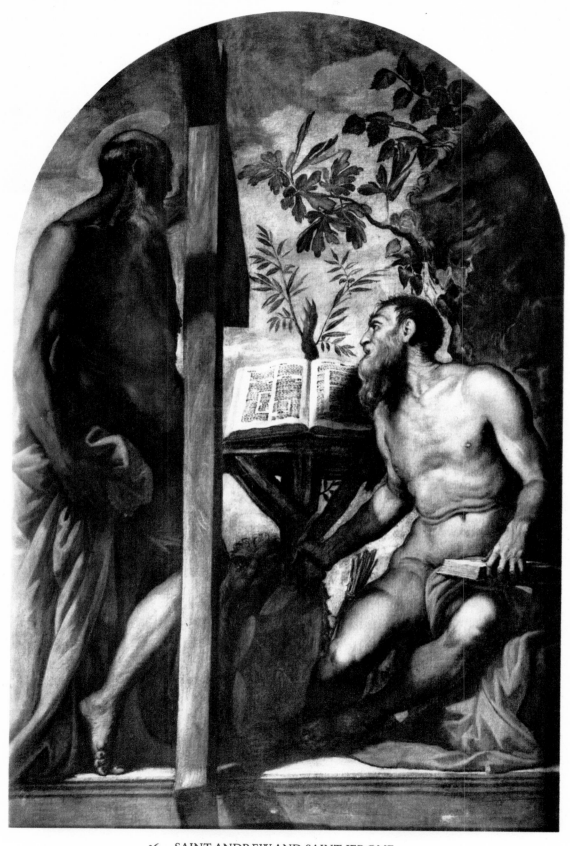

36. SAINT ANDREW AND SAINT JEROME. 1553.
Oil on canvas, 7' 5" × 4' 9". *Gallerie dell'Accademia, Venice*

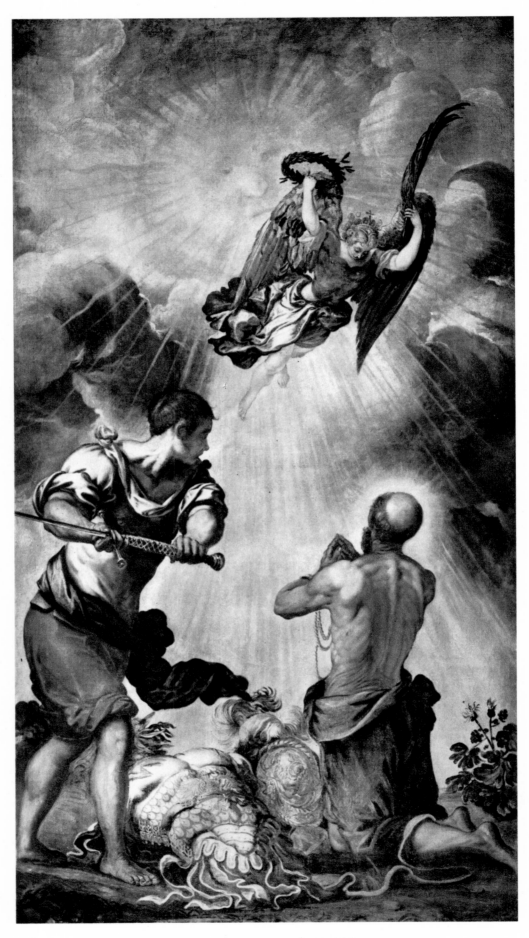

37. THE MARTYRDOM OF SAINT PAUL. c. 1555–56.
Oil on canvas, 14′ 1″ × 7′ 10″. *Madonna dell'Orto, Venice*

THE LARGE NARRATIVE PAINTINGS

In themselves such minor notes recalling Titian or Veronese do not prove that these painters had decisive influences in the progress of Tintoretto's aesthetic language. At the most they stirred up something dormant. He lost no time, however, in returning to the large narrative pictures typical of him, intact in his own style and not truly distracted from it. He remained tenacious in his partiality toward an expression rooted in popular theatrics; bursting with invention, his work continued to be vividly evocative in portraying the stuff of miracles and in its unsophisticated religiosity.

The paintings for the organ shutters (now three separate canvases) for the church of the Madonna dell'Orto were completed in 1556 and again establish the visionary power of the master who proved himself in the *Miraculous Rescue of a Christian Slave*. The *Apparition of the Cross to Saint Peter* (colorplate 17) is one with the *Martyrdom of Saint Paul* (fig. 37) in the blinding burst of golden light that seems to thrust the shapes of the protagonists toward the viewer, accelerating their movements and thus giving substance to their three-dimensional forms. In both paintings, however, there is an astonishing harmony of color and light so conceived as to bring out the drama of the events depicted. The *Presentation of the Virgin* (colorplate 8), on the former outer faces of the organ shutters that became a single picture when closed, is dominated by the scenographic effect of a great stairway. The leading personage, the tiny figure of Mary climbing the steep steps, is lit from behind, and attention is further directed to her by the gestures of the accessory figures. The artist's eloquence as preacher to the masses is becoming ever more trenchant, and already one can sense the fluent discourse he would proclaim in the Scuola Grande di San Rocco.

To this same moment of intense Christian spirituality belong the organ shutters for the church of Santa Maria Zobenigo (also known as Santa Maria del Giglio), painted perhaps in 1557 and of which the two inner faces, one with the *Evangelists Luke and Matthew*, survive (colorplate 18, fig. 38). In these the chiaroscuro is extremely marked, with the raw light highlighting the brusque contrapposto of the figures against a cushion of clouds.

A similar animation, pushed almost to the point of fracture, was resorted to for the *Healing of the Paralyzed Man at the Pool of Bethesda* (fig. 39), painted in 1559 for the shutters of the silver cupboard in the sacristy of the church of San Rocco. Perhaps too much has been made of Ridolfi's notion put forward in 1648 that here Tintoretto adjusted his pictorial conception to go with the *Saint Martin and Saint Christopher* by Pordenone on

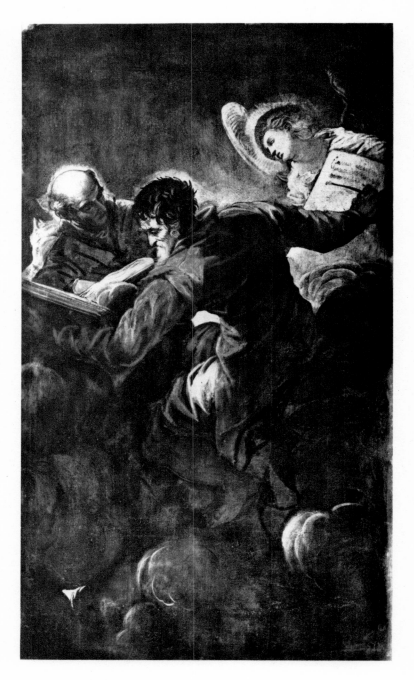

38. THE EVANGELISTS LUKE AND MATTHEW. c. 1557.
Oil on canvas, 8′ 6″ × 5′ . *Santa Maria Zobenigo, Venice*

the opposite wall (fig. 40). In Tintoretto's luminous painting, with its iridescent effects, the colors surprisingly retain a gamut of tones even in the shaded areas. Apart from the obvious choice of a symmetrical architectural setting in perspective—a colonnaded loggia with low-pitched roof—there is nothing

39. THE HEALING OF THE PARALYZED MAN AT THE POOL OF BETHESDA. 1559.
Oil on canvas, 7' 10" × 18' 4". San Rocco, Venice

that suggests the painter bowed to a much earlier artist's monumental sculptural approach, as Ridolfi and later writers conjectured. If anything, a certain pictorial richness makes one think that he had not observed in vain the *Martyrdom of Saint Sebastian* frescoed in the previous year by Veronese for the Venetian church of that saint. As for the emotional élan, the gestural dynamic, and the theatrical effects in the painting for the church of San Rocco, these were fully part of their author's innate and by then proven bravura. Never forgetful of inventions that arouse suspense or unstinting devotion, he showed himself master of them in this depiction of the paralytic who takes up his bed and walks while Christ has already turned to another ecstatic group of the faithful.

The lighter and more transparent color that characterizes this painting can be thought of as the guiding motive of a group of canvases from about 1560, which all have natural settings, a fact that may explain why their luminosity is emphasized in highly harmonious pictorial touches. In these large canvases—the *Multiplication of the Loaves and Fishes* in The Metropolitan Museum of Art in New York, the *Worship of the Golden Calf* in The National Gallery in Washington, D.C., and *Moses Striking Water from a Rock* in Frankfurt (fig. 41)—what is truly singular is the function the artist assigned to his naturalistic backgrounds. Trees and foliage in amber green are set against a flaming sky, while a procession in the background of small figures in rose, azure, violet, and silver add a harmonic commentary to the miraculous event in the foreground.

The great achievement of this concern with landscape may be the small *Saint George Rescuing the Princess from the Dragon* (colorplate 21). The dynamic of the composition arouses the greatest interest with its intersection of two counterposed movements: the horseman plunging sharply toward the left and the princess desperately straining every nerve in her flight toward the right. A play of reds and deep blues shot with silver accentuates the swirling of the garments of the fleeing woman, while the knight stands out against a background of fields and water at the lower edge of a terraced slope of green and golden woods from which emerges, like a phantom, a walled castle.

The obligation to complete the decoration of the church of the Madonna dell'Orto called the painter back to his more usual large-scale tasks. This time it was to works incomparable for the dimensions imposed by the extremely high apse into which they were to be fitted. The *Last Judgment* (fig. 42) and the *Worship of the Golden Calf* both measure over 47 feet in height and in addition are wreathed by five *Christian Virtues*, likewise of gigantic dimensions. Thanks to the recent restoration, one can again appreciate the compositional values of these enormous canvases, theatrical backdrops for a monumental Gothic church. With something of the attitudes of a fresco artist, Tintoretto faced up to the huge task, disposing the innumerable figures in several planes, which, especially in the *Last Judgment*, pile up like the voices in the polychoral masses and motets of his Venetian contemporary Andrea Gabrieli.

In this period Tintoretto was probably starting his work on two canvases now in the Cappella del Santissimo Sacramento (Chapel of the Holy Sacrament), built in 1556 in the church of San Trovaso: a *Last Supper* (colorplate 19) and a *Washing of Feet*, familiar themes he now treated with a particular accent of verism and popular earthiness. The *Last Supper* is laid out on a diagonal schema that accentuates the disorder and slovenly nature of a rude country inn—a flask of wine on the floor in the immediate foreground, an overturned chair, a cat stealing food, the Apostles in a state of at least exalted enthusiasm. Yet above this human disarray the Christ rises in solemnity, mystical symbol of the Eucharist in an aureole of blinding light. As in similar works there is an unseen human witness to the miracle, a child

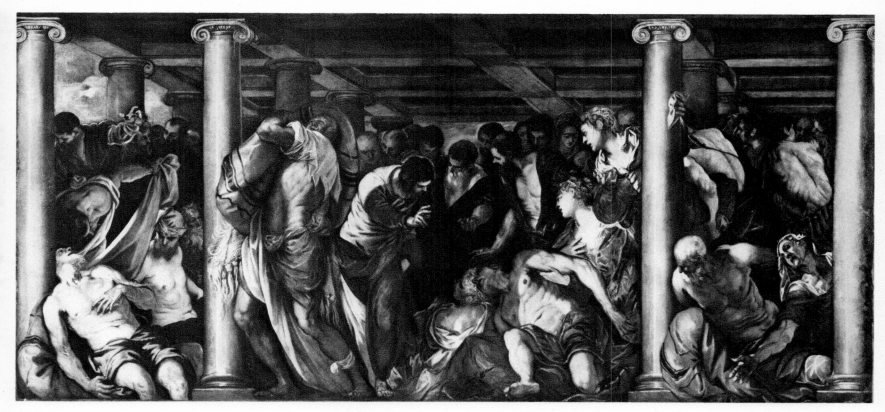

40. Pordenone (Giovanni Antonio de' Sacchis).
SAINT MARTIN AND SAINT CHRISTOPHER. 1528.
Oil on canvas, 6' 2" × 14' 4". *San Rocco, Venice*

41. MOSES STRIKING WATER FROM A ROCK. c. 1560.
Oil on canvas, 46 × 71". *Städelsches Kunstinstitut und Städtische Galerie, Frankfurt*

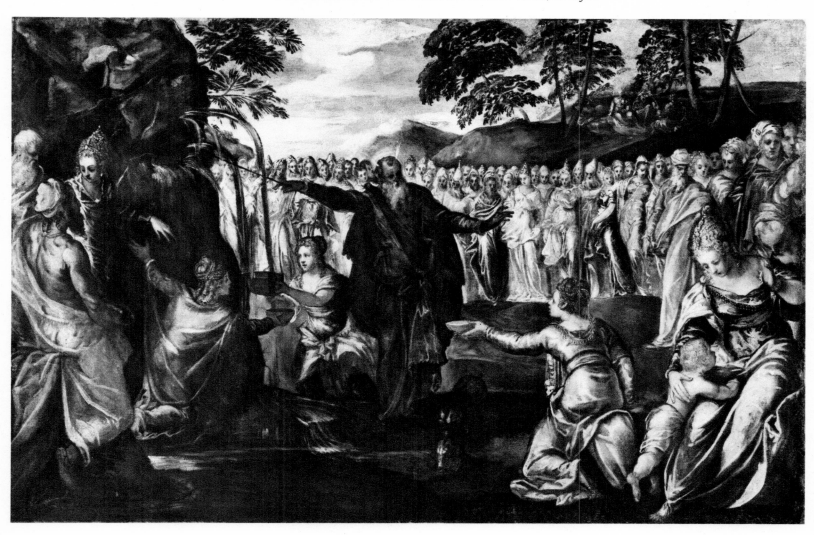

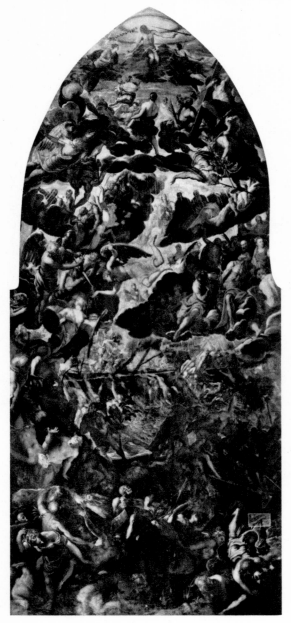

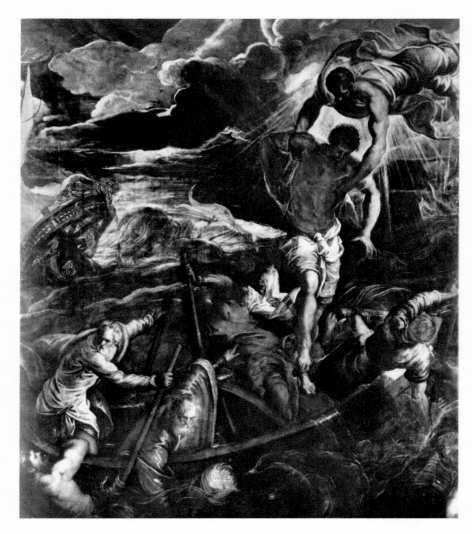

43. THE MIRACULOUS RESCUE OF A
SHIPWRECKED SARACEN BY SAINT MARK. 1562–66.
Oil on canvas, 13′ × 11′ . *Gallerie dell'Accademia, Venice*

42. THE LAST JUDGMENT. c. 1564.
Oil on canvas, 48′ × 19′ 4″. *Madonna dell'Orto, Venice*

perhaps six to eight years old, who is not a participant in the main activity. Could this perhaps be Tintoretto's mysterious eldest son, Giambattista, or his favorite, Domenico? What is important is the "believable miracle," one that the profoundly simple and popular mind of the painter could think of as taking place under the eye of a flesh-and-blood person of his own time.

A similar meaning can probably be attributed to the youth in the left foreground of the *Washing of Feet*, which is now in the National Gallery in London (fig. 44); he holds up a torch that leads our eye to the background, where its flicker is answered by the red flame of the hearth. Again the wretchedly poor furnishings—basin, bench, the rough table of an inn—confirm how natural it was for the painter to resort to nonaristocratic decorative paraphernalia readily understood and appreciated by even the most uncouth seaman of the Cannaregio quarter. This is true too of the large *Last Supper* (fig. 45) done almost a decade later for the church of San Polo. Giving way to an irrepressible capricious inspiration, the painter scattered his personages

in this picture like wind-whipped leaves around a Christ who seems to have been forced into the role of peacemaker.

In 1562 Tintoretto returned to the project he had begun at the Scuola Grande di San Marco and in the next four years added three major works: the *Finding of the Body of Saint Mark* (colorplate 26), the *Removal of the Body of Saint Mark* (colorplate 25), and the *Miraculous Rescue of a Shipwrecked Saracen by Saint Mark* (fig. 43). The mise-en-scène of the *Finding of the Body of Saint Mark* is acted out in an arcade lined with sarcophagi from which one corpse after another is being removed in the hunt for that of the saint. The deus ex machina of the drama is Saint Mark in person, who miraculously appears to the terrorized searchers, concentrating on himself the light from the proscenium, which also illuminates the foreshortened cadaver on the ground and the grand guardian Tommaso Rangone in his red senatorial robes. If it is kept in mind that this canvas was designed to go with the *Miraculous Rescue of a Christian Slave by Saint Mark* (colorplate 6), the images of Tintoretto, though softened by a more mature pictorial sense of color harmony, have clearly lost nothing of their force.

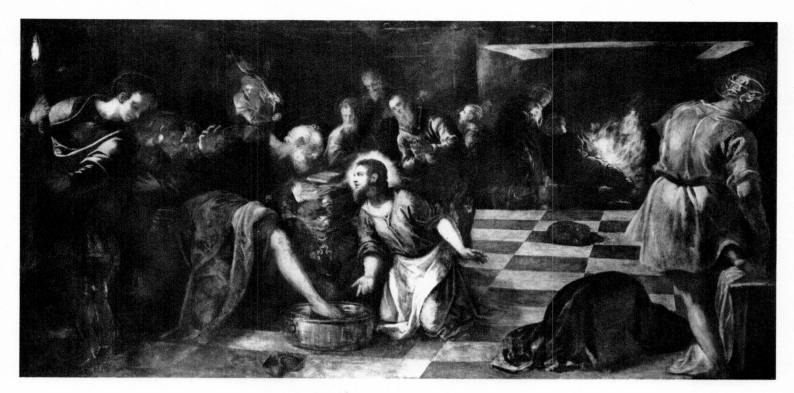

44. THE WASHING OF FEET. c. 1560.
Oil on canvas, 6′ 7″ × 13′ 5″. *National Gallery, London*

45. THE LAST SUPPER. c. 1569.
Oil on canvas, 7′ 6″ × 17′ 6″. *San Polo, Venice*

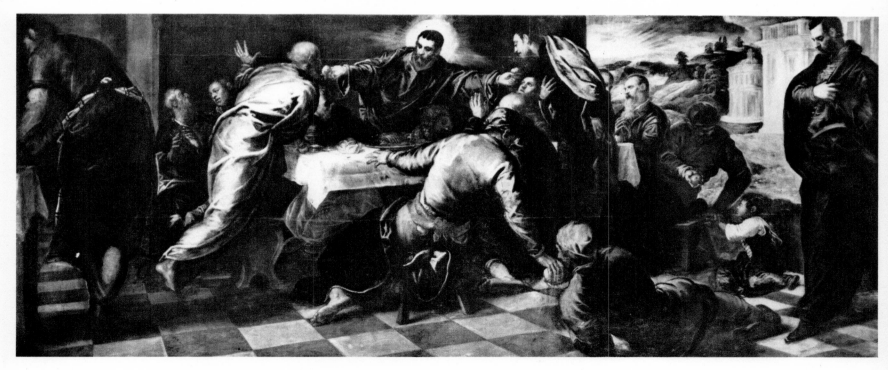

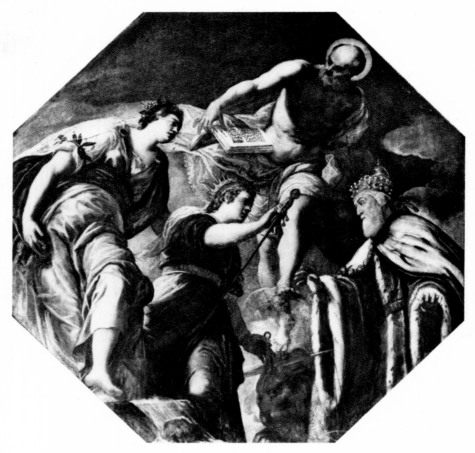

46. DOGE GIROLAMO PRIULI RECEIVING THE SWORD FROM JUSTICE
IN THE PRESENCE OF SAINT JEROME AND VENETIA. c. 1565.
Octagonal ceiling painting, 7' 6" × 7' 6". Atrio Quadrato, Palazzo Ducale, Venice

Equally impressive is the *Removal of the Body of Saint Mark*, which with a sure sense of dramaturgy is set under a furious storm. Rain, pouring onto the square from which the Venetians are hastening with their sacred booty, blots out in a silvery shimmer the Turks fleeing under the portico for shelter. With the added touch of lightning flashes across an ominous sky, it all adds up to melodrama incarnate. Yet it would be unjust not to credit the artist with an overwhelming power of expression and an unrivaled evocative force in the invention of superbly skilled theatrical scenes.

It was an enterprising doge, one truly inspired in the field of art, Girolamo Priuli, who, in about 1565, called on Tintoretto to work in the Doges' Palace. In that year decoration was begun in the rooms located on the third floor, at the top of the great Scala d'Oro (Golden Staircase) completed a few years earlier by the architect Jacopo Sansovino. The first hall to be painted was the so-called Atrio Quadrato (also known as the Salotto Dorato), a square drawing room that did duty as antechamber for the College or the Senate. Predominating over all, in the central octagon of the ceiling (fig. 46), is, naturally, the doge himself portrayed with his patron saint, Jerome, and the symbols of power—the lion of Saint Mark, the doge's cap, and ermine robes—and facing personifications of justice and peace. It is an allegorical system of political significance of a sort perhaps not previously dealt with by this artist. Around the octa-

gon are narrow panels with biblical episodes of Solomon, Esther, and Samson, which allude obviously to wisdom, justice, and force, along with others personifying the seasons as a sign of the harmony of nature attendant on good government under the dogeship. The theme, evidently dictated by one of the many men of learning who constituted the cultural staff of the various doges (Grimani, Barbarigo, and Navagero, among them), was not congenial to the imagination of Tintoretto and, if anything, must have fettered his natural élan. Yet one can admire the scintillating mirrored luminosity of the doge's portrait, which redeems the intrusion—surely decided at the last minute—of Saint Jerome in a strangely incongruous pose with his large book poised in midair on creamy clouds diligently whipped up by the clever painter. Practical skill and poetry, before this almost always magnificently attuned in the imagination of Tintoretto, here for once seem to be uncomfortable bedmates.

In the face of such a lowering of general tone, true also of other works from the middle 1560s, it may be justified to hypothesize that Tintoretto might already have been caught up in the preparatory phase of his new task for the confraternity of San Rocco. He would have also been distracted by the public relations activities inevitable with such a great undertaking and preoccupied above all with grandiose ideas for the new project.

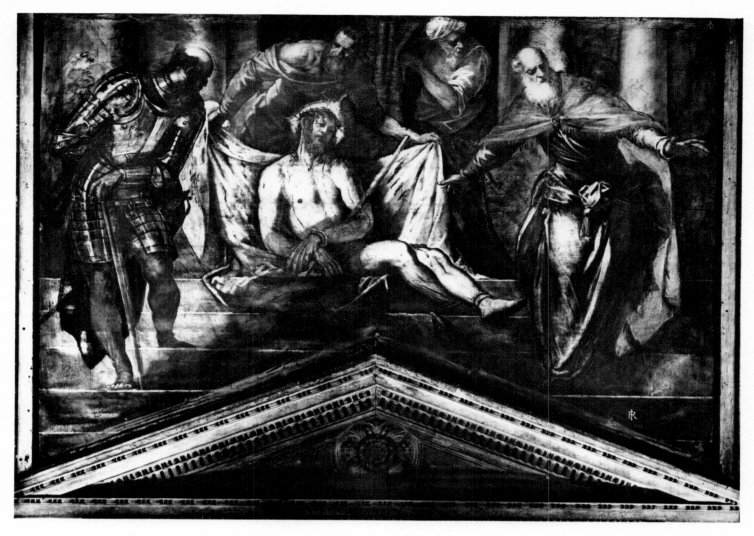

47. ECCE HOMO. 1566–67. Oil on canvas, 8' 6" × 12' 9". *Sala dell'Albergo, Scuola Grande di San Rocco, Venice*

THE SCUOLA GRANDE DI SAN ROCCO

Almost twenty years had passed since the Scuola Grande di San Rocco had been rebuilt. The board of directors decided that it was high time it should be provided with appropriate pictorial decoration, especially in the Sala dell'Albergo, where they held their meetings. Titian himself, it was rumored, had offered to provide a large picture, but perhaps the modest sum appropriated, a mere two hundred ducats, had chilled his ardor. In 1564 a group of council members volunteered to superintend the financing. Immediately—and this seems proof that the artist had already been planning on his own—Tintoretto was taken into consideration, an obvious choice since he had already done such good work for other confraternity headquarters. But there was to be no plain sailing this time. One of the councillors of the Scuola Grande, Giovanni Maria Zignioni, whose name has entered history only because of his ludicrous stipulation, made his personal contribution contingent on not hiring Tintoretto. To settle the matter, a public competition was proclaimed in which Tintoretto had as rivals men like Veronese, Giuseppe Salviati, and Federico Zuccari. What followed is an amusing tale not only told by Vasari but documented in the archives of the confraternity. The contestants were each to sub-

mit a sketch for the central section of the ceiling showing Saint Roch in glory among angels. Tintoretto, however, with the complicity of a custodian, one night installed on the ceiling not a sketch but his finished painting, announcing the next morning to the judges that "this was his way of designing" and that in any case he was making the confraternity a gift of the picture (colorplate 23); three weeks later the directors decided to entrust this master with all the decoration of the hall, walls as well as ceiling. In that one stroke the artist succeeded in antagonizing three of his chief rivals and even the great Titian. What counted was that he had the job: the great adventure of the Scuola Grande di San Rocco was under way.

The ensemble for the Sala dell'Albergo, entirely concerned with the Passion of Christ and comprising the several elements of the ceiling plus six large paintings on the walls, took three years to complete. Not counting the two *Prophets* of 1566–67, the four narrative scenes—the *Christ Before Pilate* (colorplate 28), the *Ecce Homo* (fig. 47), the *Ascent to Calvary* (fig. 48), and the *Crucifixion* (colorplate 24)—are all dominated by the figure of a Christ who is no pitiable victim but a triumphant hero. His dominant spirit commands all four scenes: incredibly tall in the

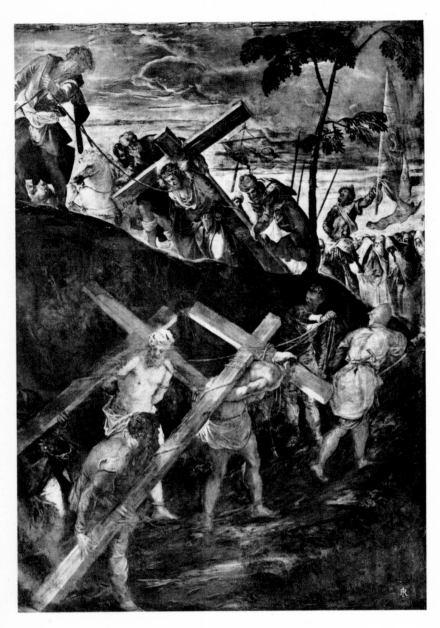

white drapery that is a sharp contrast to the shadow that shrouds Pilate; invincible, seated like an enthroned king crowned with thorns and attended by soldiers and judges; unconquered beneath the burden of the cross and, already bathed in supernatural light, leading forward his fellow victims; immense on the cross, with arms outstretched in a universal embrace, symbol rather of victory than of death.

What began as creative enthusiasm soon turned to a veritable fury. Figures multiply, heap up breathlessly; lights shoot out saberlike, cutting blinding swathes; the colors, held to high registers in which reds, whites, greens, and deep blues dominate, resound and yet are skillfully disposed within a completely secure pictorial architecture. A triumph, above all where the *Crucifixion*—of dimensions and number of figures rarely seen before—imposes its titanic presence by means of the simple formula of sentiment expressed in ways accessible to the popular mind.

Unfortunately no written documents exist that might indicate something of the success—surely exceptional—this great work must have had. It was easy for the anonymous mass of the poor—and there were many indeed in that prosperous Venice with its population of more than 150,000—to recognize themselves in those crowds accompanying Jesus. Yet it was easy too to see in Tintoretto's Christ a symbol of hope and peace.

Without substantial variations in style are the three paintings mentioned in a document of 1567 as done for the presbytery of the church of San Rocco rather than for its confraternity. Yet, at least partly because uncertain identifications within early sources confuse these canvases with the 1549 *Saint Roch Ministering to the Plague Victims*, only one, *Saint Roch in Prison*

48. THE ASCENT TO CALVARY. 1566–67.
Oil on canvas, 16′ 11″ × 12′ 10″.
Sala dell'Albergo, Scuola Grande di San Rocco, Venice

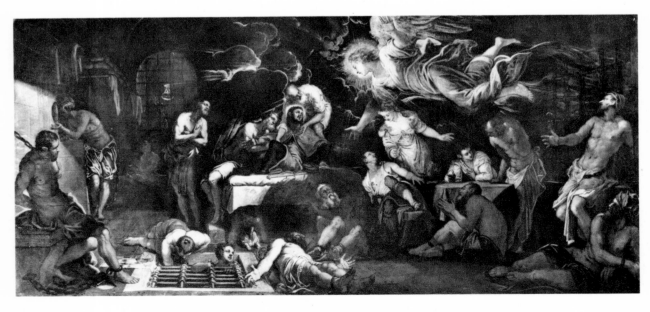

49. SAINT ROCH IN PRISON COMFORTED BY AN ANGEL. 1567.
Oil on canvas, 9′ 10″ × 22′ . *San Rocco, Venice*

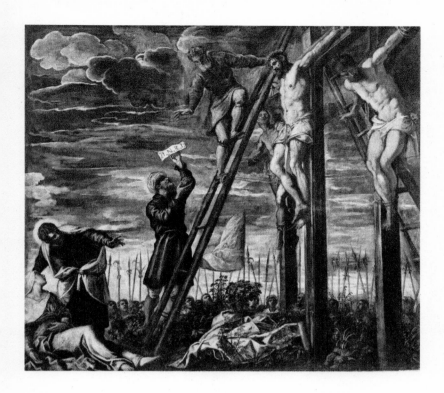

50. THE CRUCIFIXION. c. 1568.
Oil on canvas, 11' 2" × 12' 2". *San Cassiano, Venice*

51. CHRIST IN LIMBO. c. 1568.
Oil on canvas, 11' 3" × 12' 3". *San Cassiano, Venice*

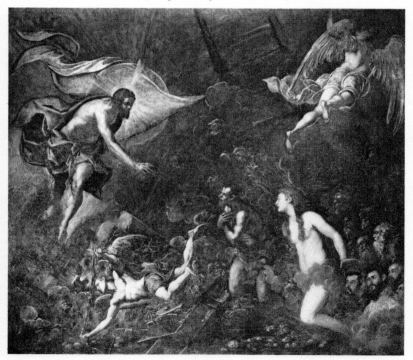

Comforted by an Angel (fig. 49), is assigned with certainty to the artist—justly so, for it is the true masterwork in the group. Of the other two, the *Saint Roch Healing the Animals* was probably left partly to assistants, and the *Capture of Saint Roch at the Battle of Montpellier* was finished later. In *Saint Roch in Prison* the blond angel who descends among the prisoners, dazzling them with his golden light, is an invention of such innovative force that some historians consider the figure a later addition. Although that hypothesis is untenable, the apparition does reveal an unquestionably pre-Baroque character in its dazzling inventive élan and calls to mind a Guercino or a Luca Giordano, the latter of whom could have remembered it since he had the privilege of viewing the picture when in Venice. What some critics find to be a forced exaggeration in the contrasting poses and lighting—achieved, according to them, at the expense of the color—is the result of deterioration of certain laca pigments (oxblood red) or of excessive darkening of whites rather than of any deliberate striving on the part of the artist to work within a limited color range. Certainly light remains the most active aspect of his language and permits him to achieve theatrical or outright visionary effects.

Two canvases in which the dramatic use of light is largely essential to the figurative representation—the *Crucifixion* (fig. 50) and *Christ in Limbo* (fig. 51)—were painted in 1568 on commission from the Scuola del Santissimo Sacramento for the narrow presbytery of the church of San Cassiano. In part because it would be difficult for them to be seen in such a cramped space, the painter had to rely on an exceptional theatrical staging, which, especially in the *Christ in Limbo*, is based on an authentic "luminism." Out of the obscurity of Limbo, swarming with the faces of lost souls, emerge only the figures of the protagonists, Christ and Adam and Eve. The supernatural glow of miracle caresses the shoulders and arms of the Christ stretching forward with strained effort (a reminiscence of Michelangelo?) to call back Adam and Eve into the light. Eve, radiant in her limpid nudity, stands out prominently, while three chancellors of the Scuola Grande (one of whom, Cristoforo de Gozi, commissioned this work) look on; the chancellors' expressions of ecstasy, however, do not excuse their ungainliness. Light in the *Crucifixion* is for once treated as a natural element, with the low rays of sunset catching the figures of those being crucified. But behind stretches the immense sky against which are profiled the tense or desperate gestures of the executioners and of John and Mary. Farther to the rear, with an invention extraordinarily modern in its implication, Tintoretto hedged the scene with an ominous row of lances brandished by the soldiers, who impress on the scene their own sense of cruelty.

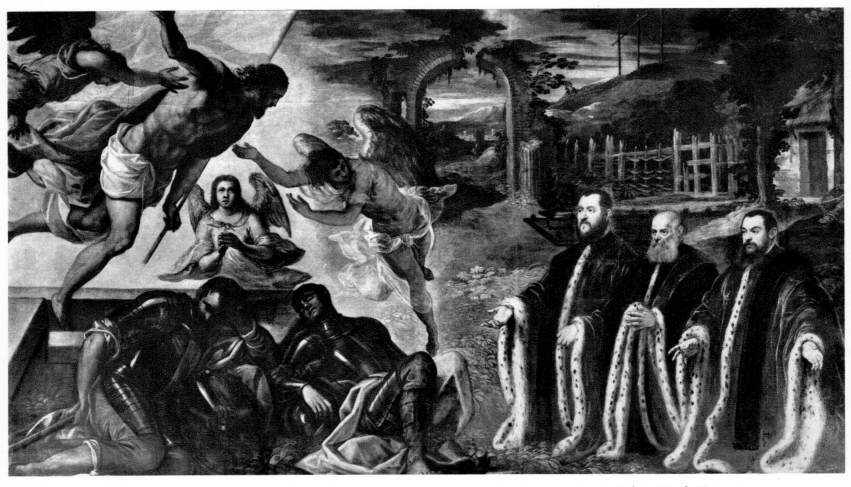

52. THE RISEN CHRIST WITH THREE AVOGADORI. c. 1571. Oil on canvas, 8' 8" × 15'. *Palazzo Ducale, Venice*

53. DOGE ALVISE MOCENIGO AND FAMILY BEFORE THE MADONNA AND CHILD. c. 1573.
Oil on canvas, 7' 1" × 13' 8". *The National Gallery of Art, Washington, D.C. Samuel H. Kress Collection*

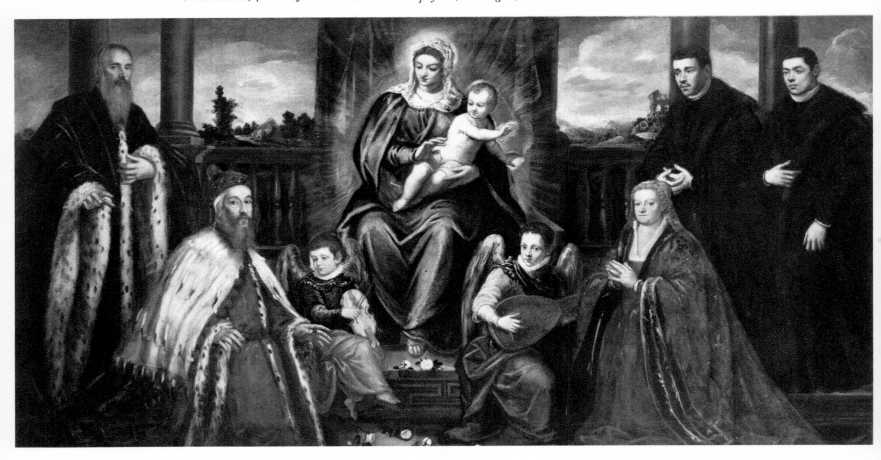

THE PORTRAITS

That every painting by Tintoretto must by definition be a masterwork would be a very tenuous claim indeed. Too many among the hundred or so portraits from the central decades of his maturity, for example, plainly reveal his boredom with this way of making a living. Yet some have justly earned a place as authentic masterpieces chiefly because of their introspective analysis and faithful rendering. Good examples would be the *Portrait of a Man in Gilded Armor* (colorplate 20), the Prado *Gentleman with Gold Chain*, the *Vincenzo Zeno* and *Alvise Cornaro* in the Palazzo Pitti, and the majestic *Jacopo Sansovino* in the Uffizi. Where Tintoretto did get into difficulty was with the group portraits in official paintings, particularly when the clients' demands proved distracting enough to snuff out his creative enthusiasm and render merely risible the sacred personages forced to endure the company of these conventional and pose-wearied sitters. With due respect for his powers of execution—often masterful on the pictorial level of handsome costumes, impressive poses, and trustworthy likenesses—one can be sure that the painter's mind was elsewhere, almost as if he were storing up reserves of fantasy which would explode again, ineluctably, the instant the artist's enthusiasm was no longer diverted from its true ends.

Does this explain why the style of Tintoretto is damned sometimes as inconstant and erratic? Yet his weaker moments were perhaps not a matter of style but of subjects imposed and accepted. The mediocre results come from the flat necessity to get things done and paid for, when in fact he did not hand over such tasks to his workshop. Examples of this are the many official works churned out in the 1560s and 1570s that testify to a popularity from which he did not know how to escape or simply did not wish to. The 1566 *Madonna of the Treasurers* in the Accademia is boring in invention and slack in pictorial execution. Nor is there much profit and pleasure to be gained from the *Saint Mark and Three Procurators* of 1571 in Berlin or the *Risen Christ with Three Avogadori* (fig. 52) done about the same year for the Doges' Palace, a work composed with a certain coolness. There is an irremediable contrast between Christ looming up unexpectedly and the three worthy gentlemen in an apparent state of profound dejection and not at all dressed for such an occasion. Behind it all is the most conventional of landscapes.

In all fairness, the *Doge Alvise Mocenigo and Family Before the Madonna and Child* (fig. 53) done about 1573 is an honorable exception to this discouraging series. Its frontality recalls certain pictures that by those years were virtually classical, for instance the so-called *Pala Barbarigo* by Giovanni Bellini in the church of San Pietro Martire in Murano. Such a lineage would not have been without purpose, lending added significance to the portraits of the five noble personages along with their two grandchildren dressed as angel musicians in the time-honored fashion of the previous century. The calm and diffuse luminosity helps to render the scene credible. Nor is the viewer disturbed by the mystical presence of the Madonna and Child; solemn as an icon, they make a binding tie compositionally as well as spiritually in this portrait of a family at peace with God and each other.

After a serious fire in the Doges' Palace, the Signoria decided in 1576 to resume decorating the ceremonial halls. While Veronese was at work on the ceiling of the Sala del Collegio, the chief public hall, Tintoretto was putting the finishing touches to the walls of the Atrio Quadrato with canvases devoted to allegories of the four seasons, transferred to the Sala dell'Anticollegio about 1716. These four paintings—*Mercury and the Three Graces* (fig. 54), *Minerva Driving Back Mars* (fig. 55), *Bacchus and Ariadne with Venus* (colorplate 32), and *Vulcan and the Cyclopes* (colorplate 33)—which were completed in 1577–78, probably represented respectively spring, summer, autumn, and winter. Yet their meaning does not end there since they doubtless symbolize the four elements of air, water, earth, and fire as well, making for a complex cosmogonic allegory of fortune and the good government promoted by the same Doge Priuli already portrayed on the ceiling (see De Tolnay, 1960).

These four new paintings were very different in style from those done on the ceiling about thirteen years earlier, and it could well be that, faced with the silvery cascades of color Veronese was pouring forth in the Collegio, Tintoretto felt impelled to seek a stylistic answer richer in congenial blends and more refined in design. Consciously or unconsciously he came very close to the limits of an unprecedented sensuality—a passing distraction from his true way and due almost certainly to the nature of the subjects as well as to specific prescriptions from the unknown litterateur who devised the iconographic program. Considered more seriously, the notion that Tintoretto could reconcile himself to the approach with which Veronese was garnering such admiration in the Collegio seems too farfetched. By that time his conception of form was so mature that not even in these new paintings, unusual as their manner was for him, did he depart in any substantial way from his ingrained feeling for compositions dynamically articulated in light. Nor did he contradict the emphatically three-dimensional conception that he had always maintained as the basis of his figuration.

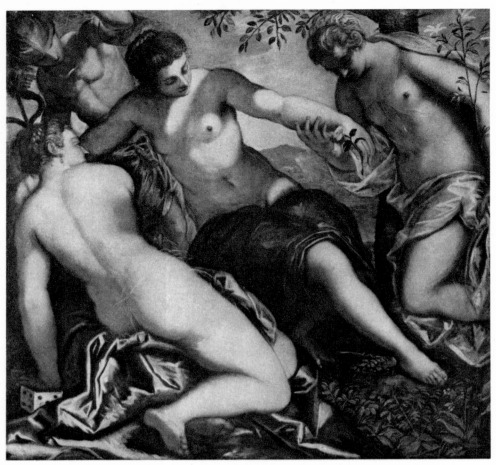

54. MERCURY AND THE THREE GRACES. 1577–78.
Oil on canvas, 57½ × 61″. *Anticollegio, Palazzo Ducale, Venice*

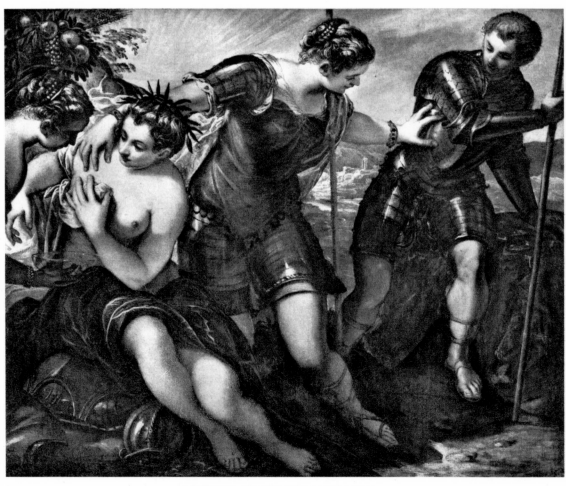

55. MINERVA DRIVING BACK MARS. 1577–78.
Oil on canvas, 58¼ × 66″. *Anticollegio, Palazzo Ducale, Venice*

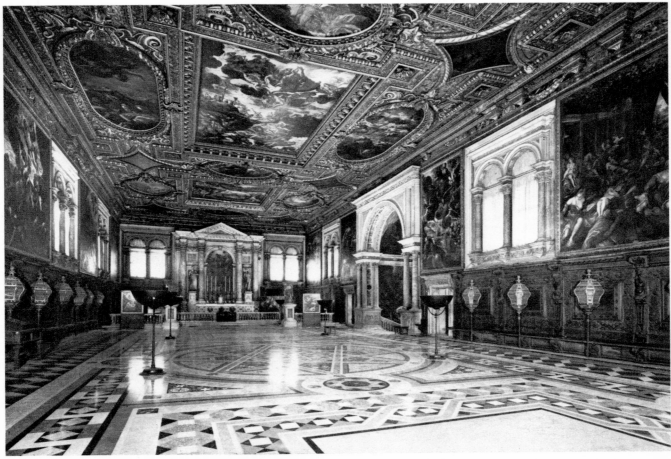

56. Sala Grande, Scuola Grande di San Rocco, Venice

THE GREAT RELIGIOUS SERIES FOR SAN ROCCO

In 1575 Tintoretto urged the Scuola Grande di San Rocco to authorize him to go ahead with the ceiling paintings for the Sala Grande, the hall on the upper story (figs. 56, 57). No more than a year later he finished the enormous canvas of the *Raising of the Brazen Serpent* (colorplate 30). In its lower half there is a great piling up of powerfully foreshortened figures of the Israelites tormented by the serpents. In the sky a swarm of angels are in flight in the wake of the figure of the Eternal. In the midground, in a lighter zone at the left, Moses gestures toward the brazen serpent on a cross, symbol of the Redeemer. In all this there is again an allusion to the function of the confraternity in ministering to victims of the plague.

The other two huge ceiling paintings were finished in 1577. Both *Moses Striking Water from a Rock* (colorplate 31) and the *Gathering of Manna* seem even more felicitous than the *Brazen Serpent*, as if the painter had finally succeeded in recovering the mystical impetus and sense of popular religiosity that had inspired the masterpieces executed for the Sala dell'Albergo in the Scuola Grande. Cascades of light bring their emphasis to the miraculous events; skies, rent by mystical light, open to reveal celestial apparitions; and crowds, articulated with plastic force and daring line, throng together in inspired gestures.

According to more recent studies on the iconography of the paintings for the Scuola Grande, there was no set program but rather a basic idea that the artist followed: the glorification of the welfare functions of the confraternity as seen through parallel passages in the Old and New Testaments (see De Tolnay, 1960). In September 1577 Tintoretto came to an agreement with the officials concerning the paintings still to be done for the ceiling, walls, and altar area, committing himself to deliver three each year on the feast day of the patron saint and thereafter to carry out all other decoration required (that is, on the ground floor now) for the token payment of a hundred ducats a year for the remainder of his life.

If today we are less able than were the members of the confraternity to admire and understand the complex meanings of the paintings inserted into the richly elaborate frames of the ceiling, our esteem is immediate for the ten canvases on the walls recounting the life of Jesus, which are linked to the scenes of the Passion already in place in the smaller meeting hall. Per-

45

57. Arrangement of paintings in the Sala Grande,
Scuola Grande di San Rocco, Venice

Altarpiece
(1) The Apparition of Saint Roch

Ceiling
(2) Melchisedek Brings Bread and Wine to Abraham
(3) The Passover of the Jews
(4) The Vision of Jeremiah
(5) Elisha Multiplying the Loaves
(6) The Gathering of Manna
(7) Elijah Fed by the Angel (colorplate 34)
(8) The Sacrifice of Isaac
(9) Daniel in the Lions' Den
(10) The Assumption of Elijah
(11) The Vision of Ezekiel
(12) The Raising of the Brazen Serpent (colorplate 30)
(13) Jacob's Ladder
(14) Samson Draws Water from the Jawbone of an Ass
(15) Jonah Emerges from the Whale's Belly
(16) Samuel and Saul
(17) God Appears to Moses
(18) Moses Striking Water from a Rock (colorplate 31)
(19) The Pillar of Fire
(20) The Three Youths in the Fiery Furnace
(21) The Original Sin
(22) Moses Saved from the Waters

Walls
(23) The Multiplication of the Loaves and Fishes (fig. 60)
(24) The Resurrection of Lazarus
(25) The Ascension (colorplate 42)
(26) The Pool of Bethesda
(27) The Temptation of Christ (fig. 61)
(28) Saint Roch
(29) Saint Sebastian
(30) The Adoration of the Shepherds (colorplate 39)
(31) The Baptism of Christ (colorplate 40)
(32) The Resurrection (fig. 58)
(33) The Agony in the Garden (fig. 59)
(34) The Last Supper (colorplate 41)

haps disposed in an order dictated by the available lighting sources, these comprise an *Adoration of the Shepherds, Baptism of Christ, Resurrection* (fig. 58), *Agony in the Garden* (fig. 59), *Last Supper, Multiplication of the Loaves and Fishes* (fig. 60), *Resurrection of Lazarus, Ascension, Pool of Bethesda,* and *Temptation of Christ* (fig. 61); between the windows are the two titular saints of the Scuola Grande, Sebastian and Roch. (See fig. 57 for the arrangement of the paintings in the Sala Grande.)

The painter kept his pledge. Although the altarpiece had to wait until 1588, Tintoretto completed all ten canvases between the years 1577 and 1580. Unarguably these are among the artist's most extraordinary works—Baudelaire felicitously described the paintings as "*miracles et spectacles*" (see Hüttinger, 1962). Whatever limitations these subjects may have had for him, unlike those for the ceiling they permitted the artist to give free rein to his own feelings. Two motifs dominate. One is the recurring figure of Christ as a protagonist of great physical dignity with the command of an actor's art. The other is the participation—often called for by the subjects themselves—of a kind of chorus that makes a counterpoint to the Christ and renders the miracles depicted much more credible. It has been justly pointed out that this figural approach closely corresponded to the mystical oratory of popular preachers such as the famous Capuchin preacher Mattia Bellintani, whose *Prattica dell'orazione mentale* (The Practice of Silent Prayer) published in Brescia in 1573 had much in common with the *Spiritual Exercises* of Ignatius of Loyola (see Anna Pallucchini, *Arte Veneta*, 1969). Besides the spur of the Counter Reformation, the painting of Tintoretto here once again had as its basis a sensitivity to the common folk. Rich in naive and disarming religious accents, these paintings amply justify the incarnation of a splendidly handsome and victorious Christ as well as the insistent presence of the adoring crowd that surrounds him.

The ten canvases also unleashed all the compositional fantasy of the painter. The *Adoration of the Shepherds* (colorplate 39), for one, presents the scene in a most original manner, with the shepherds on the ground floor and the holy family in the hayloft of a rustic cabin with its roof opened to a glowing red sky. Like silvery rain, a lunar light pours down and caresses the figures. Images of this sort, steeped in sulfurous light within a palette of chrome yellow, deep blue, and burnt ocher, occupy large areas of at least three other canvases in the series: the *Baptism of Christ,* the *Last Supper,* and the *Ascension* (colorplates 40, 41, 42). They seem to characterize a specific stylistic mode of their author, realizing a tendency to the fantastic that had cropped up elsewhere without being brought to full embodiment. Here, though, the ecstatic feeling that imbues his personages seems to be linked with precisely the aesthetic means needed to weld it all into a style, permitting the artist to con-

jure up virtually enchanted visions in the superhuman world of miracle. This may explain how he was able in the *Baptism* to treat the crowd along the banks of the Jordan in terms of mystical vision. It also explains the significance of the almost intimidated comment taken on by the shadows of the ordinary folk within the background in the *Last Supper* at the precise moment the betrayal by Judas is announced. Of the same stamp, too, are the figures of the Apostles who witness the triumphant *Ascension* and above all of Moses and Elijah, distant and almost evanescent, immersed now in eternity, who seem to be there to assure the simple of heart that the ancient prophecies are being confirmed in the present as they will be reaffirmed in the future.

It was to such superhuman expression, conveyed in supranatural forms and realized with a visionary figural language, that Tintoretto entrusted the message of his grandiose sermon. Nor is that eloquent force lacking or even attenuated in other paintings in this group. Two represent Jesus in solitary dialogues: the *Temptation of Christ* (fig. 61), confronted in the wilderness by a beautiful Lucifer horrendous in the color of his flame, which reeks of infernal smoke and pitch, and the *Agony in the Garden* (fig. 59), in prayer in the garden of Gethsemane with the angel while three Apostles sleep below. It is as if Christ's words burst forth on an arc of supercharged light: "Get thee behind me, Satan!" in one, and in the other, "O my Father, if this cup may not pass away from me, except I drink it, Thy will be done."

That wave of popular consensus is to be sensed again, more stringently, in the paintings depicting the public miracles of Christ, those witnessed by the masses: in the *Resurrection of Lazarus*, the *Pool of Bethesda*, and above all the *Multiplication of the Loaves and Fishes* (fig. 60), the miracle most dear to the poor and on which the painter imprinted an expressive charge that passes between one gesture and another in a mass of figures rising from the foreground to the hilltop where Jesus stands, powerful and consoling. We should like to think that it was with the triumphal image of a victorious Christ that Tintoretto completed this series around 1581 in the *Resurrection* (fig. 58), which looks out on the entire magnificent hall and is directly facing anyone coming up the stairs. Christ is depicted in flight as if propelled by an explosion of light that by its force crushes to the ground whatever is not divine. It is a simple gesture but extraordinary in its effect; it is also found in works of lesser importance such as the *Vision of Saint Nicholas* from about 1582, rediscovered only in modern times in a parish church at Novo Mesto in Yugoslavia.

To this final period of work in the upper hall of the Scuola Grande di San Rocco are connected three not very well-known canvases removed early in the last century from the church of

58. THE RESURRECTION. 1579–81.
Oil on canvas, 17' 4" × 15' 11".
Sala Grande, Scuola Grande di San Rocco, Venice

59. THE AGONY IN THE GARDEN. 1579–81.
Oil on canvas, 17' 8" × 14' 11".
Sala Grande, Scuola Grande di San Rocco, Venice

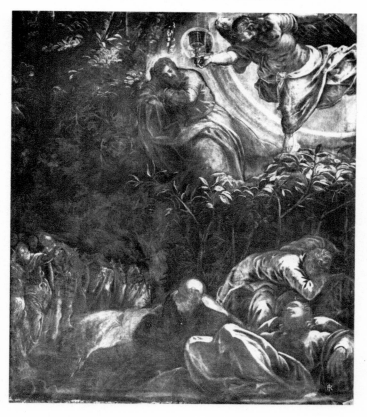

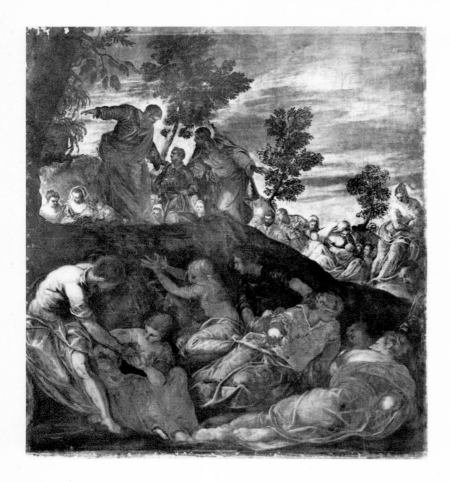

60.　THE MULTIPLICATION OF THE LOAVES AND FISHES. 1579–81.
Oil on canvas, 17′ 2″ × 15′ 7″. *Sala Grande, Scuola Grande di San Rocco, Venice*

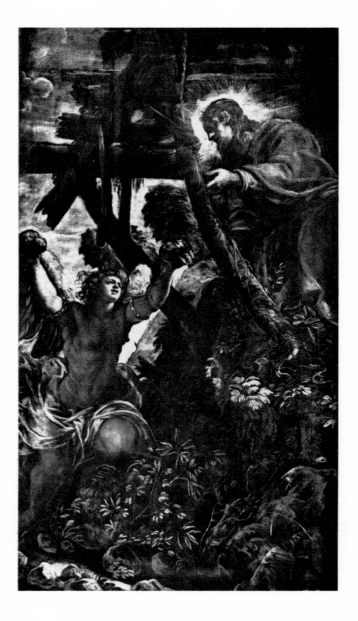

61.　THE TEMPTATION OF CHRIST. 1579–81.
Oil on canvas, 17′ 8″ × 10′ 10″.
Sala Grande, Scuola Grande di San Rocco, Venice

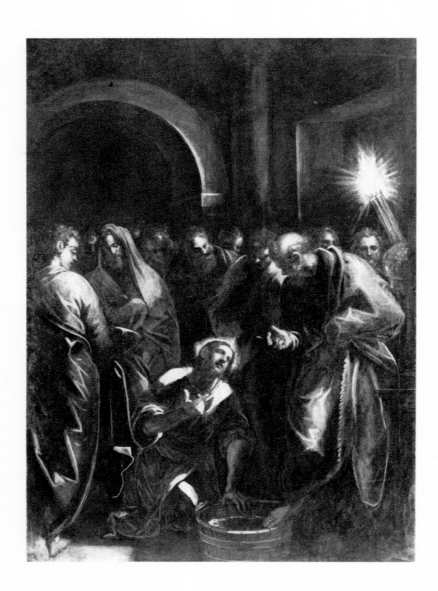

Santa Margherita in Venice to the sacristy of Santo Stefano: the *Washing of Feet* (fig. 62), *Last Supper*, and *Agony in the Garden*. These carry to a paroxysmal tension the mystic insistence of at least two analogous paintings in the Scuola Grande, so that even if one must accept that the artist's son Domenico had a part in their execution, as is generally held, one cannot fail to recognize in these works as a whole the sovereign sense of composition and the expressive power of the master himself.

62.　THE WASHING OF FEET. c. 1580.
Oil on canvas, 9′ 3″ × 5′ 4″. *Santo Stefano, Venice*

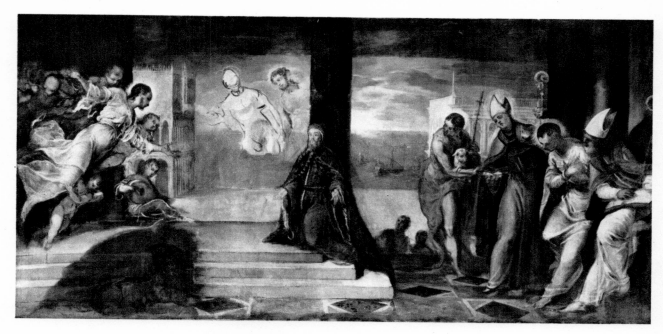

63. DOGE ALVISE MOCENIGO PRESENTED TO THE REDEEMER. c. 1577.
Oil on canvas, 38¼ × 78″. *Metropolitan Museum of Art, New York. Kennedy Fund, 1910*

THE ASSISTANCE OF THE WORKSHOP

In works of the 1580s and later the problem inevitably arises of the part played by assistants in carrying through the enormous number of tasks Tintoretto persisted in taking on though manifestly unable to deal with all of them personally and entirely as he had before. Even if we are only poorly informed about his workshop, by those years composed at least of his children Marietta and Domenico along with lesser assistants whose names are now forgotten, we are inclined to believe that his assistants were largely confined to working on less important areas of the canvases, not only because of the family tie and the submission that could be expected but also because of the imperiousness of the recognized master that Tintoretto had by

now become. What responsibility they may have been allowed must therefore have been partial and at best modest, and indeed it does not seem that one can as yet detect in these works any difference in figural style. Compositional invention and spiritual intention were affected least of all.

Tintoretto and his assistants devoted a good portion of the years between 1577, the date of the second fire in the Doges' Palace, and 1582, when he resumed work at San Rocco, to redecorating the damaged halls in the seat of the Signoria. Their first productions were for the Sala del Senato: the *Triumph of Venice as Queen of the Seas*, *Doge Pietro Loredan in Prayer Before the Madonna*, and the *Dead Christ Adored by the Doges Pietro*

64. DOGE ALVISE MOCENIGO PRESENTED BY SAINT MARK TO THE REDEEMER. 1581–83.
Oil on canvas, 12′ 9″ × 21′ 8″. *Sala del Collegio, Palazzo Ducale, Venice*

65. Tintoretto, Paolo Veronese, Palma Giovane, and others;
designed by Cristoforo Sorte. Ceiling, western half. 1578–85.
Sala del Maggior Consiglio, Palazzo Ducale, Venice

67. THE VENETIANS DEFEATED ON THE ADIGE AT LEGNAGO IN 1439.
c. 1578. Oil on canvas, 9' × 12' 8". *Alte Pinakothek, Munich*

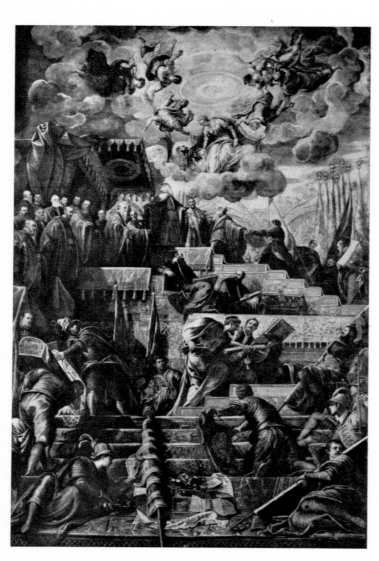

66. Tintoretto and assistants.
THE TRIUMPH OF DOGE NICCOLÒ DA PONTE
OVER THE CONQUERED PROVINCES. 1581–84.
Oil on canvas, 38' 5" × 22' 8".
Ceiling, Sala del Maggior Consiglio, Palazzo Ducale, Venice

Lando and Marcantonio Trevisan, works in which a certain rhetorical heaviness results more or less from the nature and limitations of the commission itself. It is not surprising that the series in the Sala del Collegio of the palace, in which one doge after another is gifted with a celestial vision, often reveals an extensive assistance by the workshop. This intervention is most evident in the impoverishment of the lighting effects, which begin to manifest a veritable lessening of tension. The results are no more than watered-down renderings of what had often begun as quite felicitous ideas. Look, for a demonstration of this, at the sketch of *Doge Alvise Mocenigo Presented to the Redeemer* and at the final version (figs. 63, 64).

A certain change in character and quality that marks the resumption of the work for San Rocco is summed up in two paintings for the church itself: the organ shutters, which are quite conventional, and the *Capture of Saint Roch at the Battle of Montpellier,* which, on the contrary, is splendid. In the second work the explosions of battle shatter the jagged lights and torn clouds while the cavalcade sweeps along irresistibly with an impetuosity that already anticipates the ultimate endeavor in the Sala del Maggior Consiglio of the Doges' Palace (fig. 65): the battle scenes done for the ceiling in 1581–84, an assignment that led to a significant misadventure for the painter, who had to face the charge that he did not himself paint the large ceiling picture of the *Triumph of Doge Niccolò da Ponte over the Conquered Provinces* (fig. 66). As reported by Ridolfi, the painting received a hostile reception from the senators while the defense of the old master was taken up by a few young artists, Leonardo Corona, Aliense, and others, perhaps themselves among

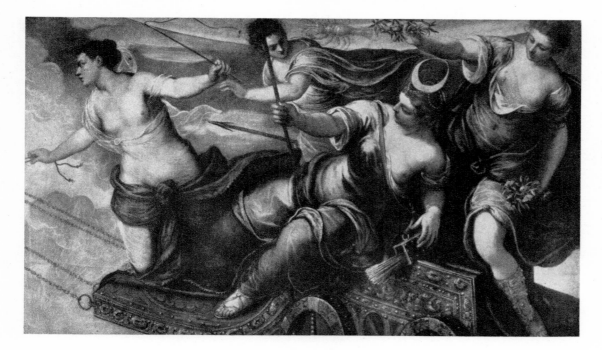

68. LUNA AND THE HOURS. c. 1580.
Oil on canvas, 4' 10" × 8' 4".
*Formerly Kaiser-Friedrich-Museum, Berlin
(destroyed in 1945)*

the several assistants who would have had to collaborate if Tintoretto was to complete in such a brief time a canvas in which grandiose dimensions and political import counted much more than an expression of poetic inspiration. What with haste, a lack of enthusiasm to begin with, and a certain intervention by the workshop, something similar might be said of the "*Fasti gonzagheschi*" (colorplate 36, fig. 67), eight canvases celebrating the great personages and deeds of the Gonzaga family which in 1580 were brought to the family court in Mantua by the painter in person.

A brief, and somewhat extravagant, commission made a presumably pleasant interruption to the burden of ponderous state assignments beneath which the artist in the years around 1580 seems to have been literally crushed. Datable to the first years of the 1580s are the four "Tales of Hercules" commissioned by Rudolf II, the bizarre Holy Roman Emperor in Prague. As is true of the various pictures he had previously ordered from Veronese, which are among the most fascinating of that artist's late works, Rudolf wanted profane themes with more than a hint of the erotic about them. Tintoretto obliged him with the *Origin of the Milky Way* (London, National Gallery), *Hercules Chasing the Faun from the Bed of Omphale* (Budapest, Szépmüvészeti Múzeum), a *Hercules Fondled by Omphale* difficult to identify, and a *Concert of the Muses* now lost. The one most readily appreciable, particularly because of its excellent state due to a recent restoration, is the *Origin of the Milky Way* (colorplate 38), composed of agile figures wheeling in flight around an impressive Juno from whose breast stream stars that will take their places in the heavens. With some effort, perhaps, the sensuously mannerist Tintoretto of the 1550s can be discerned here (and see fig. 68), but the color is denser and with tonalities

that are almost burnt; the manipulation of the shadows is more knowing, swept into complicated interplays by the incessant movement of the figures in flight.

The ground floor room (Sala Terrena) of the Scuola Grande di San Rocco was decorated with eight canvases between 1583 and 1587 on the terms already agreed on in 1577. Tintoretto had meanwhile grown old and now had to depend much more on help from his workshop. In their settings and artless presentation, six of the pictures, which treat the lives of the Virgin and the infant Jesus, strike one as inspired by the deliberately hum-

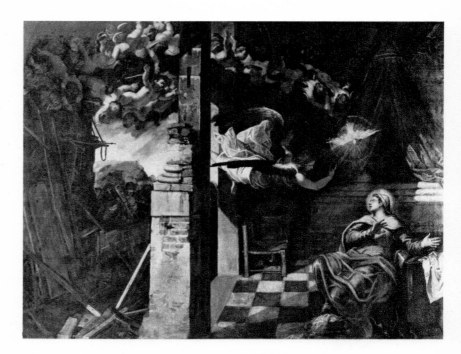

69. THE ANNUNCIATION. 1583–87.
Oil on canvas, 13' 10" × 17' 11".
Sala Terrena, Scuola Grande di San Rocco, Venice

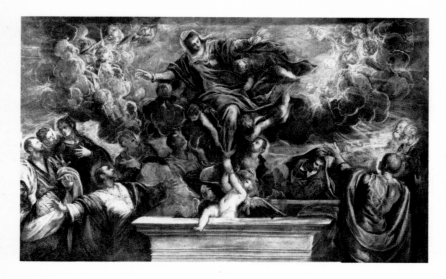

70. THE ASSUMPTION OF THE VIRGIN. 1583–87.
Oil on canvas, 13′ 11″ × 19′ 3″.
Sala Terrena, Scuola Grande di San Rocco, Venice

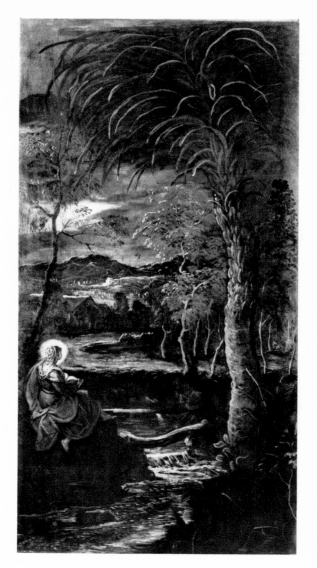

71. SAINT MARY THE EGYPTIAN. 1583–87.
Oil on canvas, 13′ 11″ × 6′ 11″.
Sala Terrena, Scuola Grande di San Rocco, Venice

ble manner of a *Biblia pauperum*, one of the small late-medieval religious picture books for instructing the poor (see De Tolnay, 1960). Nothing, though, had changed in the spiritual attitude of the painter, and the links with his popular vision are still much in evidence. The *Annunciation* (fig. 69) is especially remarkable as one of the most ingenious and iconographically subtle representations ever made of that theme. A galaxy of cherubs swarms perilously into Mary's room to her perfectly comprehensible consternation. Joseph, intent on sawing lumber, notices nothing of the angelic intrusion into the bedchamber with its symbolic sumptuous furnishings: gilded coffered ceiling, richly hung inlaid wooden bed with silken sheets, tasseled velvet footstool. A rickety wooden chair with coarsely woven straw seat marks the other symbolic aspect, that of humility.

The *Flight into Egypt* (colorplate 44) is perhaps the finest picture of this series. Again the chief figures are drawn to the foreground by strong though soft and diffuse illumination. As convincing counterpoint, in the background to the right there is a thoroughly realistic landscape with peasants going about their tasks in the sunset light.

More finicky in composition are the *Adoration of the Magi* (colorplate 43)—yet with passages of splendid quality such as the cortege of the three kings painted with sulfurous touches incandescent against the light—and the *Circumcision*, which is much indebted to the workshop. The *Massacre of the Innocents* (colorplate 45), with its patent echoes of motifs drawn from Michelangelo, and the damaged *Assumption of the Virgin* (fig. 70) are quite anomalous. The final two canvases, at either side of the altar, are *Saint Mary the Egyptian* (fig. 71) and *Saint Mary Magdalen* (colorplate 46), and they are not unrelated to the *Flight into Egypt* with their wilderness landscapes rendered as extremely original night pieces. Both are dominated by the tall trunks of exotic palm and eucalyptus trees swept by the sinister lightning flashes of a torrid Eastern night. Quivering streams

fall in cascades below the small figures of the saints, whose phantasmal aureoles of light define them and give them their prominence. With the rushing of the water, streaming along in threads and clusters of light against the greenish brown of the forest, there is an atmosphere of an old tale of great deeds against tremendous odds. By this time, after all, Tintoretto had been at his task in the church and confraternity of San Rocco for over twenty years. Perhaps there was some significance in the events and legends of religion beneath the roofs of the Scuola Grande and church of San Rocco. Perhaps there was some significance too in the choice of the two female hermit saints: their meditation seems that of the man who painted them and who—like these holy women bravely indifferent to the storm-threatened night—could look ahead now only to the long night that lay before him. At the age of sixty-nine he had at last fulfilled the pact by which he sold his soul to the Scuola Grande di San Rocco. If, not entirely without reason, the appellation of another Sistine Chapel has been denied to these halls (Longhi, 1946), it cannot be forgotten that they were the mystic refuge and the place of hope of such a great heart as that of Tintoretto.

72. THE CAPTURE OF ZARA BY THE VENETIANS IN 1346. 1584–87. Oil on canvas, 21′ × 35′ . *Sala dello Scrutinio, Palazzo Ducale, Venice*

THE FINAL YEARS

His final years brought the painter back to the Doges' Palace, where the restoration undertaken after the last fire was well under way. Now it was the turn of the Sala dello Scrutinio, the hall where elections took place. Between 1584 and 1587 he produced for it the gigantic *Capture of Zara by the Venetians in 1346* (fig. 72), measuring 21 by 35 feet. The work was prepared by careful drawings of its details (fig. 98), and despite the inevitable dispersion due to the extensive intervention of assistants, the battle scene has an extraordinary compositional forcefulness. The arrangement is based on a truly splendid impetus and counterimpetus. With clouds of arrows streaking across the sky and flashing banners marking the rhythms of the combatants' movements, it is a masterpiece of theatrical imagination and of a deliberate *terribilità* in the exploitation of effects.

But it was for the wall above the doge's throne in the Sala del Maggior Consiglio (Hall of the Great Council) that between 1588 and 1592 Tintoretto did his last work for the Doges' Palace. The *Paradise* (fig. 73) was for centuries the largest canvas in the world, measuring about 23 by 72 feet. No one supposes that a painting of those dimensions with a great number of figures—literally hundreds—and such complexity of execution and montage could have been done without extensive collaboration. It is unanimously agreed that Tintoretto's part was limited to the conception and the design—which is documented by a large oil sketch (fig. 74) in the Louvre and a model now in the Thyssen-Bornemisza Collection in Lugano—and that the realization had necessarily to be compromised in many

particulars for reasons external to the work itself. The finished painting not only lacks the dynamic tension of the concentric circles of the Blessed, very much present in the Louvre sketch, but also is weaker in color when compared to the Thyssen model. With the excessive denseness of the final rendering, especially at the margins, the extraordinary screen of light against which the figures are profiled also became attenuated. Intact, however, is the total impact, and it is unforgettable in its fantastic vividness, a true monument to the sense of triumph of the Catholic Counter Reformation.

The unexpected success of a recent restoration has recovered another work in large part from Tintoretto's own hand and very close to the *Paradise* in its dramatic contrasts of plastic forms and light—yet another *Washing of Feet*, this one in the church of San Moisè (fig. 75). Perhaps only the portraits of the donors are to be credited to Domenico, and there is a truly astonishing array of domestic objects. The unusual plays of light are rendered with a realistic spirit that strikes one as new, but the painting, merely for that, certainly should not be denied to the aged master himself, as some critics would have it. If anything, the treatment seems to prepare the way for the complex staging of the final great works, the *Gathering of Manna* and the *Last Supper* painted in 1592–94 for the church of San Giorgio Maggiore.

Though a common symbolism, the institution of the Eucharist, unites these two inventions for San Giorgio Maggiore, their inspiration is singularly different. The *Gathering of Manna*

73. PARADISE. 1588–92. Oil on canvas, 23' × 72' 7". *Sala del Maggior Consiglio, Palazzo Ducale, Venice*

(fig. 76) is set in a calm morning light with silvery reflections, while its pendant is an authentic night piece lit by a blazing oil lamp. Impressed on a pulsating alternation of deep blues and shades of rose in the garments of the Israelites and Moses in the Old Testament scene, the colors of the *Gathering of Manna* hark back to the lighter gamuts of the first cycle for the Scuola Grande di San Rocco. Yet a more nervous draftsmanship, particularly in the poses and drapery, implies a certain tension in dealing with form, almost an anxiety over how to close it and yet contain the many ideas and details suggested by the theme. The composition is in consequence dispersed, especially because of an excessive attention to picturesque rustic details such as one would expect of a Bassano but also because of an almost emotional desire to make the landscape itself reflect the miracle depicted.

None of this is in the *Last Supper* (colorplate 48, fig. 77). There the composition is architecturally closed and complete. Using a formula already put to the test in the San Rocco cycles, Tintoretto placed the table on a diagonal in order to create a scenographic disposition enabling him to accentuate individually the figures of the Apostles and the predominant one of Christ distributing the symbolic bread. The triangular sector of the foreground is reserved to setting the scene with a number of episodes involving servants, scullions, onlookers, animals, everyday objects of use. In representing this starkly bare large room the painter took many liberties with the iconographic tradition, chiefly to give even greater emphasis to one of his very personal, mystically triumphant interpretations of the Eucharist. Miraculously the light rays and smoke of the oil lamp condense and materialize into soaring forms of angels beneath

74. PARADISE. c. 1574. Oil on canvas, 4' 8" × 11' 11". *Musée du Louvre, Paris*

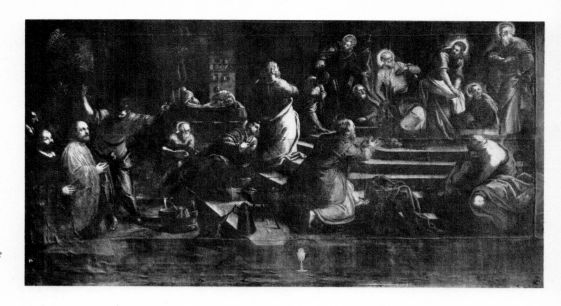

75. THE WASHING OF FEET. c. 1592.
Oil on canvas, 9' 6" × 18' 8". *San Moisè, Venice*

whom the head of Christ emanates its own dazzling light as, to a lesser degree, do those of the haloed Apostles. The interest in theatrical scenery and costume design that the painter already had in his youth immediately comes to mind. But the light—with its two luminous sources, natural and supernatural—has also its precise spiritual significance, which aims to bring out once again a compelling realization of the miracle of the first sacrament.

It is certainly to Tintoretto himself that all honor goes for this final visionary creation, which brings together the diverse but coherent motifs in the man's remarkable breadth of poetic and spiritual expression. Nevertheless there was to be yet one more admirable work. During the very last days of his life, at the age of seventy-five, he painted an *Entombment of Christ* (colorplate 47) for the Cappella dei Morti (Chapel of the Dead) in San Giorgio Maggiore. On May 30, 1594, he had written in his last will and testament that "being sound, for the grace of God, in mind and intellect but infirm in body," he wished to recommend himself "to the Eternal God, our Saviour Jesus Christ, to the Glorious Virgin Mary." These are the very personages in that final painting which seems in truth the illustration of those heartfelt words. Anyone looking long and hard at this picture and gazing intently at the gloomy light that broadens out from the dark hill of Golgotha to the sepulcher will become deeply aware of the desperation of the gestures, the resignation, the lamentation, and will not fail to recognize the painter in the old man looking down on the head of Christ. It was a final encounter: the man who all his life had exalted God with his brush was now being summoned to enjoy the eternal peace of the faithful. It is the same hair wreathing the high forehead, the same roundish curling beard as in the famous self-portrait in the Louvre, and a pose fraught with reverent piety.

On May 31, 1594, Tintoretto died. He was buried in his own parish church of the Madonna dell'Orto, not far from his house on the Fondamenta dei Mori, number 3399.

T. P., Venice, December 1981

76. THE GATHERING OF MANNA. 1592–94. Oil on canvas, 12' 4" × 18' 11". *San Giorgio Maggiore, Venice*

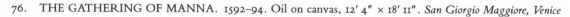

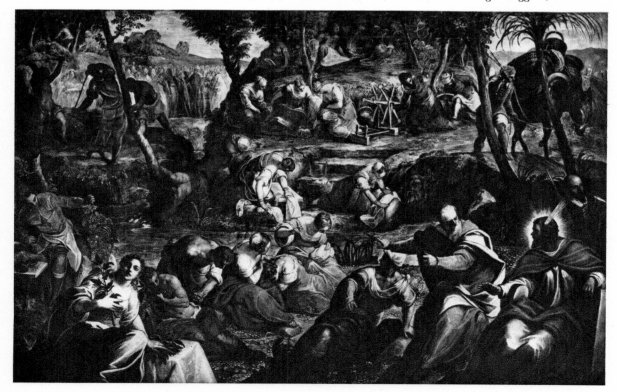

77. THE LAST SUPPER (detail). 1592–94.
Oil on canvas, overall 11′ 11″ × 18′ 8″. *San Giorgio Maggiore, Venice*

78. Sketch for THE REMOVAL OF THE BODY OF SAINT MARK
(back of canvas; colorplate 25). 1562–66.
Bitumen on canvas, 13′ ¾″ × 10′ 4″.
Gallerie dell'Accademia, Venice

DRAWINGS

Of the many drawings attributed to Tintoretto about one hundred and twenty-five have been assigned to his own hand by the most recent scholars (Rossi, 1975). Everything points to their having been done merely as graphic notations in the first stages of preparing a painting. As the subjects themselves make clear—almost always male nudes, usually drawn in black chalk sometimes heightened with white lead, and on square-ruled drawing paper—they were graphic essays intended to be enlarged to the natural size in the "true" drawing, usually done directly on the canvas (fig. 78). This has been confirmed by many recent restorations of the paintings. If that practice seems to contradict Vasari's assertion in 1568 that Tintoretto worked "at hazard and without preparatory drawing, almost as if to show that such art is a mere lark," it also explains why only a few drawings are full compositions; indeed, only a single one of these is unanimously accepted as autograph, the sketch for the Munich painting of *Venus and Mars Surprised by Vulcan* (colorplate 11, fig. 79).

In his youth Tintoretto was assiduous in training his hand in figure drawing, emphasizing chiaroscuro and taking as his models the originals and casts of antique sculpture (fig. 80) that were in numerous Venetian collections of the time (the Grimani holdings were particularly famous). He was also trying out ideas taken from Michelangelo (figs. 82, 83), whose work he surely knew long before receiving the models made by Daniele da Volterra in 1557 from the Medici tombs in Florence (fig. 81). The admiration of the young Tintoretto for the ideas of Michelangelo—and for those of Raphael, Parmigianino, and Giulio Romano as well—is attested by these explicit citations in his youthful works.

Nor in his mature years did he abandon his quest to pin down plastic forms and values by means of chiaroscuro, judging by Carlo Ridolfi's reports in 1648 of his anatomical studies on cadavers and of the model theaters he set up with manikins and artificial illumination to work out the scenic effects of his compositions. Ridolfi also specifies that he "suspended certain [miniature] models on cords from beams to observe the effects

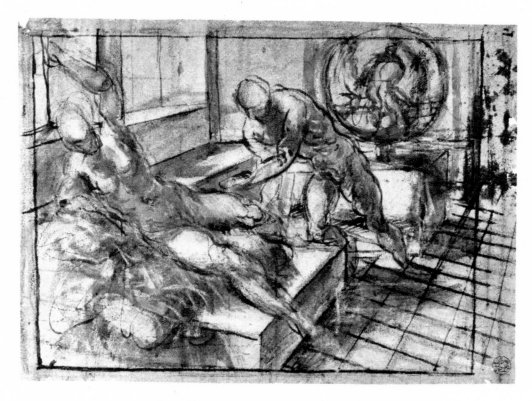

79. Sketch for VENUS AND MARS SURPRISED BY VULCAN (Alte Pinakothek, Munich; colorplate 11). c. 1552.
Pen and wash heightened with white on blue paper, 7⅞ × 10¾".
Kupferstichkabinett, Staatliche Museen Preussischer Kulturbesitz, Berlin–Dahlem

82. Studies from Michelangelo's
SAMSON SLAYING THE PHILISTINE.
c. 1545. Black chalk heightened with white
on gray-green paper, 16¾ × 10″.
Musée des Beaux-Arts, Besançon

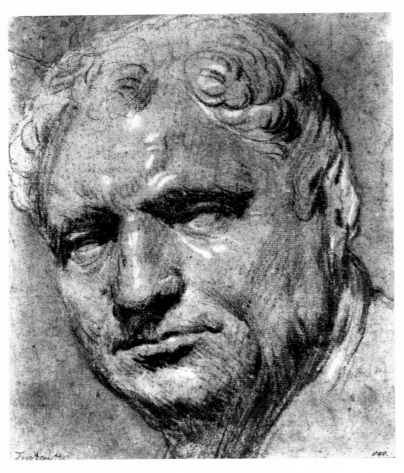

80. Study of a Bust of VITELLIUS. c. 1545.
Black chalk heightened with white on gray-blue paper, 11⅛ × 9⅛″.
Staatliche Graphische Sammlung, Munich

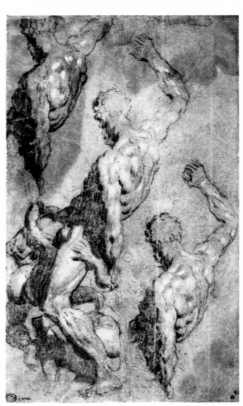

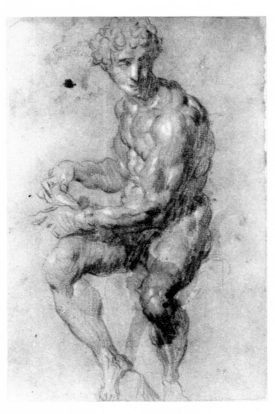

81. Study from a Model of Michelangelo's
GIULIANO DE'MEDICI (?).
c. 1545. Black chalk heightened with white
on bluish paper, 16⅛ × 10½″.
Christ Church Library Collections, Oxford

from below and thus worked out the foreshortenings required in ceilings, in that manner composing bizarre inventions.''

Beginning in the 1550s, chiaroscuro in his graphic style became attenuated, the figures serpentine in form. Poses, gestures, and foreshortenings are more excited, and rendered with nervous strokes abruptly broken off and as promptly resumed (figs. 84–87). In the slow maturing of his graphic approach what remained constant was the search to attain the synthesis of the image through a line in dynamic and luministic tension (figs. 88–93). Only in his final phase did Tintoretto's determination to test himself in highly tortuous formal solutions (figs. 94–98) reveal moments of fatigue, almost as if his style were being replaced by formula. It then becomes more difficult to distinguish his hand from those of the many assistants and collaborators, among whom his son Domenico was one of the most active.

Because of the overtly manneristic approach of Tintoretto's drawings—quite without interest in the "natural" approach, according to Ridolfi—they find their place on the margins of the Venetian graphic tradition, which tended to seek and recreate pictorial situations. What they reflect instead is an exceptional inventive fervor marked always by bravura in their rapid, and apparently facile, execution.

F. V.

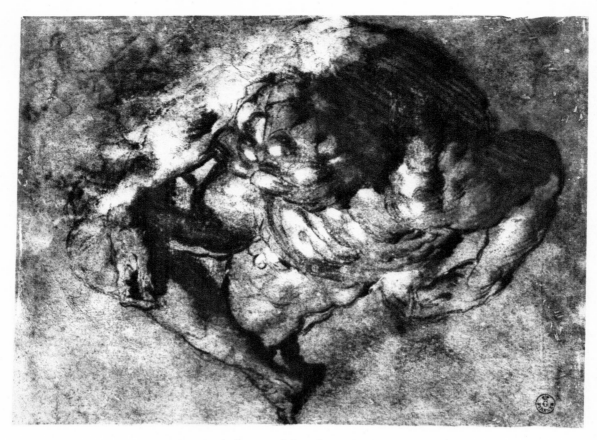

83. Study from Michelangelo's TWILIGHT.
c. 1550. Black chalk heightened with white on bluish paper, 10¾ × 14⅝″.
Gabinetto dei Disegni e delle Stampe, Galleria degli Uffizi, Florence

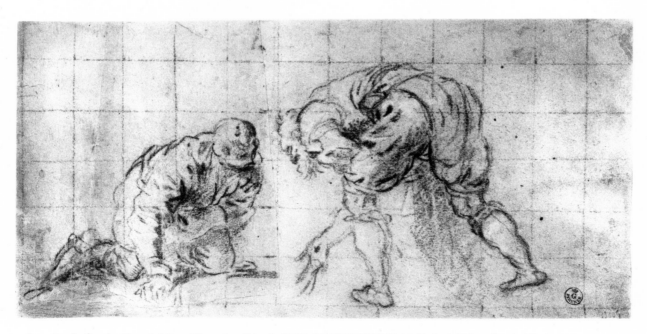

84. Study for the Two Soldiers Throwing Dice in THE CRUCIFIXION (Gallerie dell'Accademia, Venice). c. 1554.
Black chalk and traces of white on bluish paper, 8⅜ × 16⅞″.
Gabinetto dei Disegni e delle Stampe, Galleria degli Uffizi, Florence

85. Study for Recumbent Corpse in
SAINT GEORGE RESCUING THE PRINCESS FROM THE DRAGON
(National Gallery, London; colorplate 21). c. 1560.
Black chalk heightened with white on gray-green paper, 10 × 16⅜".
Cabinet des Dessins, Musée du Louvre, Paris

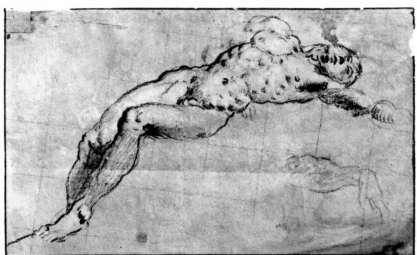

86. Figure Studies for
THE ADORATION OF THE GOLDEN CALF
(Madonna dell'Orto, Venice). c. 1564.
Black chalk on blue paper, 11¼ × 8".
Gabinetto dei Disegni e delle Stampe,
Galleria degli Uffizi, Florence

87. Study for a VIRTUE
(ceiling painting, Sala dell'Albergo, Scuola Grande di San Rocco, Venice).
1564. Black chalk on white paper, 8¼ × 11"
Gabinetto dei Disegni e delle Stampe,
Galleria degli Uffizi, Florence

88. Study for a Draped Standing Figure in THE CRUCIFIXION
(Sala dell'Albergo, Scuola Grande di San Rocco, Venice; colorplate 24). 1565.
Black chalk with traces of white on bluish paper, 8 × 6⅞".
Gabinetto dei Disegni e delle Stampe, Galleria degli Uffizi, Florence

89. Study for Eve in CHRIST IN LIMBO
(San Cassiano, Venice; colorplate 50) c. 1568.
Black chalk and traces of white on bluish paper, 9⅞ × 5⅞".
Gabinetto dei Disegni e delle Stampe,
Galleria degli Uffizi, Florence

90. Study for the Landlord in THE LAST SUPPER
(San Polo, Venice; fig. 44). c. 1569.
Black chalk heightened with white on blue paper, 12 × 7½"
Victoria and Albert Museum, London

91. Study for A PHILOSOPHER
(Libreria Sansoviniana, Venice; colorplate 29). 1570–71.
Black chalk and charcoal heightened slightly
with white on gray paper, 11½ × 7⅞".
Gabinetto dei Disegni e delle Stampe, Galleria degli Uffizi, Florence

92. Study for the Angel in ELIJAH FED BY THE ANGEL
(Sala Grande, Scuola Grande di San Rocco, Venice; colorplate 34). 1577–78.
Charcoal on brown paper, 14⅛ × 10¼″. *Hermitage, Leningrad*

93. Study for the Warrior at the right in
THE INVESTITURE OF GIOVANNI FRANCESCO GONZAGA
(Alte Pinakothek, Munich). c. 1578.
Black chalk with traces of white
on bluish paper, 13⅝ × 6¾″.
Gabinetto dei Disegni e delle Stampe,
Galleria degli Uffizi, Florence

94. Study for a Soldier in THE VENETIANS
DEFEATED ON THE ADIGE AT LEGNAGO
(Alte Pinakothek, Munich; fig. 67). c. 1578.
Black chalk on gray paper, 8⅞ × 9⅛″.
Gabinetto dei Disegni e delle Stampe, Galleria degli Uffizi, Florence

95. Figure Studies for THE WASHING OF FEET
(Santo Stefano, Venice; fig. 62).
c. 1580. Black chalk on white paper, 13⅝ × 15½".
Gabinetto dei Disegni e delle Stampe, Galleria degli Uffizi, Florence

96. Study for John the Baptist in
THE BAPTISM OF CHRIST
(San Silvestro, Venice; colorplate 37). c. 1580.
Black chalk with traces of white
on bluish paper, 15½ × 10⅜".
*Gabinetto dei Disegni e delle Stampe,
Galleria degli Uffizi, Florence*

97. Sketch of Kneeling Nude Figure Seen from Behind.
c. 1580. Black chalk on gray paper, 11⅞ × 9⅞".
Gabinetto dei Disegni e delle Stampe, Galleria degli Uffizi, Florence

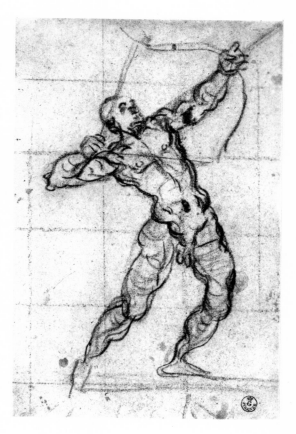

98. Study for an Archer in
THE CAPTURE OF ZARA BY THE VENETIANS
(Palazzo Ducale, Venice; fig. 72). 1584–87.
Black chalk on brown paper, 12⅝ × 8⅛".
*Gabinetto dei Disegni e delle Stampe,
Galleria degli Uffizi, Florence*

BIOGRAPHICAL OUTLINE

1519 Jacopo Robusti born in Venice, according to the certificate of his death in 1594 that gives his age as 75 years.

1539 *May 22:* In a document which he witnessed, Tintoretto signs as an independent painter residing in Campo San Cassiano in Venice.

1544 *June 8:* In a testamentary act the trade of his father, Giovanni Battista, is given as silk dyer (*tintore*), which explains why his son was called "Tintoretto."

1545 *February:* Pietro Aretino writes to thank Tintoretto for two ceiling paintings for his house, an *Apollo and Marsyas* and a *Mercury and Argus.*

1547 *August 27:* Tintoretto signs and dates the *Last Supper* for the church of San Marcuola (fig. 21).

1548 *April:* In letters to Jacopo Sansovino and Tintoretto, Aretino praises highly the *Miraculous Rescue of a Christian Slave by Saint Mark*, newly finished for the Scuola Grande di San Marco (colorplate 6).

1553 By this year Tintoretto was married to Faustina, daughter of Marco de' Vescovi, who was dean of the Scuola Grande di San Marco from 1536 and grand guardian from 1547.
December 20: The Salt Magistrate is invited by the Council of the Ten to pay the artist 100 of the 150 ducats agreed on for a vast canvas for the Sala del Maggior Consiglio in the Doges' Palace, possibly the *Coronation of Barbarossa* later lost in the fire of 1577.

1554 *January 13:* Tintoretto is living in the parish of San Marziale, in the house of Baldassarre dei Mastelli. A daughter, Marietta, who became a mainstay in her father's workshop, is born probably in this year.

1557 Tintoretto completes the commission for the organ shutters for the church of Santa Maria Zobenigo; only the two inner faces survive (fig. 35, colorplate 18).

1560 The second male son, Domenico, is born, also to become a collaborator of his father.

1561 Birth date of third son, Marco, likewise destined to follow his father's profession.

1562 *January 7:* The Council of the Ten authorizes payment of 600 ducats for completion of the cycle of paintings for the Sala del Maggior Consiglio. Tintoretto is commissioned to paint an *Excommunication of Barbarossa* for the Doges' Palace, also lost in the fire of 1577.

June 21: The grand guardian of the Scuola Grande di San Marco, Tommaso Rangone da Ravenna, is authorized to have painted at his expense three additional pictures of miracles of the patron saint of the confraternity for its meeting hall.

1563 *May 9:* Tintoretto is a member, with other artists, of a commission to arbitrate on the mosaics executed by the Zuccato family for the basilica of San Marco; together with Paolo Veronese and Jacopo Sansovino, he serves on a jury charged with selecting mosaicists for the basilica.

1564 *May 22:* The confraternity of San Rocco decides to replace the existing pictorial decoration of the Sala dell'Albergo, the main meeting hall of their Scuola Grande, with new work to be done at the expense of the members; one of these, Giovanni Maria Zignioni, declares that he will contribute 15 ducats on condition that the commission not be assigned to Tintoretto.
May 31: Giovanni Battista Tornielli, grand guardian of the Scuola Grande di San Rocco, rules to establish a competition to select an artist to execute the large oval ceiling painting for the confraternity's meeting hall.
June 22: Tintoretto makes a gift to the Scuola of his painting of *Saint Roch in Glory* (colorplate 23) which, without authorization, he has already installed on the ceiling.
June 29: The gift is accepted by a majority of the members (51 to 21).

1565 Date on the *Crucifixion* in the Sala dell'Albergo of the Scuola Grande di San Rocco (colorplate 24).
March 11: With a vote of 85 to 19 Tintoretto is accepted into the confraternity of San Rocco, his application of 1559 having been "overlooked."

1566 *March 9:* Together with Andrea Palladio, Giuseppe Salviati, and Titian, Tintoretto is named honorary member of the Accademia dell'Arte di Disegno of Florence.

1568 *December 9:* Tintoretto is paid 20 ducats for designs for a *Last Supper* and a *Marriage at Cana* to be executed in mosaic in the basilica of San Marco, the former by mosaicist Domenico Bianchini, the latter by Bartolommeo Bozza.

1572 *March 7:* Tintoretto receives 25 ducats for nine *Philosophers* for the Libreria Sansoviniana (colorplate 29).
November: The *Battle of Lepanto*, executed without payment, is finished for the Sala dello Scrutinio in the Doges' Palace (lost in the 1577 fire).

1574 *May 6:* The confraternity of San Rocco decides to replace the ceiling decoration of the Sala Grande, the larger of the two halls on the upper story of the Scuola.
June 8: Acting for Tintoretto, his father-in-law acquires a house on the Fondamenta dei Mori (present number 3399) near the church of the Madonna dell'Orto.
June: With Paolo Veronese, Tintoretto designs decorations on the occasion of the visit to Venice of Henry III of France, whose portrait he also painted.
September 27: In compensation for the *Battle of Lepanto* executed free of charge in 1572, Tintoretto requests from the Council of the Ten a brokerage in the Fondaco dei Tedeschi, the trading center for German merchants.

1575 *June 2:* Tintoretto offers to paint the *Raising of the Brazen Serpent* on the central canvas of the ceiling of the Sala Grande in the Scuola Grande di San Rocco (colorplate 30).

1576 *June 22:* Tintoretto pledges to deliver the *Brazen Serpent* as a gift on August 16, 1576, feast day of Saint Roch, patron saint of the Scuola Grande.

1577 *January 13:* Tintoretto offers to paint the two other large pictures for the ceiling of the Sala Grande in the Scuola Grande di San Rocco, the *Gathering of Manna* and *Moses Striking Water from a Rock* (colorplate 31), asking to be reimbursed only for the expenses of canvas and paints.
March 25: He declares himself disposed to complete the entire decoration of the ceiling for whatever compensation the confraternity decides is just.
March 30: He is paid for three portraits of procurators and for some cartoons for mosaics for the basilica of San Marco.
November 27: In a petition to the confraternity he offers to work steadily for the Scuola Grande di San Rocco as well as its church of San Rocco, pledging himself to complete three paintings each year on August 16, the feast day of Saint Roch, asking as compensation in advance a yearly stipend of 100 ducats until his death.
December 2: The proposal is accepted in a majority vote of the confraternity.

1578 *July 28:* Paolo Veronese and Palma Giovane are assigned to set a value on the four paintings done by Tintoretto for the Atrio Quadrato in the Doges' Palace (colorplates 32, 33; figs. 54, 55).
November 10: He is paid for the paintings on the basis of that valuation.

1579 *October 1:* Count Teodoro Sangiorgio, acting through a representative of the duke of Mantua in Venice, commissions from Tintoretto four paintings celebrating the deeds of the house of Duke Federico Gonzaga.
December 17: The sketches for these "*Fasti gonzagheschi*" are approved with some reservation.

1580 *May:* Tintoretto is invited to Mantua to install the second set of four paintings commissioned.
September: Accompanied by his wife, he travels to Mantua.

1581 *July 19:* Gilded frames are being prepared for paintings for the walls of the Sala Grande in the Scuola Grande di San Rocco, now completed.

1583 *July 22:* Tintoretto has begun to work on paintings for the lower hall, the Sala Terrena, of the Scuola Grande di San Rocco (colorplates 43–46, figs. 69–71).

1586 *September–November:* Payments made for his cartoons for mosaics in the basilica of San Marco.

1587 Tintoretto is reported to be at work on a *Last Judgment* for Philip II of Spain.
August 12: Last of the paintings are installed in the Sala Terrena of the Scuola Grande di San Rocco.

1588 *August 27:* Tintoretto is paid 49 ducats for an altarpiece for the altar of Saint Leonard in the basilica of San Marco.
August–October: He receives payments for mosaic cartoons done earlier for San Marco. After considerable dissension he is assured of the commission for the *Paradise* for the Sala del Maggior Consiglio in the Doges' Palace (fig. 73).

1592 *June 27:* Final payment for Tintoretto's long activity in preparing mosaic cartoons for San Marco.
December 27: Named a member of the Scuola dei Mercanti (Confraternity of Merchants), which is near his parish church of the Madonna dell'Orto; he pledges, with his son Domenico and his pupil Aliense, to decorate the ceiling of their meeting hall.

1594 Tintoretto is paid for the *Entombment of Christ* done for the church of San Giorgio Maggiore (colorplate 47).
May 30: He makes his will, leaving to Domenico the equipment in the workshop and entrusting him to complete any work he might leave unfinished.
May 31: Tintoretto dies at the age of 75 years and is buried in the Vescovi family tomb in the church of the Madonna dell'Orto.

F.V.

COLORPLATES

THE DISPUTE OF THE BOY JESUS
IN THE TEMPLE

c. 1542

Oil on canvas, 6' 6" × 10' 6"

Museo del Duomo, Milan

Although this painting is among the earliest works of Tintoretto that can be identified with any certainty, for years it was ignored until rescued from oblivion in 1955 by Francesco Arcangeli. The neglect seems unusual since it had been remarked on favorably in the late-sixteenth-century guide to Milan by Carlo Torre and, as late as 1737, in that by Serviliano Latuada.

The painter, then only in his early twenties, achieved an impressive amplitude in the setting by stressing the marked linear perspective created by the two rows of great columns. The extreme illusion of depth converges at the exact center of the far background, first on the boy Jesus and then on a statue just visible at the summit of the rear of the temple. The complexity of the spatial invention as well as the vivid palette are perfectly attuned to the tumult caused by the words of the young Jesus in the listeners in the foreground, who loom large and sculpturesque in movements of agitated opposition.

The willfully original composition and the impetuous pictorial command were qualities that would arouse much admiration among Lombard painters at the turn of the next century. In even as early a work as this Tintoretto showed he had already arrived at a figurative strength uniquely his own. He had already gone beyond the direct influences of Bonifazio dei Pitati and Andrea Schiavone and had taken what he needed from Titian's three ceiling paintings of 1542 now in Santa Maria della Salute (fig. 30). Profiting from the study of his much-admired Michelangelo (figs. 81–83), he had also shaken off any mere intellectualism of Tuscan-Roman and Emilian mannerist origins.

It has been suggested that, almost as a symbolic memento of his true sources of inspiration, in the group behind the beautiful woman in the left foreground the youthful artist may have portrayed himself as the young man listening intently to a companion viewed from the rear, Titian as the choleric-looking aged doctor against the second column on that side, and Michelangelo as the bearded man with red headgear. What is certain is that Tintoretto has already shown his originality and independence in confronting traditional Venetian painting, then so dominated by a partiality for Titian's warm tonalities.

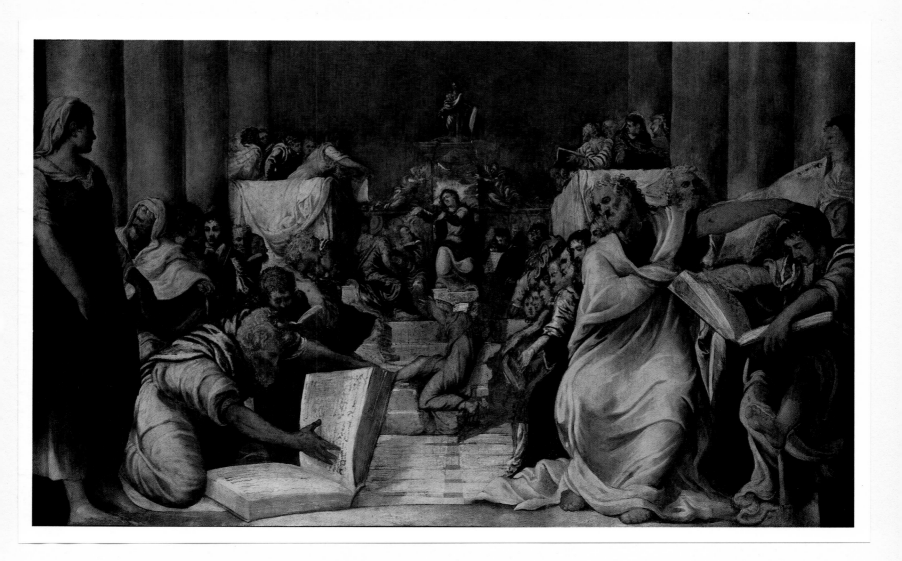

THE FEAST OF BELSHAZZAR (detail)

c. 1544
Oil on panel, overall 11½ × 61¾"
Kunsthistorisches Museum, Vienna

The *Feast of Belshazzar* and five other panels with biblical subjects may have been part of a series done as fronts for chests of the cassone type or perhaps, though less likely, for organ cases or as decorations for a room interior (see Benesch, 1958). Long attributed to Andrea Schiavone and then in part to the workshop of Bonifazio dei Pitati, in 1922 Detlev von Hadeln proposed Tintoretto as the originator while admitting another hand in two of the paintings, a hand that Hans Tietze (1948) considered to be that of Bonifazio. Such uncertainties in the attribution of these six paintings are not without significance since they are prime examples of how the young Tintoretto undertook to master the unconstrained graphic phrasing and fluent brushwork of both Bonifazio and Schiavone. But wholly alien to these artists, and characteristic of his own approach to pictorial language, is the sculptural assurance of every detail achieved through the use of chiaroscuro and of flashes of color laid on firmly and confidently.

This picture, with its intense painterly approach and its composition already revealing an enthusiasm for narration, recalls one of Bonifazio's more justly famous works, the *Banquet of Dives* (fig. 4). With Tintoretto, however, the markedly fable-like and sensual tone of his picture takes on meanings that could almost be called realistic. By emphasizing the varicolored slabs of marble flooring, the perspective is made to accelerate toward the background of this spacious loggia separated by a dense colonnade from a garden planted with trees.

The different episodes that make up the picture are all vividly differentiated through a variety of actions and poses, notably in the group of musicians at the center of the detail illustrated here. All elements are caught with a keenness of representation: the manservant entering at the left apparently still talking to someone offstage, yet handling with aplomb his tray with its sparkling Murano glass vessels; the accurately depicted musical instruments; the ewers placed on the floor at center right. Not a brushstroke is for mere decoration; each has its part in re-creating with sureness of observation a domestic scene that appears totally unaware of impending doom.

THE CONVERSION OF SAINT PAUL

c. 1545

Oil on canvas, 5' × 7'9"

The National Gallery of Art, Washington, D.C.

Samuel H. Kress Collection

This canvas, on a theme that Tintoretto was to treat many times and one eminently suited to his personal expressive gifts, is perhaps the one reported by Carlo Ridolfi in 1642 and again in 1648 as one of the paintings in the Venetian home of Senator Gussoni. It is particularly important as evidence of the ideas and approach of the young artist, since certain versions of the theme mentioned by his contemporaries are no longer in existence, among them one done for the exterior of the organ shutters in the church of Santa Maria Zobenigo (see commentary for colorplate 18) and also one in fresco on the façade of the Palazzo Zen on the Campo dei Gesuiti, painted in collaboration with Schiavone. The refined mannerist elegance of that Slavonic artist, whose masterwork is on this same subject (fig. 5), is sharpened here by Tintoretto into a pungent and virtually wrenched handwriting rich in plastic and chiaroscuro effects and fully expressive of the violent action in the biblical episode it relates. The young painter's multiplicity of interests and fervid curiosity are well exemplified here: his enthusiasm for Titian, in the overall composition much like that of the lost *Battle of Cadore*, which the older master painted in 1538 for the Sala del Maggior Consiglio in the Doges' Palace (see fig. 2); for Leonardo, in details that echo certain ideas of that artist, particularly the horse capering on the bridge; for Pordenone, in the rearing horse at the left, recalling that in his now-effaced façade fresco on the Palazzo d'Anna in Venice.

In the artist's eagerness to convey the full force of the event, it seems almost as if all clues to real space were scattered, swept into a multiplicity of directional lines of perspective that have their fulcrum in the figure of Saul on the ground, ecstatically confounded by the divine message announced to him on the road to Damascus. The effect of spatial confusion results not only from the piling up of figural rhythms, but also from the juxtaposition of vivid colors that are full-hued on the proscenium level and dissolve into transparency in the farther planes. The wind-whipped banners of a standard bearer in the right background make a startling display of pinks and pale yellows.

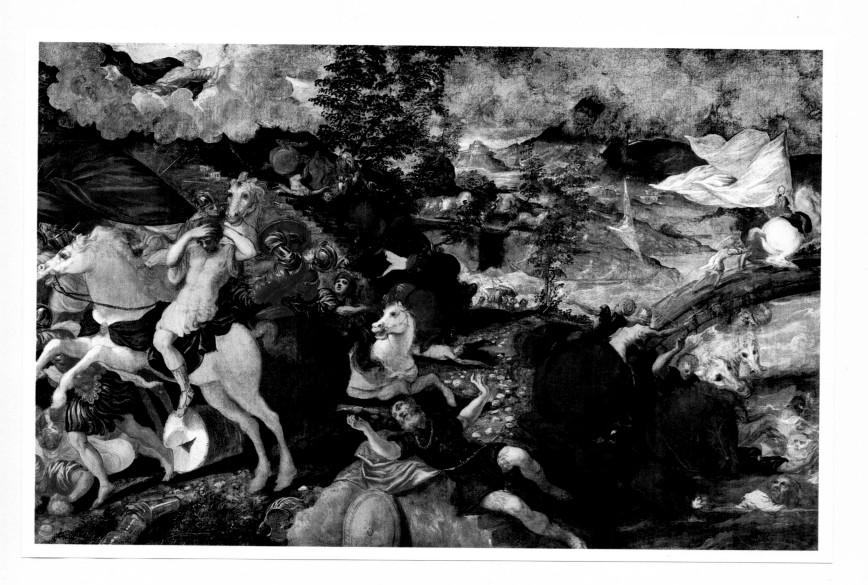

COLORPLATE 5

THE WASHING OF FEET

c. 1547
Oil on canvas, 6'11" × 17'6"
Museo del Prado, Madrid

This is a second version of the painting (fig. 22) now in Newcastle-upon-Tyne, England, which Rodolfo Pallucchini (*Arte Veneta* 30 [1976]: 81–97) proposes as the pendant to the *Last Supper* in the Venetian church of San Marcuola (fig. 23); the inscription on the Venetian painting reads: MDXXXX/VII/A DI XXVII/AGOSTO/IN TEMPO/DE · MISER · ISE/PO MORANDE/LO · ET · CONPA/GNI (1547, the 27th of August, in the time of Messer Iseppo [Jacopo] Morandello and fellow members). As early as the beginning of the seventeenth century (perhaps even the last years of the sixteenth, when arrangements for the high altar chapel of the previous church of San Marcuola were made) the painting in England must already have left Venice if, in 1642, Ridolfi could state that the church held only a copy of it, whereas this Prado version was acquired after 1649 by Philip IV of Spain from the collections of Charles I of England. There need be no doubt, however, that the Prado painting is very slightly later than the one in England and, further, that any perplexity about the differences in style between those two paintings and the San Marcuola *Last Supper* of 1547 can be explained by the difference in their subject matter.

Tintoretto had utilized the same scenic disposition in earlier paintings, but here it is transposed into a more dilated resonance of space because of the steep direction of the perspective toward the left in the wonderfully luminous architecture surrounding the length of the canal beyond the shadowed loggia. The interior is rich in realistic details, clearly expressed in a series of separate figural episodes distributed rigorously along lines that fan out from the dog crouching in the lower foreground. This compositional device is worthy of the ideas being explored at the time by Jacopo Bassano (fig. 21). Unrealistic, however, is the architectural setting, which opens broadly in the deep sunlit background and has its own center in a triumphal arch and obelisk borrowed from the woodcut illustration (fig. 17) of the ideal setting for tragedies proposed by Serlio in his architectural treatise of 1545 (see Gould, 1962).

The complex architectural scenery appropriate to this particular subject must have especially fascinated Tintoretto since at least four original versions of the composition are known: one in the Pembroke Collection in Wilton House, Salisbury, England, which is the earliest and differs most from the others; the one in Newcastle-upon-Tyne; another in the Art Gallery of Ontario, Toronto; and this Prado example. Precisely because of its ostensibly realistic approach and the spare orchestration of its colors and chiaroscuro, this work could not have failed to excite the admiration of Velázquez, who was in his fifties when the picture was acquired.

74

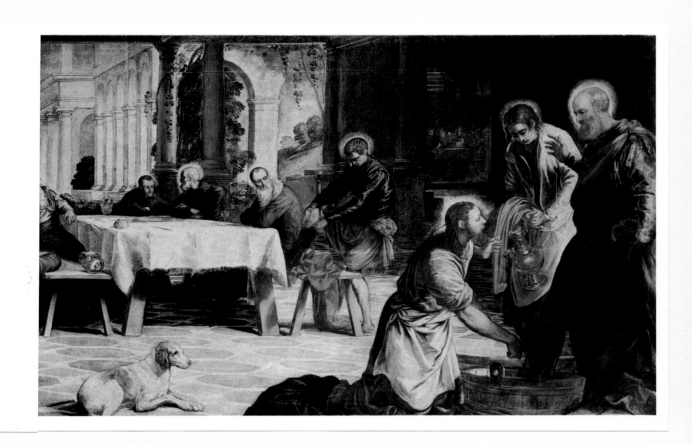

THE MIRACULOUS RESCUE OF A CHRISTIAN SLAVE BY SAINT MARK

1547–48

Oil on canvas, 13' 8" × 17' 10"

Gallerie dell'Accademia, Venice

On November 30, 1542, the heads of the confraternity of San Marco decided that the meeting hall in their Scuola Grande (now incorporated into the Ospedale Civile) should be decorated with scenes from the life of their patron saint. In 1648 Ridolfi observed that the first painting was commissioned from Tintoretto for the sufficient reason that "certain of the governors of the confraternity were among his relatives." This meant, of course, Marco de' Vescovi, his future father-in-law, who held the high post of grand guardian of the Scuola Grande in 1547, the year the commission was probably awarded. In April 1548 Pietro Aretino wrote to the artist in praise of the work, only recently completed but already much talked about in the cultural circles of the city—yet talked about with so much argument that, according to both Boschini and Ridolfi, the young artist, indignant at the lack of enthusiasm of certain members of the Scuola Grande, demanded his picture back and consented to return it only after much persuasion. Aretino himself, in the same letter, had certain reservations about the "skillful swiftness" (*prestezza*) of the execution, while nonetheless he praised the "newness" of the draftsmanship (*disegno*), the three-dimensional qualities, and the achievement of a "spectacle" more "true than simulated."

Since the restoration of 1965 we can more easily understand how the dynamic tension of its composition, the violent use of light, and the rapid execution could have disoriented the artist's contemporaries. Such a dramatic conception of reality, unlike the passionately heroic approach of Titian, was too radical for them.

Taking his cue from the bronze relief (fig. 29) on the same subject produced by Sansovino between 1541 and 1543 for the choir on the left of the apse of San Marco, Tintoretto eliminated all architectural framework from the foreground in order to make room for the crowd of onlookers looming in consternation over the supine body of the slave. While the rescuing saint, in acrobatic foreshortening, plummets swiftly into the scene, a flood of intense light from an invisible source gives way in the midground to a natural noonday light that plays over the white marble gate and wall of the mysterious garden and the projecting balcony. One senses that the grandiose scenic conception and the sure touch revealed here must have owed something to the artist's early activity as a fresco painter.

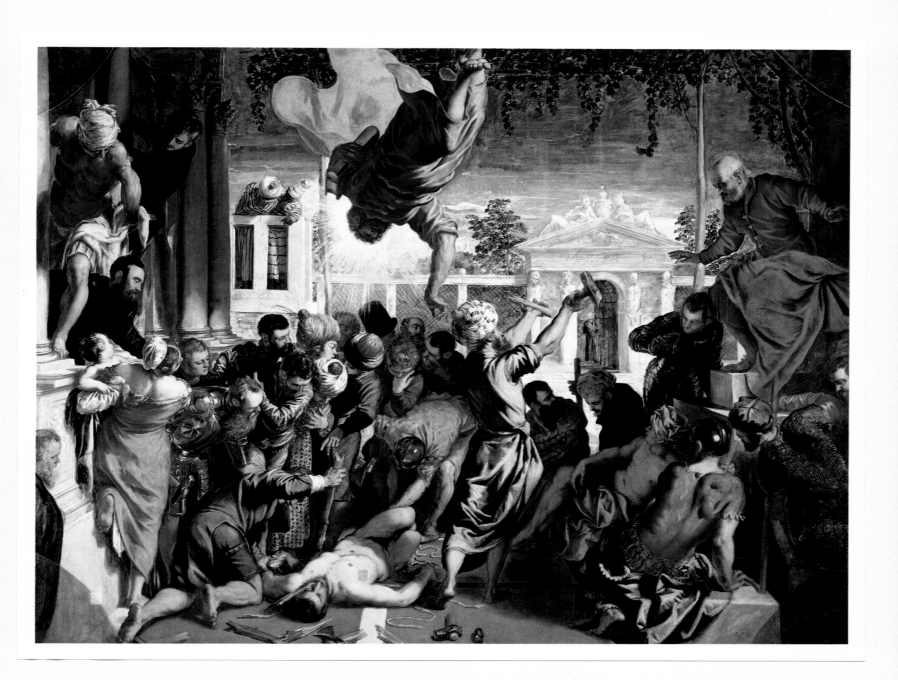

SAINT ROCH MINISTERING TO THE PLAGUE VICTIMS

1549

Oil on canvas, 10' 1" × 22' 1"

San Rocco, Venice

During his visit to Venice in 1566 Vasari much admired this large painting, and in the second edition of his *Lives*, published two years later, he made a point of praising its nudes as "very understandingly contrived, and an extremely fine dead man in foreshortening." The precise year the work was executed is known from a note of March 1565 in the registers of the Scuola Grande di San Rocco, which records that "already in 1549 was done the picture in the main chapel of the church, by Ser Jacomo Tentoreto [*sic*]." Rudolf Berliner (1920) doubted that date and proposed 1559 instead, while Hans Tietze (1948) raised the possibility that the artist returned to the work and revised it in 1567 when he was doing other scenes from the life of that saint for the presbytery of the church (fig. 49). There seems no reason, however, to disassociate this large painting from the date indicated in a document written only sixteen years later. Nor should the audacious approach to composition and the free and complex treatment of light at such an early date come as a surprise since the artist had already proved his mettle splendidly in the two paintings of 1547 for San Marcuola (figs. 22, 23) and the *Miraculous Rescue of a Christian Slave by Saint Mark* (colorplate 6), completed at the start of 1548.

Again a double source of illumination creates the complex dramatic scene. In the vast edifice the shadows in the background are pierced by the smoky gleam of two torches, while the figures distributed in a semicircle in the foreground are virtually embossed in sculptural relief by light entering diagonally from the right. Like the Christ in the Madrid *Washing of Feet* (colorplate 5), who is not given special prominence, here Saint Roch kneeling beside a plague victim and offering his blessing to bring about the sufferer's recovery is scarcely singled out as chief protagonist; he simply takes his place among those who compassionately succor the sick and the dying. The realistic approach is no less compelling in this picture. Each of the plague victims is individualized by a particular movement, and the bold foreshortening is unprecedented and rescued from being merely rhetorical by the well-balanced sense of presence and a synthesis created by the dramatic interplay of patches of shadow and slashes of light.

In such an evocation of the grief-stricken and gloomy atmosphere of a *lazaretto* of his time, the artist also presents in all their force the profoundly religious thoughts that were a spur to his creative imagination.

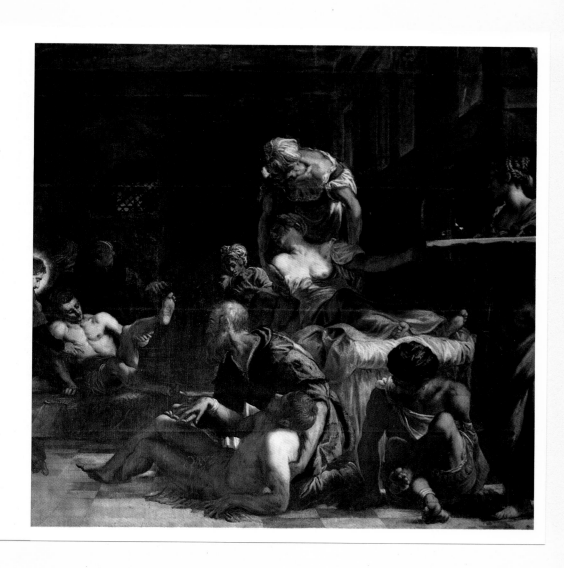

THE PRESENTATION OF THE VIRGIN

c. 1552
Oil on canvas, 14'1" × 15'9"
Madonna dell'Orto, Venice

As early as 1548 Tintoretto pledged himself to provide paintings for the organ case shutters in the church of the Madonna dell'Orto for a fee of five gold scudi, two bushels of flour, and a cask of wine. Three years later he must still have been at it since on November 6, 1551, a new contract was drawn up allowing additional compensation of thirty ducats and calling for the work to be ready for Easter Sunday, April 17, of the next year. Not even the extension seems to have helped, because the final payment was not made until May 1556 and was probably for the two canvases on the inner faces of the shutters: a *Martyrdom of Saint Paul* (fig. 37) and an *Apparition of the Cross to Saint Peter* (colorplate 17). For obvious stylistic reasons the painting on the outer face must date from about 1552, a dating that has been confirmed since the restoration of 1968 permitted a new reading of a work highly praised by the artist's contemporaries, including Vasari. Once the yellow pall of varnish was removed, the color regained its cold intensity, and the chiaroscuro reasserted its vigorous phrasing. Real pictorial substance was returned to the fascinating invention of the pyramid, as remote in its overt theatricality from the humanistic serenity of the prototypes by Cima da Conegliano and Vittore Carpaccio as from the sumptuous classicizing version of this theme that Titian painted between 1534 and 1538 for the meeting hall of the former Scuola Grande di Santa Maria della Carità.

Inverting the usual funnel-shaped compositional scheme, Tintoretto laid out his entire picture on a vast rounded staircase rising steeply to the towering high priest at the top. On the gold-inlaid steps, at the right, the tiny figure of Mary ascends in full light against a frigid sky, while at the left the sick and the infirm sprawl in dense shadows. The rapid intensification of the light and color, in which all rules of proportion are contradicted, is an immediate attraction and it involves the viewer in an atmosphere of Christian spirituality which, direct and spontaneous as a folktale, already prefigures the great canvases the artist would do for the Scuola Grande di San Rocco.

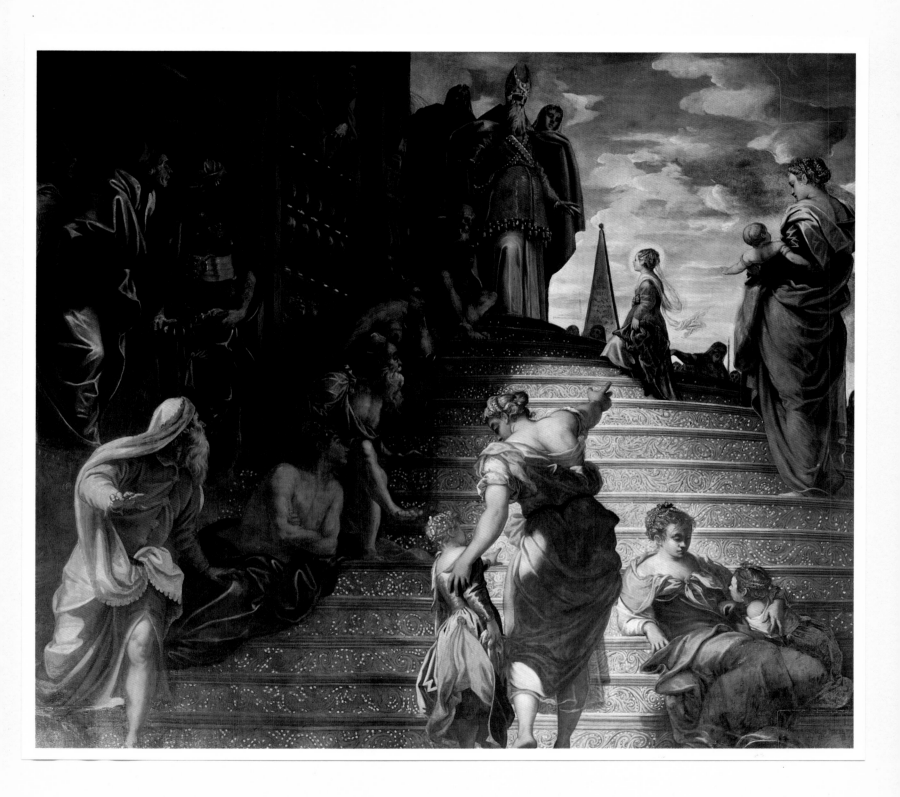

THE CREATION OF THE ANIMALS

1550–53
Oil on canvas, 5' × 8'6"
Gallerie dell'Accademia, Venice

B egun by Francesco Torbido between 1545 and 1547, the cycle of canvases with scenes from Genesis for the meeting room of the Scuola della Trinità (a building demolished in the seventeenth century to make room for the basilica of Santa Maria della Salute) was continued and completed by Tintoretto between 1550 and 1553. Four of his five pictures survive: in the Venice Accademia this *Creation of the Animals*, the *Fall of Man* (colorplate 10), and a *Cain Slaying Abel* (fig. 32)—virtually patterned after Titian's ceiling painting on that subject made initially for the church of Santo Spirito in Isola (fig. 30)—while the Uffizi in Florence has the *Adam and Eve Before God the Father*. The long-lost *Creation of Eve* is known through a drawing by Paolo Farinati (fig. 31).

The *Creation of the Animals* is the only painting in the cycle to preserve approximately its original measurements. It also stands out among the others for the impulsive, dynamic, almost shorthand quality of its language brought to a maximum of power in order to convey the cosmic force of the great event. A flashing light surrounds the Lord of Creation, who soars above an earth from which all shadows have not yet been dispersed. In a sky and a sea densely streaked with phosphorescent filaments, birds shoot through the air and fish swiftly furrow the waters as if suddenly unleashed by the gesture of their creator. Behind them the terrestrial animals quietly explore their newly created habitat. Figurative elements and landscape are represented with graphic conciseness, and the force of color and light unfurls in an uninterrupted crescendo clearly expressive of the divine intervention.

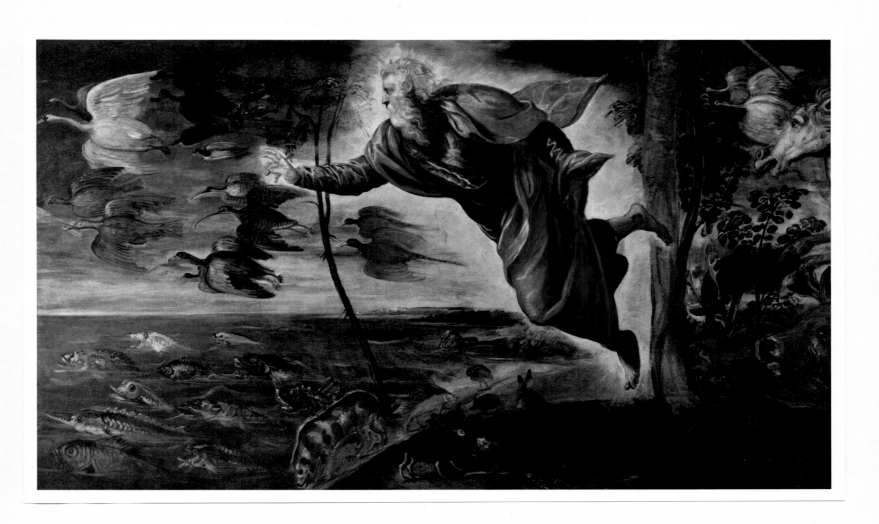

THE FALL OF MAN

1550–53

Oil on canvas, 4'11" × 7'3"

Gallerie dell'Accademia, Venice

This painting—as well as the *Creation of the Animals* (colorplate 9)—was part of the decoration of the Scuola della Trinità and, together with the *Cain Slaying Abel* (fig. 32), was most acclaimed by Tintoretto's contemporaries. Unfortunately, as we know from an engraving by Andrea Zucchi published in 1720 in the *Gran teatro di Venezia* by Domenico Lovisa, its left side has been mutilated, with the loss of part of the landscape.

The linear tension inherent in the *Creation of the Animals*, which renders with such force the imperious gesture of the Deity summoning into life the creatures of the world, loses intensity here. The images of mankind's original forebears in their first abode are represented by a slower-paced concreteness; a serene nature appears to reflect their own sentiments. Their nude figures, disposed along parallel diagonals at either side of the tree, have a statuelike solidity that suggests the plastic and graphic world of Tuscan-Roman mannerism. Since the golden film of nineteenth-century varnishes was removed in the restoration of 1966, the peaceful light has regained its original cold transparency, emphasizing the pinkish ivory flesh and revealing the full details of the wooded landscape. Gone now are the canons handed down by antiquity: Eve in an enchanted shell of foliage stretches forward to offer the forbidden fruit to Adam, who draws back in fear. The relaxed cadence of lights and shadows of the larger couple gives way abruptly at the right to a minuscule agitated episode depicting the dramatic epilogue to their disobedience; the flaming angel drives these first sinners toward the disquieting distances of plains and hills that are still empty of human life.

In the paintings for the Scuola della Trinità Tintoretto assigned a new role to landscape: it is no longer an idealized semblance as with Titian but a fragment of nature mirroring the emotions and actions of mankind.

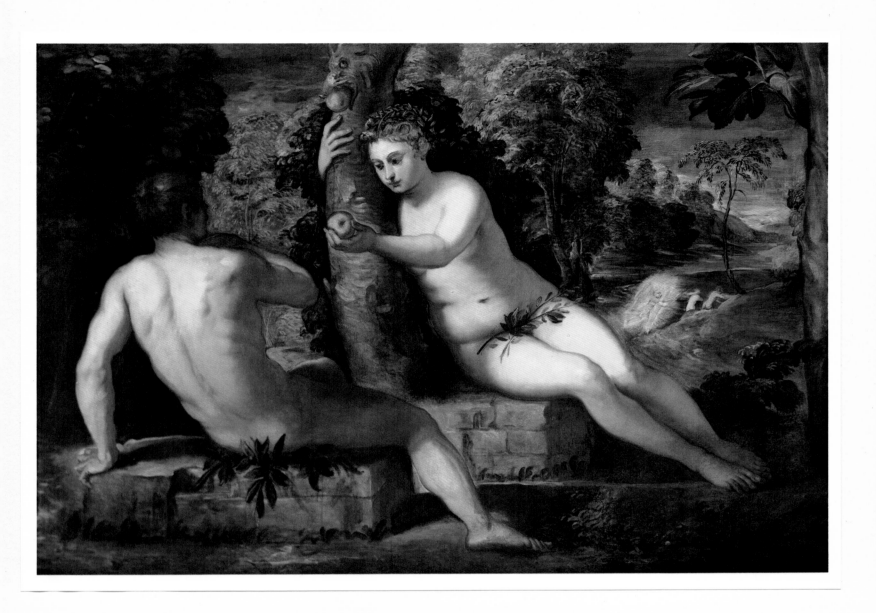

VENUS AND MARS SURPRISED BY VULCAN

c. 1553
Oil on canvas, 4' 5" × 6' 6"
Alte Pinakothek, Munich

Profane subjects, mythological ones in particular, are rare in the work of Tintoretto. Given his natural bent for splendidly orchestrated compositions with great masses of figures and an immediate emotional impact, the artist was more often commissioned to paint religious subjects or those celebrating the political and civil fortunes of Venice. Thus it must have been with particular enthusiasm that he approached this painting, one of the few for which a compositional drawing exists and indeed the only such drawing generally conceded to be from his own hand (fig. 79). His long meditation on the subject is evident in the deliberate striving for tension in forms, drawing, and color with which he captures the precise moment when, without waking the sleeping Cupid, Vulcan slips into the connubial bedchamber to expose the infidelity of Venus, whose situation is altogether safe so long as Mars remains hidden beneath a chest.

In the soft light diffused along intersecting rays, the refinement of the linear rhythms is perfectly matched by the highly developed gamut of colors, of a splendor unusual for Tintoretto and certainly not uninfluenced by the first examples of Paolo Veronese's works seen in Venice. The richness of detail and color would have been stimulated too by the sheer pleasure he must have taken in painting this Venetian ambiance of his time, with the round mirror reflecting the figure of Vulcan bending over Venus, the wide windows with their bull's-eye glass, the transparent Murano glass vase on the sill. It is precisely these picturesque domestic notes, together with the painter's overtly ironical verve, that drain the classical fable of its nobility and make it instead merely a diverting, sensational sixteenth-century tale.

The stylistic qualities contradict the very late dating of 1580 proposed by Mary Pittaluga in 1925 and lend support to the earlier date of about 1555 (still a few years too late, I think) that Hans Tietze suggested in 1948 when he also rejected Pittaluga's assumption that the artist's pupils had a hand in it.

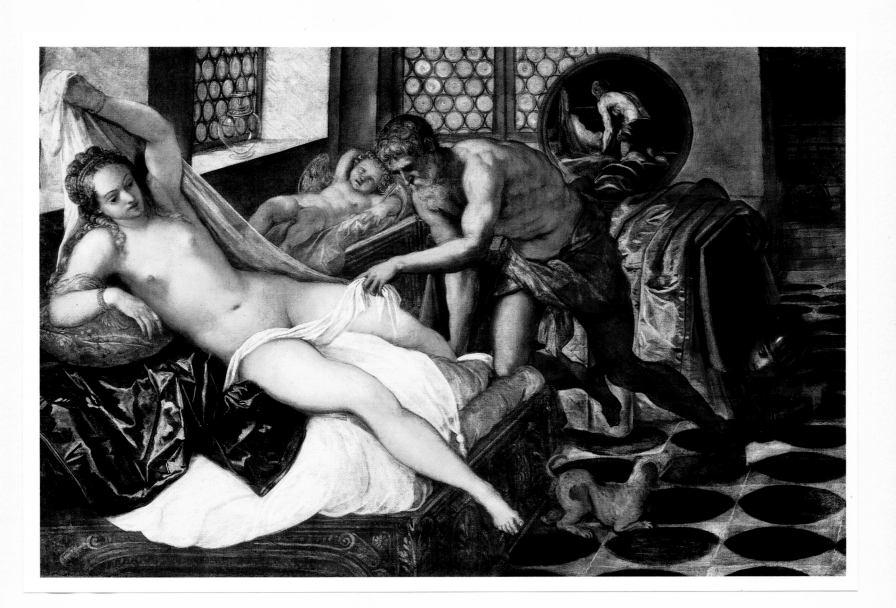

SAINT LOUIS OF TOULOUSE AND SAINT GEORGE WITH THE PRINCESS

1552–53
Oil on canvas, 9' 9" × 4' 10"
Gallerie dell'Accademia, Venice

This painting and its pendant, *Saint Andrew and Saint Jerome* (fig. 36), were originally in the hall of the Magistrato del Sale (Salt Magistracy) in the Palazzo dei Camerlenghi at the Rialto, where they flanked a *Madonna and Four Senators* (also now in the Accademia). One was commissioned by Giorgio Venier and Alvise Foscarini, the other by Andrea Dandolo and Girolamo Bernardo, magistrates who left office between May 1 and October 9 of 1552 and who, according to the Venetian custom, endowed the offices with votive pictures of their respective patron saints at the end of their terms. Removed in 1777 to the small church, the Antichiesetta, in the Doges' Palace and altered in dimensions to fit their new location, both pictures were freed of these arbitrary additions and taken to the Accademia in 1937.

This painting offers one of the key pieces in the various contemporary polemics for and against Tintoretto and the quality of his art, this time fomented in all likelihood by Titian himself. In Lodovico Dolce's *Dialogo della pittura intitolato l'Aretino* (1557), which heaped praise on the older master, Dolce criticized the "lack of thought" revealed by the artist in depicting the princess in an unseemly pose astride the dragon, although Dolce mistook her for Saint Margaret, an iconographical error perpetuated by Ridolfi. In fact the composition is compressed into a very limited space by means of a carefully calibrated interlocking of the figures of the princess gazing upward at her rescuer and herself virtually joined to the monstrous beast, of Saint George in properly declamatory pose, and of Saint Louis of Toulouse gazing down in thoughtful reserve. The solidity of the plastic forms is enriched by the manipulation of chiaroscuro: light prevails over shadow, with color of rich and profound timbre that has moments of particular beauty in the amarinthine red of the princess's garment, the grayish reflections in the shining armor, and the grayish green banded by red in the French saint's cope. The new interest in color shown by Tintoretto in these years is, beyond question, influenced by the simultaneous rise to favor of the rather different manner of Paolo Veronese.

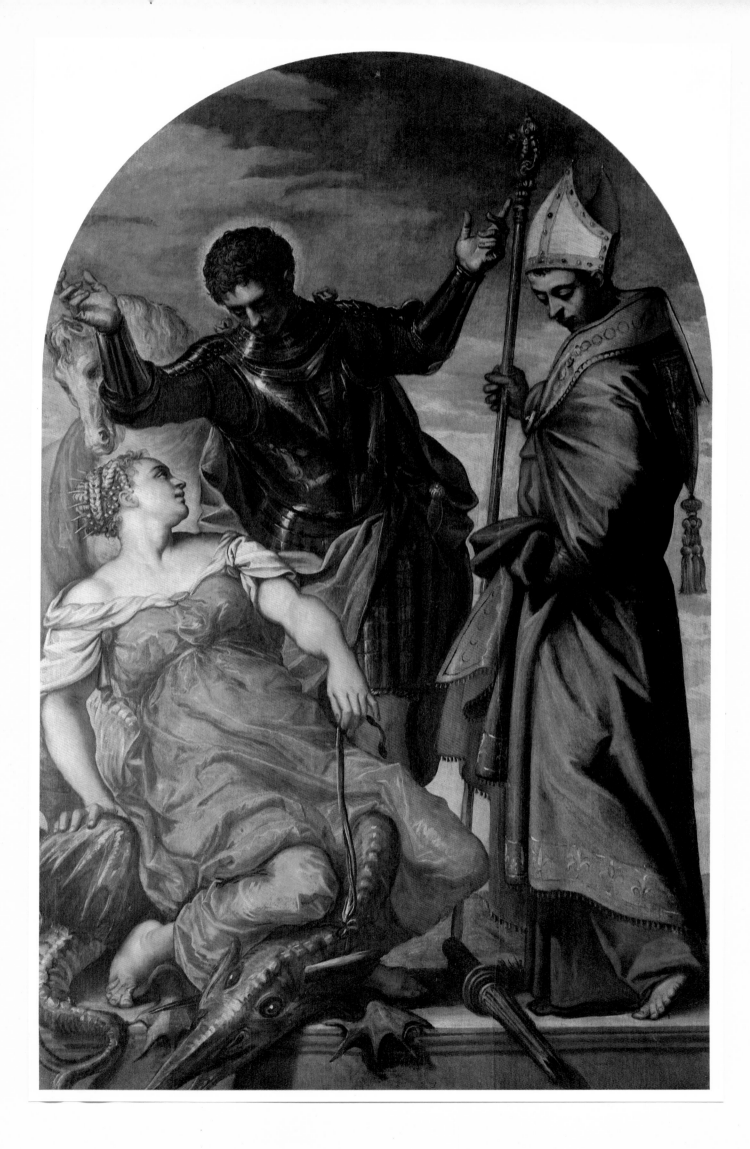

PORTRAIT OF A MAN STANDING BEFORE A TABLE

1553
Oil on canvas, 44 × 37½"
Kunsthistorisches Museum, Vienna

This painting, listed in the inventory made in 1659 of the collection of the Hapsburg archduke Leopold Wilhelm, was exhibited by the Vienna museum in Paris in 1947 as a self-portrait, although Wilhelm Suida had already challenged this identification. When that exhibition moved to London in 1949, Cecil Gould (*Burlington Magazine*, August 1949) was able to confirm Suida's identification. Since the date MDLIII painted on the table is followed by the intertwined letters LS and the age given as thirty-five (ANI XXXV), the sitter is identified as Lorenzo Soranzo, who was born in 1519 and died in 1575, and thus the right age in 1553. He does in fact resemble one of the persons in the huge group portrait (fig. 28a, b) that Tintoretto painted about 1550 of the powerful Venetian Soranzo family (see also Rossi, 1974).

In the nobly reserved pose and sober disposition of color there is an evident relationship with contemporary or slightly earlier portraits by Titian, such as the *Daniele Barbaro* in the National Gallery of Canada, Ottawa, or the so-called *Knight of Malta* in the Prado, Madrid. The difference here lies in the three-quarter twist of the torso, which lends to the likeness of this gentleman, early in his middle age, a feeling of insecurity that the artist was able to pin down in a fleeting moment along with a look of melancholy. It is in the face, hollowed out with authoritative force from the indistinct background, that Tintoretto proves his extraordinary capacity to capture even the most ephemeral mood and humor of his sitters with a true pictorial sensibility and naturalness.

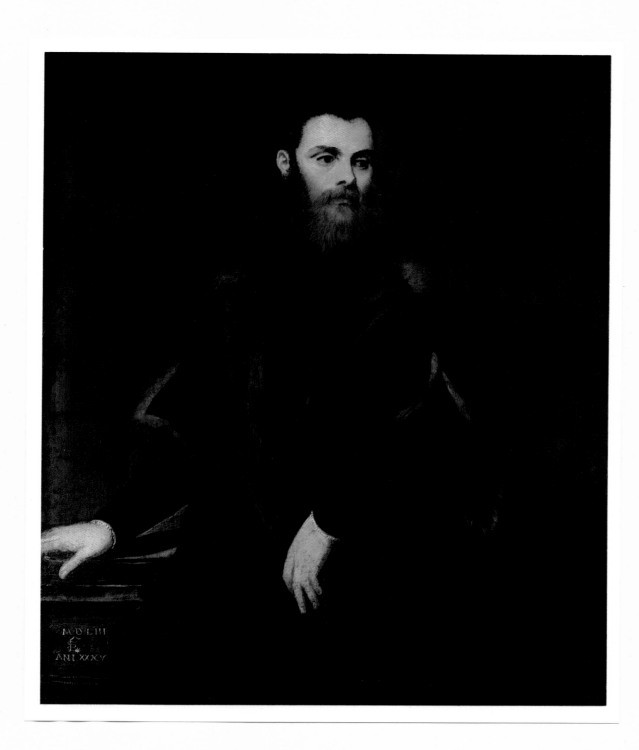

THE ASSUMPTION OF THE VIRGIN

c. 1554
Oil on canvas, 14'5" × 8'6"
Santa Maria Assunta, Venice

This great painting, originally on the high altar of the church of Santa Maria dei Crociferi (razed in the eighteenth century to make place for the present church), was cited by Francesco Sansovino in 1581, Borghini in 1584, and with great praise by Boschini in 1660, for whom it was "one of the truly exceptional works in the world." Ridolfi recounts the story that Tintoretto, having learned that the officials of the church were intending to entrust the task to Paolo Veronese, immediately offered his services and promised that "he would do it in the exact style of Paolo so that everyone would believe it to be from his hand." Whether the tale should be taken seriously or not, the highly varied and brilliant color indicates one of the instances in which Tintoretto was closest to Veronese. Nonetheless, Tintoretto's preference for figural rhythms charged with internal tension is reflected in the group of the Apostles—reminiscent of the lower part of Titian's *Assumption* in the Frari—as well as in the Virgin borne aloft by angels. Fields of color shot through with bursts of shadow and light within a symbolic and dynamic space are further evidence of Tintoretto's characteristic style. The oblique disposition of the tomb, the agitation with which the Apostles check and countercheck one another in abrupt contrasts of faces and arms against the sky, the twisting forms of the Virgin and the angels supporting her in her celestial voyage, even the impasto of color dissolved in an intricate texture of brushwork— all conspire to suggest an incessant spiraling motion that seems to burst out of the physical space of the altarpiece onto the walls around it.

JOSEPH AND POTIPHAR'S WIFE

c. 1555
Oil on canvas, 21¼ × 46"
Museo del Prado, Madrid

The group of six canvases with biblical themes to which this belongs (see also fig. 34) was first mentioned in the 1686 inventory of the Alcázar at Madrid. These canvases are not to be identified with the "eight different narrative [*di poesie*] subjects" painted, according to Borghini, for Philip II. Through an early-eighteenth-century account by Antonio Palomino we learn instead that they are the "paintings for a ceiling with stories from the Old Testament from the hand of Jacopo Tintoretto," acquired for Philip IV by Velázquez during his second sojourn in Venice, in 1649 (see F. J. Sánchez Cantón in the Prado catalogue, 1952). Their perspective foreshortening from below confirms that they were part of a ceiling decoration. Palomino described the central picture as an oval *Gathering of Manna*, but Sánchez Cantón has identified it with the oval *Purification of the Midianite Virgins* in the Prado, a matter now impossible to judge because of the heavy overpainting in that work.

According to Rodolfo Pallucchini (*Encyclopedia of World Art*, 1967), who dates the canvases about 1554–55, the six "Biblical Tales" belong to a moment of particular creative felicity for Tintoretto, when, vying with the young Paolo Veronese, he sought out subjects amenable to an elegantly decorative treatment. In these small canvases his pungent vision again goes beyond mere sumptuous decoration and disposes the image along the unstable course of a line continually broken off and then resumed, while color of considerable liveliness is counterpointed by the energetic mobility of the light. Yet this in no way prevents the flowing brushwork from summing up, to perfection, the pictorial elements— the beautiful female nude, the adornments of the bedchamber, Joseph's green cloak with gold-stitched bands—in a synthesis of joyous chromaticism from which the mind and fancy of Tintoretto were soon to turn away.

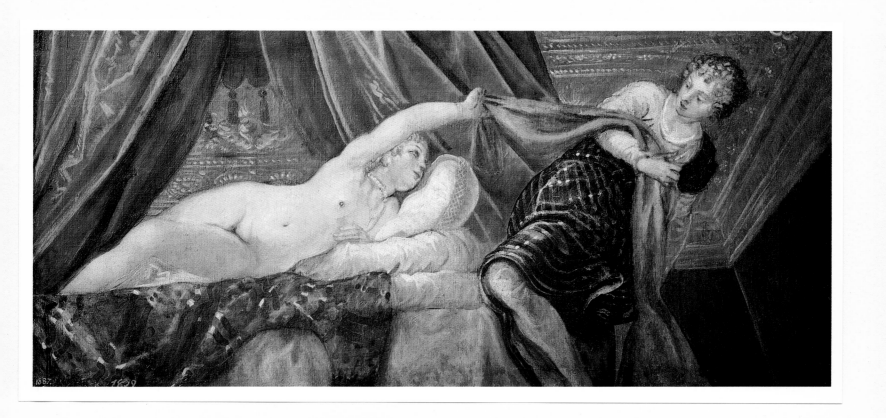

SUSANNA AND THE ELDERS

c. 1555
Oil on canvas, 4'9½" × 6'4"
Kunsthistorisches Museum, Vienna

The date of this painting is much debated. Set at 1560–64 by Erich von der Bercken (1942) and at about 1570 by Mary Pittaluga (1925), more recent writers generally accept about 1555, therefore at the close of the artist's period of experimentation with Veronese's approach.

In 1648 Ridolfi described the picture, then in the house of the painter Niccolò Renieri, (Nicolas Regnier), as "Susanna nude at her bath, and one of the elders, low on the ground and concealed behind some fronds, is observing her with considerable spirit while his companion peers into the garden from a distance." This is not the culminating moment of the biblical tale, so often depicted in the sixteenth century, when the old men suddenly confront the naked and frightened Susanna; instead it is the prelude to that—with the woman intent on her toilette and unmindful of the designs of the prurient judges.

The setting is a shady garden where wild animals roam at peace, the pool separated from it by an espalier of roses from either end of which spy the bearded old men. The contrast between the serenity of Susanna, contemplating with pleasure her own image in the mirror and heedless of her surroundings as she dries her foot, and the obscene avidity of the gaze and poses of the two old men is underlined by the dynamism of the spatial invention. At the right, in immediate close-up, the naked female beauty in all the physical substance of flesh is glazed by light but is no less "material" than the toilet objects strewn around her. To the left and rear the eye is drawn into a dramatic perspective, sweeping toward a mysterious garden separated from the shadows of a forest grove by a high openwork marble wall adorned with caryatids. The atmosphere of blissful calm in which Susanna dwells gives way to an existential anxiety. Thus even in this kind of subject, so susceptible to sumptuous decorative solutions and treated in that manner by Titian in the same period, Tintoretto held fast to his tormented and dramatic vision of reality.

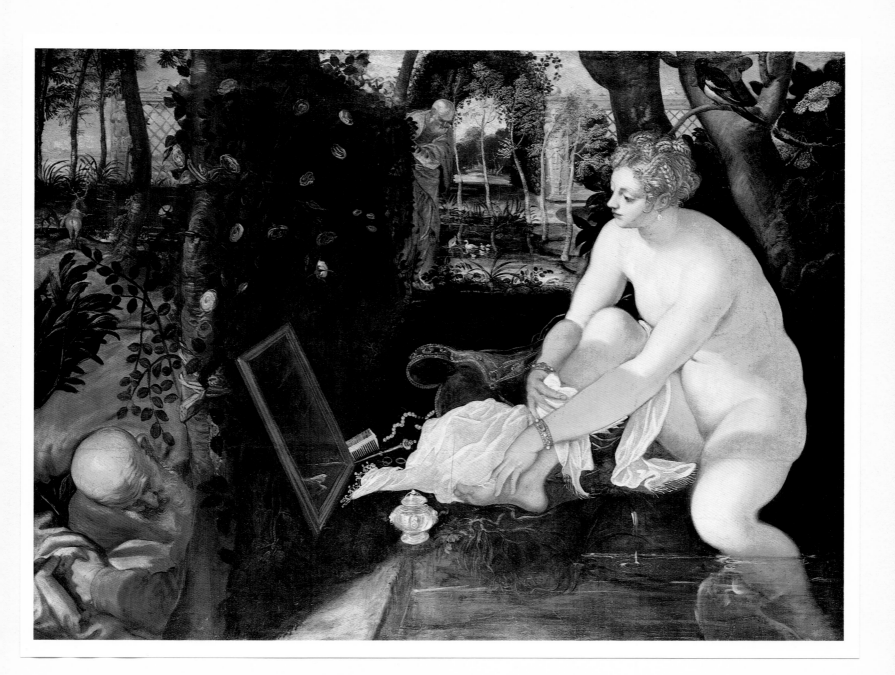

THE APPARITION OF THE CROSS
TO SAINT PETER

1555–56

Oil on canvas, 13' 9" × 7' 11"

Madonna dell'Orto, Venice

This canvas was originally on the inner face of the left shutter of the lost organ case in the church of the Madonna dell'Orto. Like its pendant, the *Martyrdom of Saint Paul* (fig. 37), the painting can be dated close in time to the final payment received by Tintoretto in May 1556 for the decoration of the organ. But it must be a few years later in date than the painting for the exterior of the organ case, the *Presentation of the Virgin* (colorplate 8), because it clearly shows evidences of the artist's study of Paolo Veronese's innovations in the treatment of color and the figure—something not found in the picture for the exterior, as the restoration of 1968 has proved.

Both the figure of Saint Peter and the cluster of angels supporting the cross are placed with extraordinary pictorial breadth along two parallel diagonals in a compositional formula common with Tintoretto, and they seem almost to shoot out from the picture plane. Overcome with awe at the sudden apparition, Saint Peter nonetheless does not lose firm hold of the large volume on his lap. The angels too are rendered with utter realism in their effort to prevent the huge cross from falling forward; their positioning is expressive in its immediacy. The color is distributed on broad surfaces under the rhythm of a firm and all-embracing light that confers on the whole as well as on each figure the effect of a triumphant spectacle standing out boldly against the golden radiance of an unreal sky.

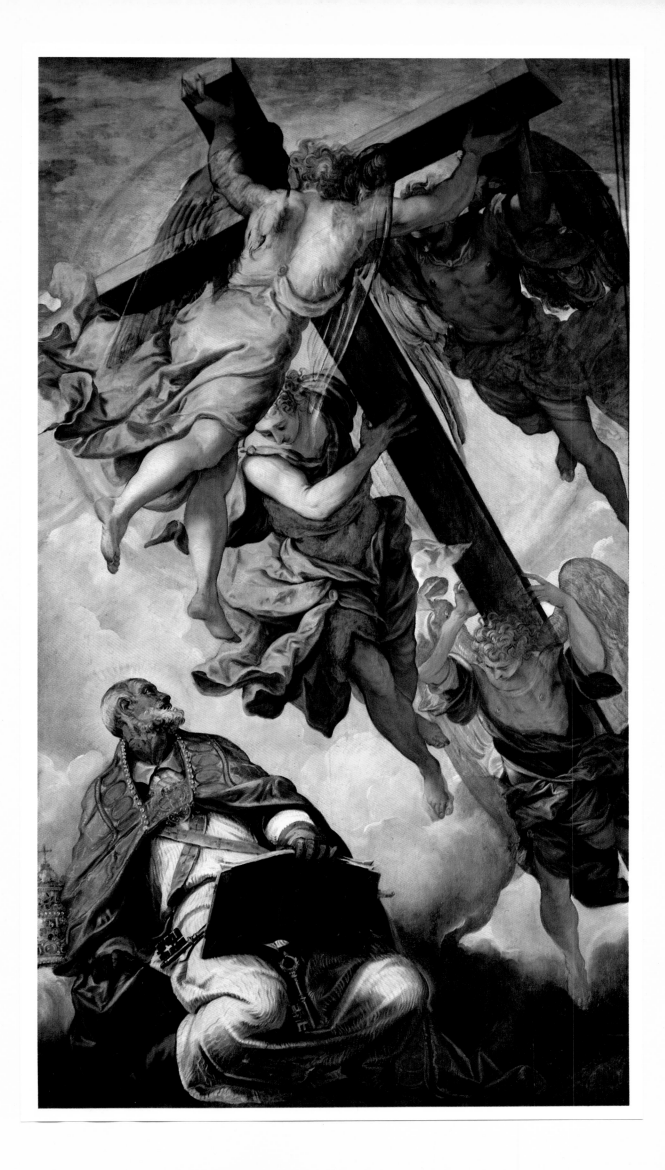

THE EVANGELISTS MARK AND JOHN

c. 1557
Oil on canvas, 8'5" × 4'11"
Santa Maria Zobenigo, Venice

The painting and its pendant with the Evangelists Luke and Matthew (fig. 38) decorated the inner faces of the organ shutters in the church where they have remained, although the organ itself has not survived nor has the exterior of the shutters with the *Conversion of Saint Paul*, described by Vasari in 1568 as done "not very carefully" and still in place in 1847 when Giovanni Antonio Moschini published the second edition of his *Nuova Guida* to Venice.

Although the commission was awarded to him with the stipulation that the shutters be completed by 1552, Tintoretto blithely put off work until 1557, when he was given a very short time in which to begin and finish the long-overdue pictures. There is not the same brilliant animation in these paintings as in those done for the inner faces of the organ shutters of the Madonna dell'Orto (colorplate 17, fig. 37). Instead a coloristic and figurative severity gives clear proof of how Tintoretto, once he abandoned the notions borrowed from Veronese, turned his thoughts again to earlier ideas of mannerist extraction and breathed life into them with a new attention to luminous values.

Saint Mark braces his feet forcefully against the clouds in order to twist backward and continue penning his Gospel, while his fellow saint, turned away in one-quarter profile, concentrates on transcribing a text. The two figures moored between shadow and light are structured with impetuous force in their foreshortening from below by explosive brush-strokes, all of which are discernible in their creative progression within the nervous web of filaments of light. This concise acceleration of formal elements leaves the distinct impression of a vitality that is both real and fantastic.

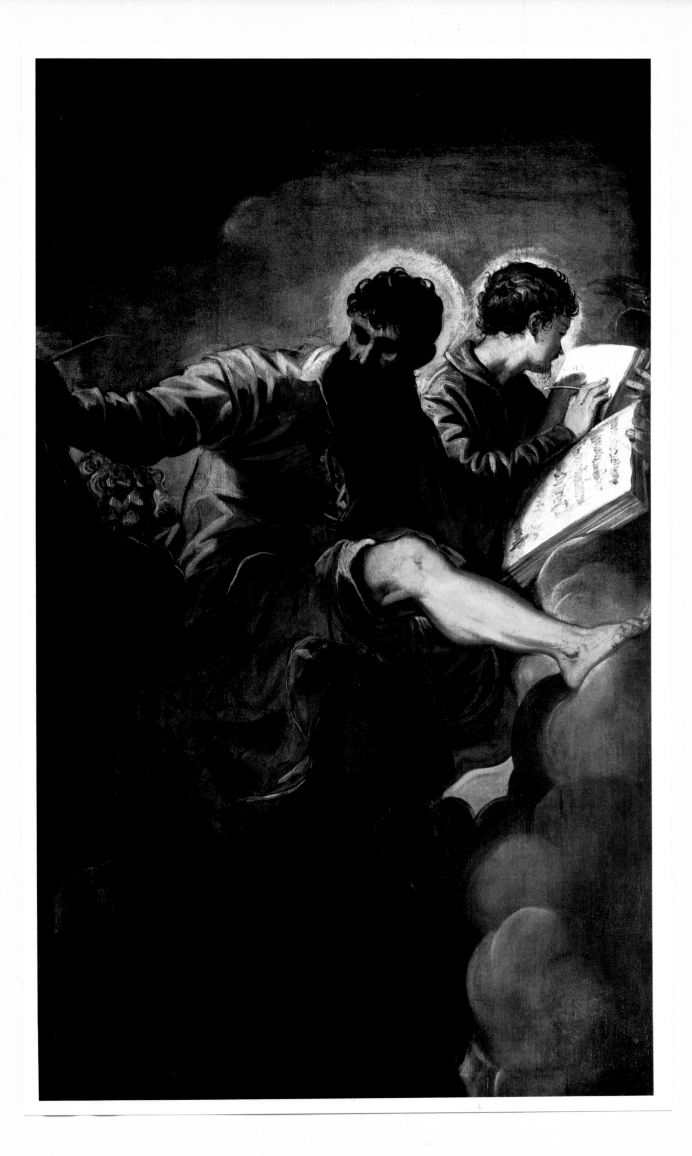

THE LAST SUPPER

c. 1559
Oil on canvas, 7' 3" × 13' 7"
San Trovaso, Venice

This version of a subject particularly favored by Tintoretto from early in his career was mentioned by Borghini in 1584 as being in the Cappella del Santissimo Sacramento (Chapel of the Holy Sacrament) together with a pendant, the *Washing of Feet* (fig. 44), now in London and perhaps removed in the first third of the seventeenth century since it was not cited by Ridolfi in 1642. Consonant in style with paintings from the end of the 1550s, both canvases can be dated to a few years after 1556, the year the chapel was built.

The composition is intensely dramatic. Interrupted in their repast by Jesus' prediction of his imminent betrayal by one among them, the Apostles are caught in gestures that reveal their dismay under the urgency of repressed feelings: one, anxious and unbelieving, leans toward the Master, another in utter consternation asks his neighbor if he has heard rightly, and yet another literally howls in rage, while one has actually fallen off his woven straw chair in the act of reaching for a flask of wine. The waves of agitation that sweep along the table are suddenly broken by the figure of Christ depicted in a mild and gentle manner. He is isolated from the tumult of human passions and even from the room itself by being placed immediately against the narrow entrance with its glimpse of a portico inundated with light that pours in and dispels the penumbra of the rustic interior.

To make the Gospel episode as plausible as any happening in his own time, the artist rendered the room and its furnishings in all their humble concreteness and even introduced a serving lad in contemporary dress. It may very well be the plain and unadorned quality of these realistically expressive figures—and those in comparable paintings by Tintoretto—as well as the direct rendering of the furnishings and foodstuffs, that Velázquez studied deeply during his visits to Venice.

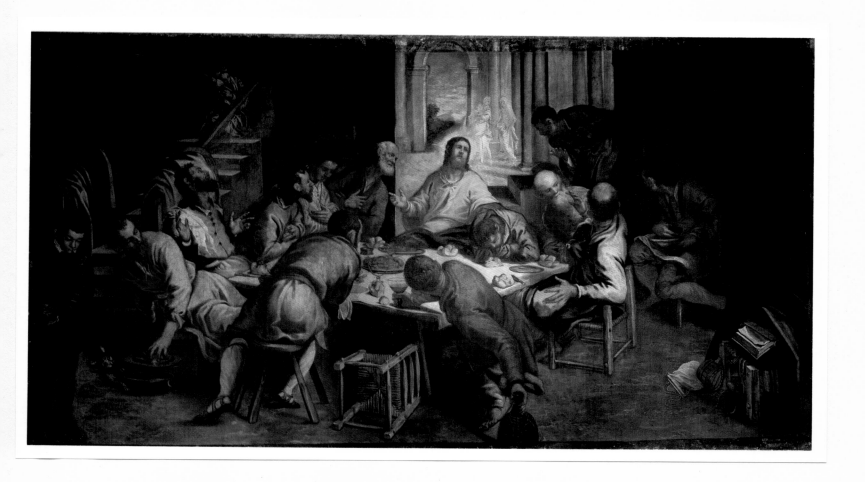

PORTRAIT OF A MAN IN GILDED ARMOR

c. 1560

Oil on canvas, 45 ½ × 38 ½"

Kunsthistorisches Museum, Vienna

This portrait too was listed in the inventory of 1659 of the collection of Archduke Leopold Wilhelm. The inscription ANOR XXX on the base of the column refers to the age of the man portrayed, and the picture can be dated about 1560 even if the form of the cuirass is more typical of the fashion in the early 1540s (see Ortwin Gamer, in *Jahrbuch der kunsthistorischen Sammlungen in Wien* 54 [1958], summarized in Rossi, 1974).

The youthful warrior strikes his pose in front of a window open on a marine view lit by the glow of sunset, which, however, scarcely touches the man himself. Instead he is strongly illuminated from above and from the left by an invisible source of light, conferring extraordinary relief to his face and armor, as it also does to the three columns in the background. Considering the characterization of the subject and the meticulously detailed armor with its richly gilded engraving, it is obvious that, as in similar portraits, the artist was striving for decorative effects—no doubt at the behest of the patron himself. The brave show of this likeness gives way in the background, beyond the window ledge, to the almost emotional lyricism of the bit of sea traversed by the red vessel propelled by oarsmen. The white sail of a small boat in the far distance also stands out in the atmospheric haze created by the soft light of a day drawing to its close.

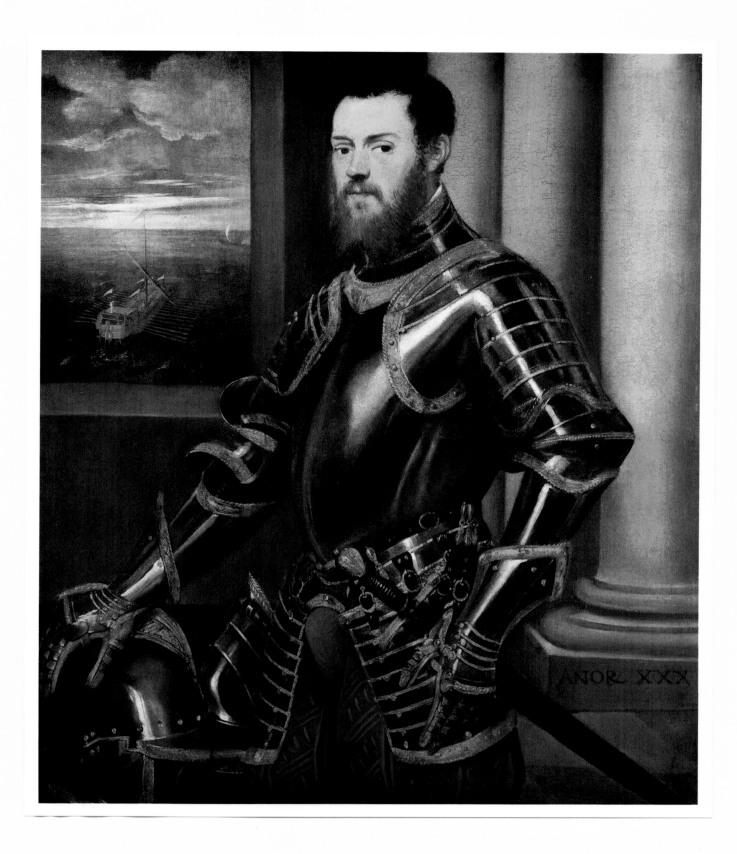

SAINT GEORGE RESCUING THE PRINCESS FROM THE DRAGON

c. 1560
Oil on canvas, 49½ × 39½"
National Gallery, London

First cited in 1648 by Ridolfi, who saw it in the house of the Venetian patrician family Correr, it was still there in 1660 when Boschini praised it in his native Venetian, the charm of which is so difficult to convey in English:

> *L'è un San Zorzi a cavalo bravo e forte,*
> *Che de ficon và con la lanza in resta,*
> *E amazza el Drago, e la Rezina resta*
> *Libera dal spavento e dala morte.*
> *Questo a Casa Corer fè corer tuti.*

> *(There is a Saint George on horseback brave and strong,*
> *Who plunges forward with lance in position,*
> *And slays the Dragon, and the Queen remains*
> *Free of fear and the threat of death.*
> *To see this in Casa Correr, the whole town comes running.)*

Far from easy to date, no doubt this small altarpiece is rightly placed by Cecil Gould (1975) at about 1560 because of its stylistic affinities with the works of the first half of the 1560s, in particular the large *Crucifixion* (colorplate 24) in the Scuola Grande di San Rocco.

The scene is extraordinarily forceful. The landscape itself is finely articulated by a succession of green outcroppings rising to the woods at the edge of the silvery green walls of a mysterious fortified city. The expanse of azure green sea shades off gradually toward the distant horizon cut off sharply by the vivid rosy gray sky inset with a flaming ellipse, in whose center can be discerned the faint image of God. Against the natural setting, woven in variations of a single tone, the deep blue and red of the garments of the princess stand out vividly, as in an arabesque, and these colors are echoed no less intensely in the cloak of the dead man on the ground and in the breeches of Saint George. Their vivid hues underscore the compositional treatment of the two protagonists: the princess on her knees in terror and enveloped in the ample sweep of her mantle, Saint George on horseback plunging against the winged dragon driven back to a last outjutting of land, all escape cut off. The dynamic tension of the two counterposed motions has a moment of pause in the center of the scene—in the beautiful youth whose half-naked body, arched back in the immobility of death, is a reminder of the dire peril from which the princess has been rescued (see fig. 85).

This small canvas is one of Tintoretto's most intense and fascinating paintings, particularly for the blazing ardor of the poetic fantasy which found its most expressive means in swiftness of execution.

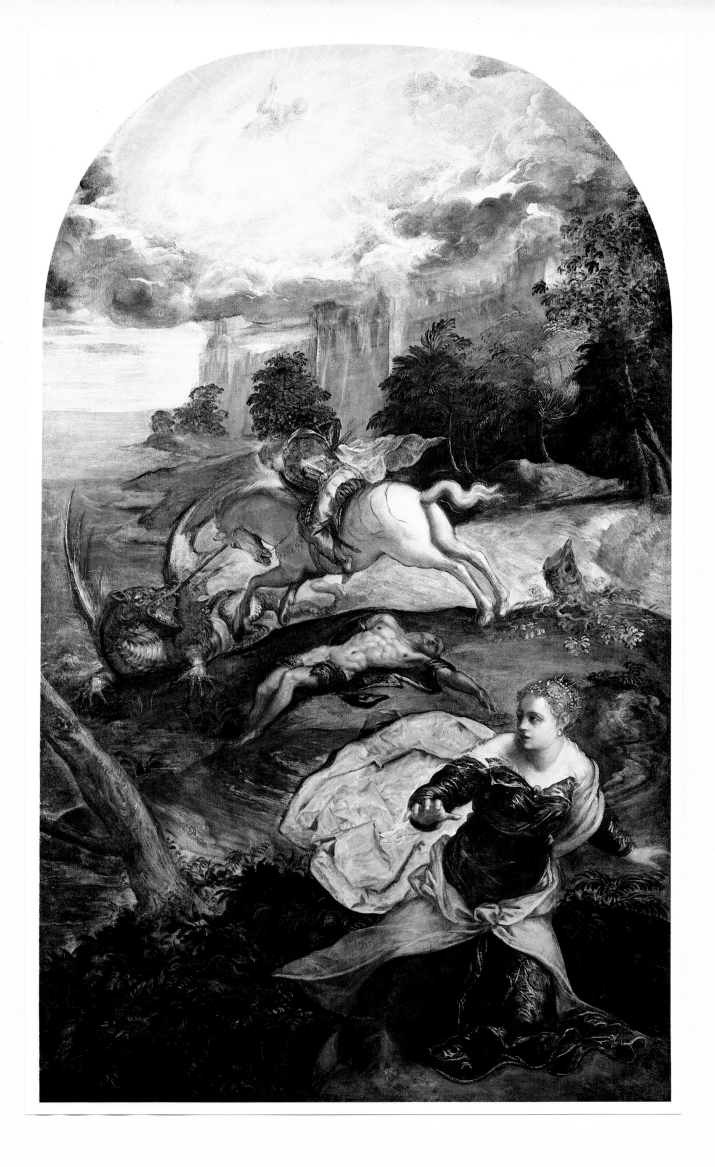

THE INVENTION OF THE CROSS

c. 1561

Oil on canvas, 7'6" × 16'8"

Santa Maria Mater Domini, Venice

Assigned by Thode in 1901 to the period immediately preceding 1545 and to the span of 1544 to 1547 by Bercken and Mayer in 1923, this is doubtless the vast canvas mentioned in the records of the Scuola del Santissimo Sacramento and in all likelihood painted for that confraternity in 1561, the year of its foundation (see Coletti, 1944). No evidence supports the notion of Wart Arslan (in *La Critica d'Arte* August [1937]) that the three superb portraits at the left were added years later. Nor is the conjectured trip to Rome justified simply on the basis of the repertory of Roman classical monuments depicted in the background. Tintoretto, a man stubbornly reluctant to leave Venice for any reason, had no need to travel abroad for information about classical architecture as long as he had Sebastiano Serlio as a fellow citizen, such a mine of erudition.

The architecture here, which serves as a theatrical backdrop, is explored by a calm light. The converging compositional lines emphasize the balanced rhythms of the central group and the bystanders on either side, both presented in an almost lengthwise frontal disposition. The central group is balanced by a progression of calibrated gestures and by shadows and transparent half lights. The individuals at the right are conceived with the subtle nobility of feminine images "dressed in such a way as to appear drawn from the antique," as Ridolfi put it in 1648, and they recall both the refinement of the figural models of Parmigianino and the formal elegance of Raphael. Behind the group at the left three passive onlookers, who show strong likenesses to members of the Scuola del Santissimo Sacramento, are rendered with a naturalness associated with the work of Jacopo Bassano.

SAINT ROCH IN GLORY

1564

Oil on canvas, 7'11" × 11'10"

Sala dell'Albergo, Scuola Grande di San Rocco, Venice

The handsome residence of the confraternity of the Scuola Grande di San Rocco was begun in 1517 and completed in 1550, but when it came to decorating the interior, the members refused the offer of Titian in 1553 to provide a large painting for the Sala dell'Albergo (the boardroom or main office on the upper story). Although the decoration of the spacious room was decreed as early as 1546, it was not until May 22, 1564, and then only after much equivocation and not unanimously, that the members decided to proceed at their own expense. Because some of the council members were unreservedly opposed to awarding the commission to Tintoretto, on May 31 it was agreed to advertise a competition for the central picture for the ceiling. Besides Tintoretto, the contestants included such formidable names as Giuseppe Salviati, Paolo Veronese, and Federico Zuccari. As Vasari told the story in 1568, while the other artists were working away at their drawings, Tintoretto checked the measurements of the area the picture would occupy and then proceeded to paint his canvas; even more audacious, he contrived to set it into the ceiling clandestinely on June 22, scarcely three weeks after the competition was first announced. His response to the pleas of the confraternity members that only a sketch by the artist had been requested, not a finished work, was that this was his way of designing and that "all designs and models for works should be of this sort so no one will be cheated." This was precisely his method when he then set to work on the entire decoration of the Scuola Grande, a task that would occupy him until 1588 and constitute the most salient episode of his own activity as well as one of the great achievements in the history of Venetian painting.

In this first canvas, with its orchestrated luminosity of colors shot through with the most refined iridescences, it seems that Tintoretto was out to prove himself fully as capable of sumptuous decoration as that rising star on the Venetian scene, Paolo Veronese. He was able to accomplish this without giving up his own vocabulary of startling foreshortenings, precipitous perspectives, expressive brushwork, and contrasting color harmonies, elements that would all be found also in his other paintings on the ceiling.

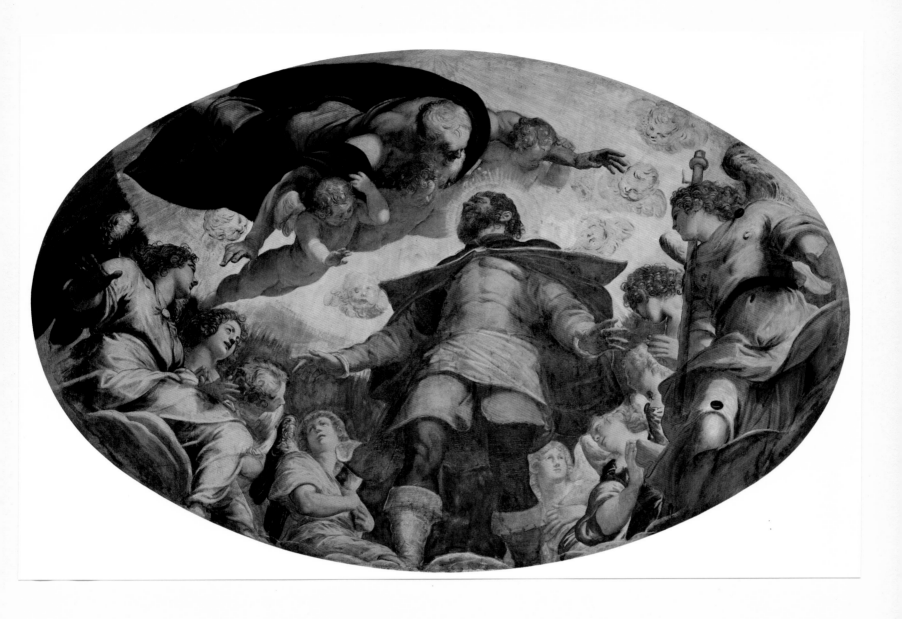

THE CRUCIFIXION

1565

Oil on canvas, 17′7″ × 40′4″
Sala dell'Albergo, Scuola Grande di San Rocco, Venice

An enormous canvas, the *Crucifixion* occupies the entire width of the rear wall of a room that is itself by no means small. The inscription at lower left, M · D · LXV/ TEMPORE MAGNIFICI/DOMINI HIERONYMI/ROTAE, ET COLLEGARVM/JACOBVS TINCTOREC/TVS FACEBAT, commemorates the fact that in scarcely more than a year the artist, now a member of the confraternity, maintained his pledge to decorate the hall by executing nothing less than his most prestigious painting.

The fulcrum of the immense human panorama is the crucified Christ in tragic solitude against a sky fraught with impending storm. He looms above the cluster of devoted mourners at the foot of the cross but also over the tumult of a great multitude articulated in groups according to precise structural tangents disposed radially and given exact orientation by the crosses of the two thieves. The light confers on the whole an unfathomable spatial perspective, making the groups of horsemen at the sides and the mourners in the center project from the surface of the painting as if in repoussé relief. Beneath a vivid light that is highly mobile in the swift changes of chiaroscuro, the color becomes heightened in iridescent effects and in harmonies that are now dense and warm, now cold and pallid, and that reach their fullest tonality in the group of mourners massed at the foot of the cross. There, amid the shades of pinks, whites, grays, and greens shot through with silver, vibrates the dark mantle of the woman straining toward Christ in an effort to receive his last words. Within the orchestrated interplay of lights and colors around the violently illuminated clearing, the spectators fluctuate in an incessant whirling motion, in concentric circles that seem to catch up and involve even those looking on from outside.

Here the imagination of Tintoretto so transcends the historical reality of the event as to bring into being a grandiose religious spectacle of profound emotional charge that sweeps us into it and makes us all participants in its tragedy.

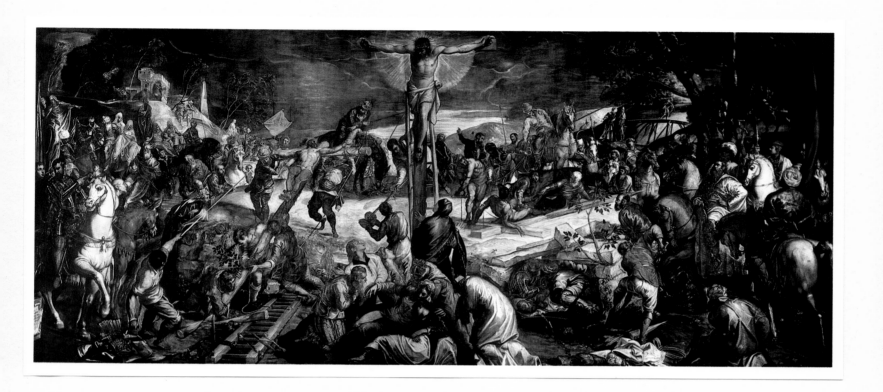

THE REMOVAL OF THE BODY OF SAINT MARK

1562–66

Oil on canvas, 13'1" × 10'4"
Gallerie dell'Accademia, Venice

Begun in 1547 with the *Miraculous Rescue of a Christian Slave by Saint Mark* (colorplate 6), the decoration of the meeting hall of the Scuola Grande di San Marco was resumed by Tintoretto in 1562 on the commission and at the expense of Tommaso Rangone da Ravenna, the grand guardian of the confraternity and an illustrious physician and philosopher. The three new paintings—the *Miraculous Rescue of a Shipwrecked Saracen by Saint Mark* (fig. 43), the *Finding of the Body of Saint Mark* (colorplate 26), and this most dramatic scene, the *Removal of the Body of Saint Mark*—were in the Scuola Grande for Vasari to see in 1566. Seven years later they were removed and, after being in the house of Rangone for less than a month, were returned to Tintoretto's studio. He pledged himself to complete them perfectly and to replace the portraits of Rangone with other figures, presumably because of some conflict within the confraternity. Eventually, however, the paintings were returned to the Scuola Grande without the slightest change having been made.

The most recent restoration, in 1958–59, brought to light elements of the composition, such as the pile of wood in the background, that had lain concealed under the nineteenth-century repaintings. This discovery once and for all dispelled any uncertainties about the subject of the picture, which for years—indeed up to the great Tintoretto exhibition of 1937, with its catalogue by Nino Barbantini—had been misread. Ridolfi described the scene incorrectly as showing the body of the saint being carried to their ship by the Venetian merchants Buono da Malamocco and Rustico da Torcello. Yet as early as 1660 Boschini read it rightly as the episode in the legend of the saint in which the Christians of Alexandria, taking advantage of a sudden storm, snatched the body from the pyre on which the pagans had planned to burn it.

The strikingly plastic group of Venetians around the body of the saint (whose shoulders are supported by Rangone himself) is counterpoised by the airy weightlessness of the architecture and of the infidels fleeing to shelter from the fury of the storm. The tension pervading the whole episode is accentuated by the vertiginous perspective. The converging arcades and the steep checkerboard pavement virtually drive the architectural backdrop—typical of the style of the architect Michele Sanmicheli—toward an unexplorable space illuminated by reddish gleams.

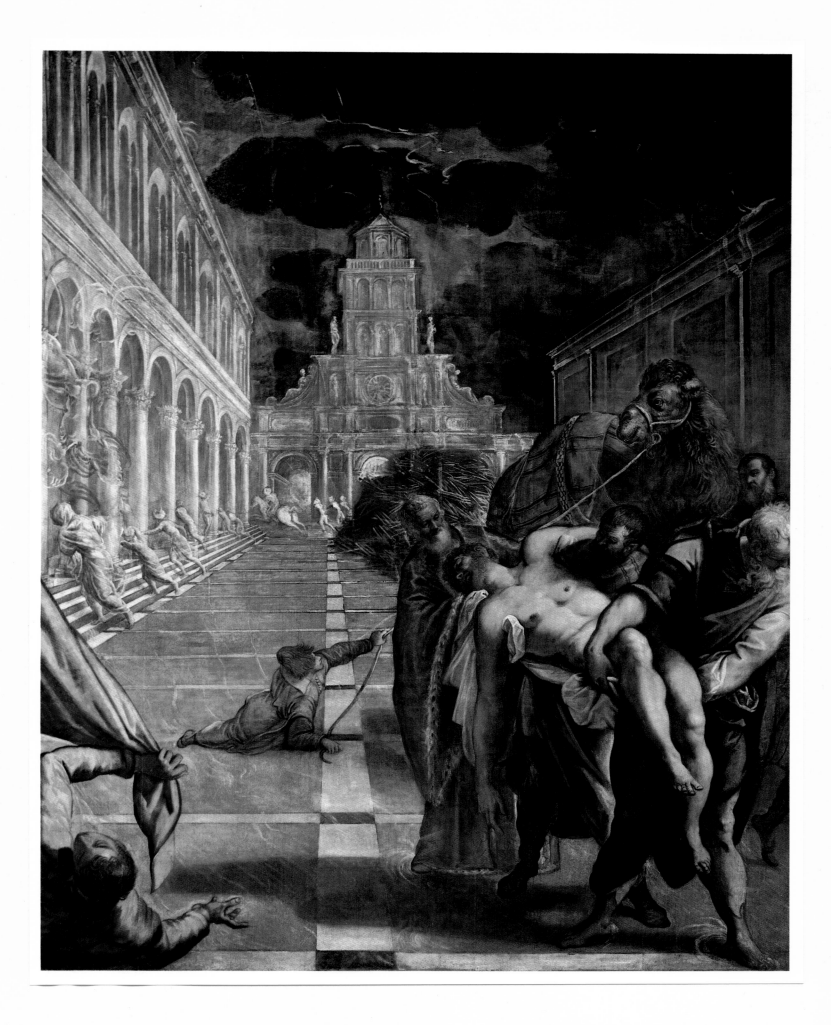

THE FINDING OF THE BODY OF SAINT MARK

1562–66

Oil on canvas, 13' 4" square
Pinacoteca di Brera, Milan

Removed to Milan's Pinacoteca di Brera in 1811, the canvas was spared the dire mistreatment endured by its pendants that remained in Venice (colorplate 25, fig. 43). Vasari, with characteristic acuteness, gave a thumbnail description of the picture: "In the fourth [of the four large narrative pictures], in which a man possessed by demons is being exorcised, [Tintoretto] invented a great loggia in perspective and in its farthest depth a fire that illuminates it with many reflections." Pinned down here are the two characteristic aspects of the large canvas and their mutual relationship: the fantastic play of light and the composition's dynamic interplay of space and perspective.

The elongated shadow-filled interior of the charnel house seems to reach infinitely toward the glare of the outdoor exit in the far distance. This effect is achieved through the obsessive insistence with which the light, in a rhythmic crescendo, conjures out of the dense gloom the arches of the vault, the projecting pilasters, and the suspended sarcophagi. No less audacious and rigorously consistent is the invention of the group of figures dominated by Saint Mark at the left, stretched to his full height in the double gesture of pointing to his own sepulcher and simultaneously curing the possessed man. At his feet is a cadaver whose elaborately foreshortened body is reminiscent of the ideas of Mantegna and also prophetic of those of Rembrandt.

Cutting through the gloomy shadows of the crypt, the light not only picks out the miraculous intervention of the saint but also synthesizes the many beautiful chromatic episodes: the orange and pale mauve of Mark's garments, the waxy pallor of the lifeless body laid out on the varicolored oriental carpet, the dark red of the senatorial robe of Tommaso Rangone, and the oranges, pinks, and off-greens of the agitated group around the possessed man and the assistant who holds up a candle to the designated sepulcher.

The overwhelming clarity of the narration—brought convincingly into their own times for Tintoretto's contemporaries by the presence of the grand guardian of the Scuola Grande—and its exploitation of the relationship of space and time, are in equal measure visionary and real.

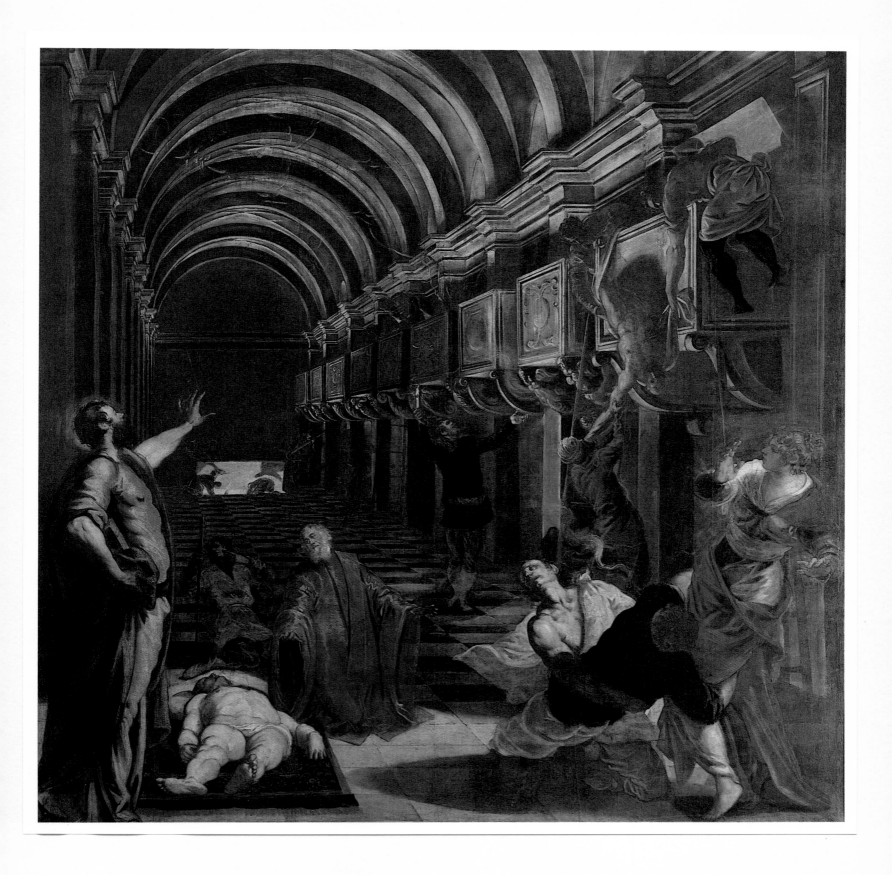

CHRIST IN THE HOUSE OF MARY AND MARTHA

c. 1567
Oil on canvas, 6'6" × 4'4"
Alte Pinakothek, Munich

This painting, signed at the lower left, is thought to have been made for the Dominican church in Augsburg from which it was acquired by the Alte Pinakothek in 1910. The central group of Christ, Martha, and Mary is concentrated into a firmly defined interlocking of gestures and of reactions both physical and spiritual.

The diversity of light sources divides the scene into three distinct episodes and intensifies the representation itself, which is completely natural in its treatment of persons and commonplace objects as well as in its range of colors. Mary—in appearance a sculpturesque figure against the greenish brown of Martha's garment—listens in fascination to Jesus seated in serpentine pose at a table covered in crimson velvet. The light that brings out every detail of Mary's sumptuous costume and rich jewelry also silhouettes Christ's highly mobile hands. Behind the animated discussion on the forestage of this broad interior, the shadows in the background are dissipated by the glow of a fire that illuminates the small figure of the serving maid and the copper and pewter kitchenware sparkling with tremulous reflections. Farther still in the background a patch of daylight clearly exposes the Apostles waiting outside the door, with a stand of tall trees behind them.

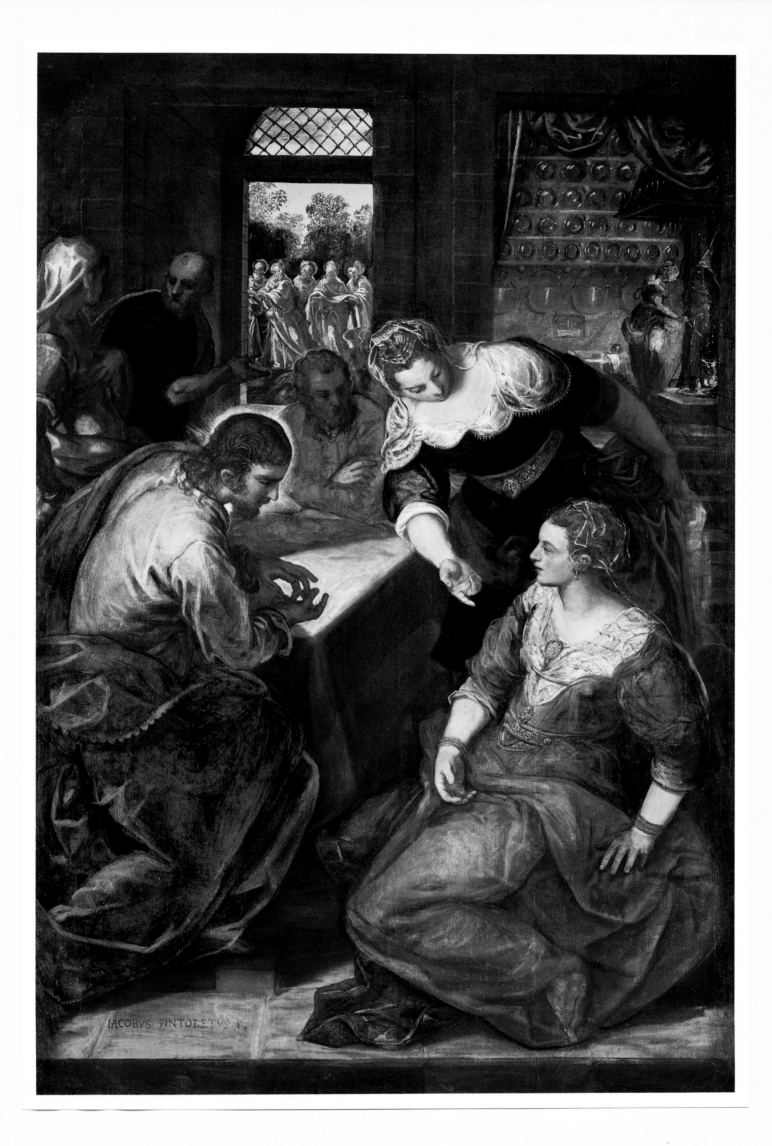

CHRIST BEFORE PILATE

1566–67

Oil on canvas, 16' 11" × 12' 6"

Sala dell'Albergo, Scuola Grande di San Rocco, Venice

In the two years after he completed the *Crucifixion* (colorplate 24) Tintoretto produced the other five paintings for the walls of the Sala dell'Albergo in the Scuola Grande di San Rocco. Throughout the years, *Christ Before Pilate* has been the most admired of these for its invention. In realizing his idea the painter to some extent kept in mind one engraving in the "Small Passion" series by Albrecht Dürer—clear evidence of how the graphic art of the German and Danube regions of the first half of the sixteenth century continued to fascinate the leaders of the Venetian variety of mannerism. Any borrowings from the northern painters are surpassed here in a mise-en-scène that takes its drama from the complex architecture, whose oppressive bulk fills most of a picture constructed in a mobile play of chiaroscuro expressed through sudden flares of light, harsh reflections, and deep wells of darkness. Emerging from this interplay of light and shadow, like a lucent sword blade, is the slender figure of Jesus, mild and defenseless in the face of the hypocritical decision of the bureaucratic Pilate, uncomfortable in his red garments within the gulf of shadow.

Perhaps borrowing the idea from Vittore Carpaccio's cycle on the life of Saint Ursula, Tintoretto introduced at the foot of the throne an aged scribe who diligently notes down every detail of the public hearing: the insistent questions of Pilate, the simple replies of Jesus, the menacing murmurs of the pitiless and irresponsible mob determined on the protagonist's death. Quite without conventional formulas of piety, the Gospel message is presented in the integrity of its profound idealism: the dignity of the Christ in subordinating his own concerns to the moral duty he has taken on for all mankind. This statement of Christian piety also pervades the final paintings in this Passion cycle, the *Ascent to Calvary* and the *Ecce Homo* (figs. 47, 48).

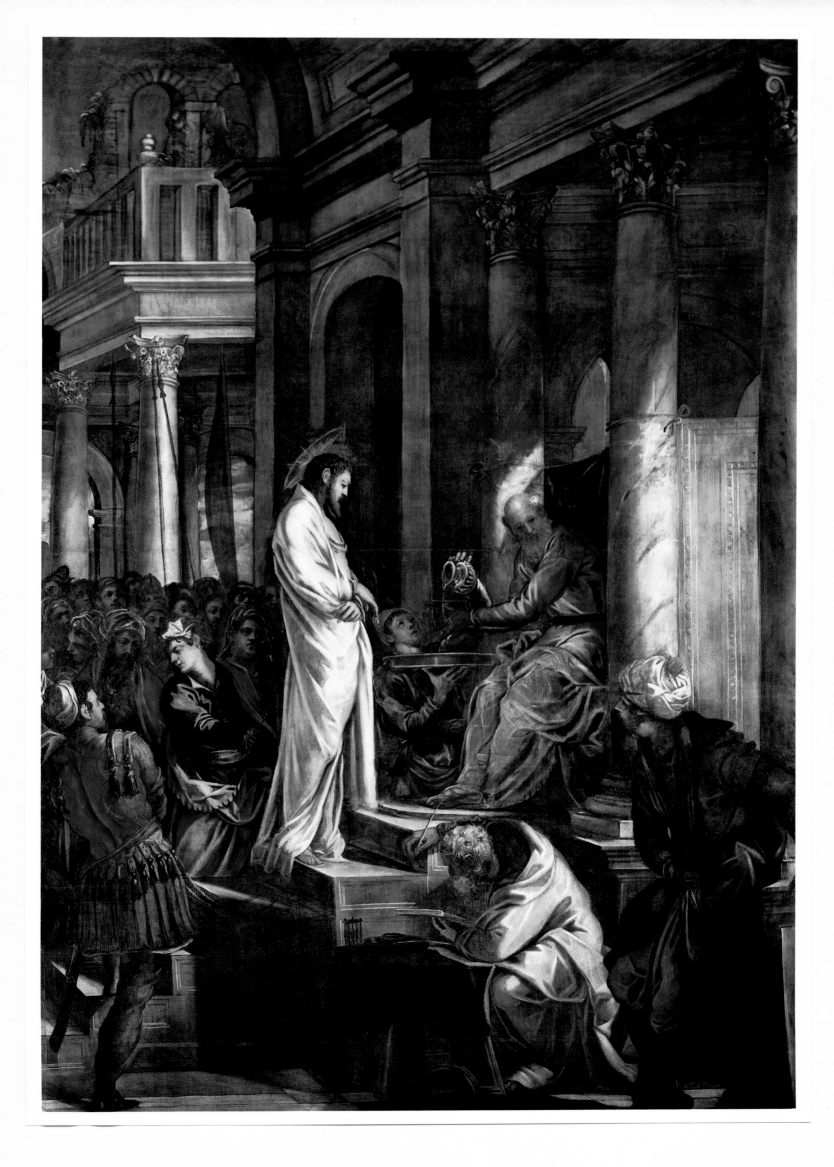

A PHILOSOPHER

1571–72

Oil on canvas, 8' 2" × 5' 3"
Libreria Sansoviniana, Venice

As Ridolfi tells it: although Jacopo Sansovino himself had invited Tintoretto to participate in the decoration of the Libreria Vecchia on the Piazzetta San Marco, Tintoretto was deliberately excluded from the group of painters whom Titian chose to decorate the main hall of the library in 1556–57—such men as Andrea Schiavone, Giuseppe Salviati, Paolo Veronese, and Giambattista Zelotti. Later, probably in 1571 (the date of a first payment), Tintoretto was entrusted with painting nine *Philosophers* for the hall; he must have completed them the following year since the final payment was effected on August 14, 1572. Of these and a further three mentioned by Borghini in 1584 only five can now be identified as autograph, but all are fascinating for their refined linear treatment with its overt mannerist intonation.

This philosopher, in an orange cloak with yellow highlights, emerges from a niche so shallow as scarcely to contain him, and the structure of the body stretches out in an improbable elongated rhythm that comes to a stop only in the disheveled hair and beard. This mannerist rendering of the proportions of the body is further emphasized by the shadow on the left-hand pilaster of the niche, which adds an extraordinary immediacy to the image.

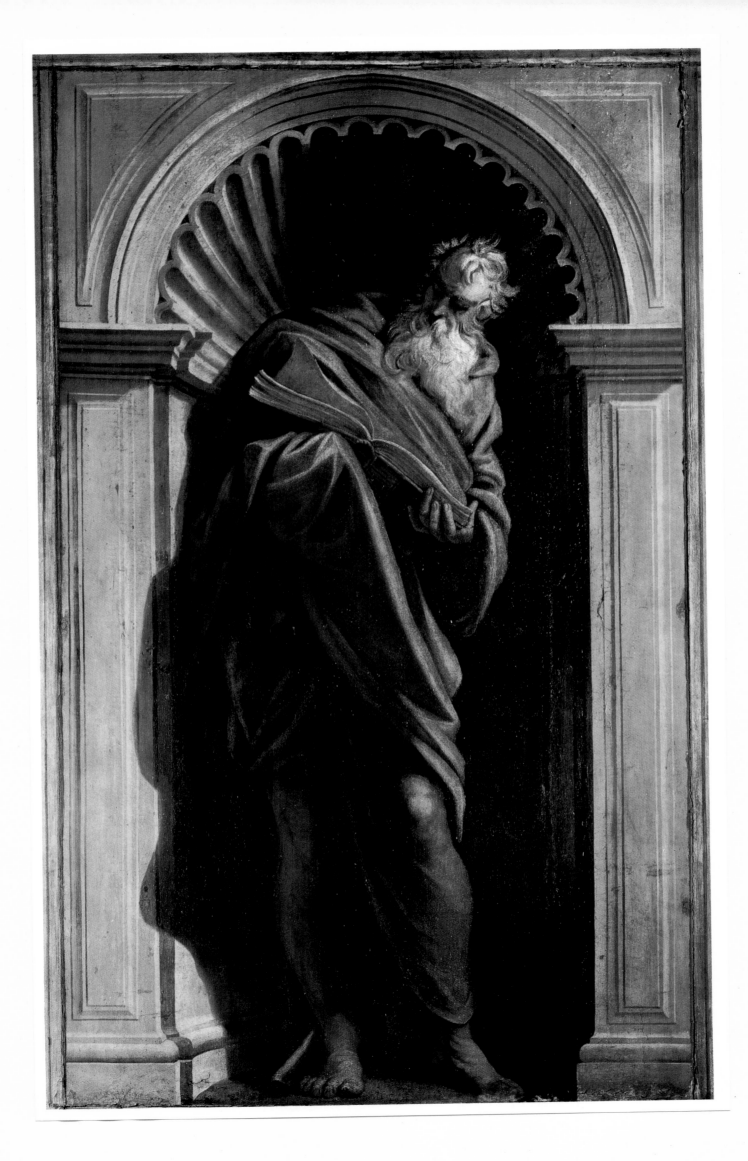

THE RAISING OF THE BRAZEN SERPENT

1575–76
Oil on canvas, 27'7" × 17'1"
Sala Grande, Scuola Grande di San Rocco, Venice

The years between 1575 and 1578 were largely taken up for Tintoretto with the execution of ceiling paintings on Old Testament subjects for the Sala Grande—the very large upstairs meeting hall—of the Scuola Grande di San Rocco (fig. 56). Begun in 1575, the grandiose central *Raising of the Brazen Serpent* was inaugurated on August 16, 1576, feast day of the patron saint of the confraternity. In January of the following year the artist offered to do the other two major canvases, *Moses Striking Water from a Rock* (colorplate 31) and the *Gathering of Manna*, and at the end of March of that year to see to the rest of the ceiling, which meant no fewer than ten large ovals and eight grisailles. For payment he agreed to abide by whatever the administrators of the confraternity might decide, asking nothing more for himself than to have his canvas and paints paid for.

According to Charles De Tolnay (1960), who expanded a study by Henry Thode (1904), this central canvas on the ceiling provides the keynote for the grandiose iconographical program governing all the paintings in the Scuola Grande (see fig. 57), whose basis is faith in Christ as the liberator from all spiritual ills. As Rudolf Berliner (1920) showed, it was during the course of the work that the entire program itself became clearer to Tintoretto, who could avail himself too of the advice and assistance of certain learned members of the confraternity. Essentially its underlying theme is the interaction between the continuity of the Old and New Testaments and the charitable aims of the confraternity.

In this painting there is clear allusion to the sufferers given aid and succor by the Scuola Grande, with an explicit visualization of the passage in the Gospel of John on the relation between the Old Testament event and the redemption of humanity through the Crucifixion of Christ: "And as Moses lifted up the serpent in the wilderness, even so must the Son of man be lifted up: That whosoever believeth in him should not perish, but have eternal life" (John 3:14–15). The whirlwind of angels attending the figure of the Eternal seem almost a wedge driving into the tangled swarm of humans and serpents, while on the hilltop at the left Moses gestures toward the cross that supports the brazen serpent. It is a grand conception worthy of Michelangelo, and, combined with the sculpturesque relief of its forms, the painting holds an extraordinary illustrative power, clear in its content of Christian piety and alleviation of human suffering. With this conception, which is no less majestic than that of his colossal *Last Judgment* (fig. 42) of a decade earlier, the Christian subjects favored by the Middle Ages and the Renaissance took on new form through the visionary fantasy of Tintoretto.

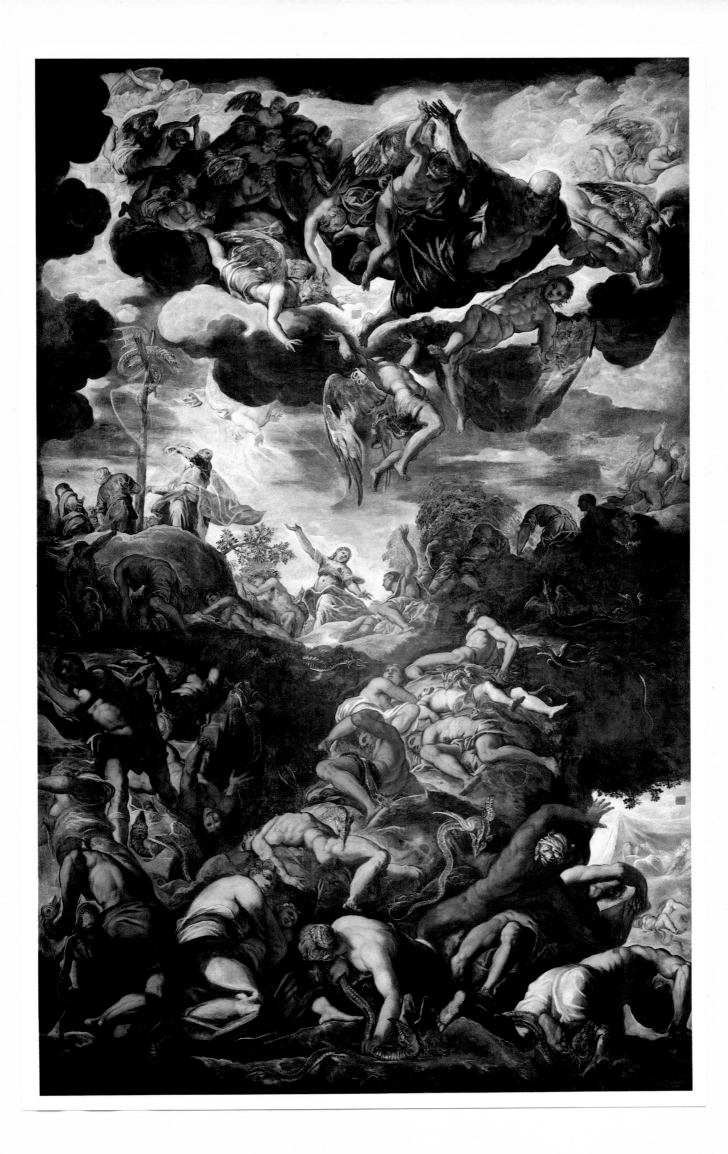

MOSES STRIKING WATER FROM A ROCK

1577
Oil on canvas, 18'1" × 17'1"
Sala Grande, Scuola Grande di San Rocco, Venice

In the later 1570s Tintoretto was so thoroughly caught up in his ideas for the Scuola Grande di San Rocco and in the ways of realizing them that increasingly he put off his other tasks for the Doges' Palace and various Venetian churches. He completed the central canvas for the ceiling of the upper hall in August 1576, and at the beginning of 1577 he went ahead with the pictures to go at either end of it.

In this one, clearly allusive to the commitment of the confraternity to relieve the thirst of the poor, De Tolnay (1960) has remarked how in pose and attire Moses recalls the figure of Christ and that the water gushing from the rock symbolizes the blood spurting from the side of the Saviour on the cross. No less coherent in inventive rigor than its immense companion, the *Raising of the Brazen Serpent* (colorplate 30), this composition is fraught with drama in the choral disposition of the masses. As in that work, the light here also takes on the role of protagonist, forcing all other formal values to subservience by a passionate imaginativeness, reworking them in a continual decomposition and recomposition into effects of scenographic grandeur, aided by the powerful dialectic of chiaroscuro.

The central image—Moses striking a rock in the desert, which causes water to spring forth—is prepared for on the right by the apparition of the Eternal astride a storm cloud within an enveloping bubble of air. It is delimited at the rear by the vision of an encampment through which sweeps a warrior on horseback. All pictorial elements within the excited rhythms of the composition contribute to the impression of an incessant rotatory motion of the crowd within a dilated space whose fulcrum, solid as a rock, remains Moses, framed against the light in his carmine mantle beneath the crystalline jet of the spring.

What Tintoretto's vibrant fantasy had done with the physical appearances of reality was not appreciated by some of the confraternity members. Nor, even less, would it have been understood by Vasari, who almost ten years earlier, in 1568, had observed of the *Last Judgment* (fig. 42) that "if that capricious invention had been carried through with correct and regular draftsmanship and if the painter had attended with as much diligence to the parts and particulars as he did to the whole, expressing the confusion, disorder, and terror of that event, it would have been a most stupendous picture." Such reservations stemming from Tintoretto's rapidity of invention and swiftness in execution have recurred again and again since then, even as recently as 1946 with such a scholar as Roberto Longhi.

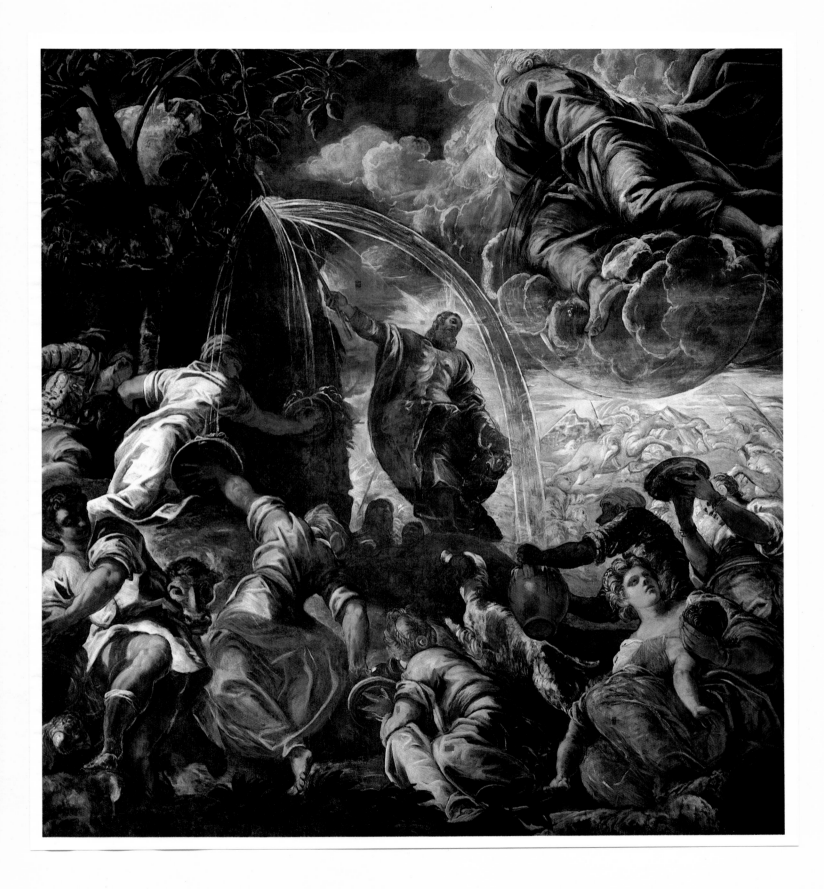

BACCHUS AND ARIADNE WITH VENUS

1577–78
Oil on canvas, 4'10" × 5'6"
Anticollegio, Palazzo Ducale, Venice

This and three other paintings—*Vulcan and the Cyclopes* (colorplate 33), *Mercury and the Three Graces* (fig. 54), and *Minerva Driving Back Mars* (fig. 55)—originally adorned the walls of the Atrio Quadrato in the Doges' Palace, a square antechamber where persons of note waited their turn to be presented to the senators or the members of the Collegio. In 1716 the paintings were shifted to an antechamber nearby, the so-called Anticollegio.

As for their dating, in 1577 Tintoretto requested the payment due to him, but it was not until November 10, 1578, that he was finally given 217 ducats, 1 lira, and 16 soldi, and then only after Paolo Veronese and Palma Giovane had made a valuation of the four canvases on July 26 at the request of the Provveditori del Sale, the officials in charge of salt provisions. The significance of these mythological pictures—the general theme of which was concord, according to the November 10 document—has been further extended by De Tolnay (1963). Considering these paintings together with the painted ceiling (fig. 46) of their original home in the Atrio Quadrato, he has read them as allegories of the seasons connected with the political aims of Doge Girolamo Priuli, constituting a cosmological vision of the birth of Venice and Priuli's capacities for governing the state. In this painting, alluding to autumn (Bacchus) and water (Ariadne), what is symbolized is the wedding of Venice with the Adriatic Sea, traditionally commemorated every year on Ascension Day with a spectacular symbolic ceremony.

Liberated in 1978 from the overlays of yellowish varnishes and numerous repaintings, the pictorial treatment clearly shows the care that the artist lavished on this mythological subject. The figures are disposed in elegant and supple rhythms by means of curves that make a kind of round dance of nude members that has as its focal point the three hands in the center. Something quite rare for the artist, in this painting he offered an image of sensual beauty in the limpid flesh tones, reflecting the diffuse luminosity of the expanse of water traversed by a ship barely glimpsed in the October haze so familiar on the Adriatic.

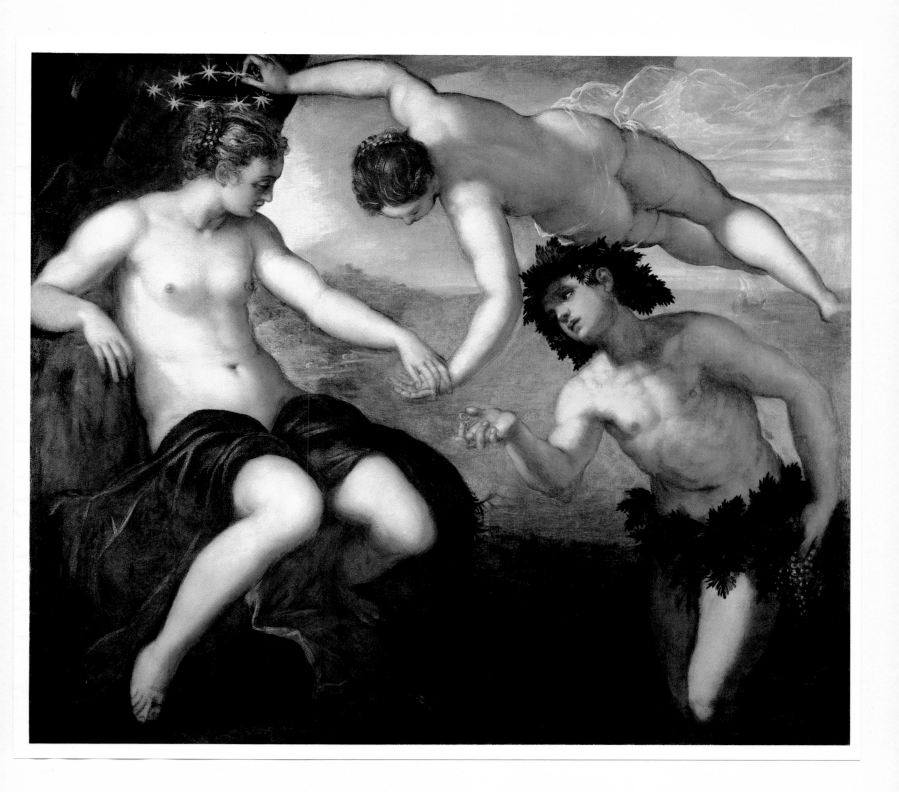

VULCAN AND THE CYCLOPES

1577–78
Oil on canvas, 4'9" × 5'1½"
Anticollegio, Palazzo Ducale, Venice

After Francesco Sansovino (1581), Ridolfi also attempted to clarify the inner meanings of the four mythological allegories originally painted for the Atrio Quadrato, explaining that in this painting the cooperative efforts of Vulcan and the Cyclopes around the anvil symbolize the "union of the Venetian senators in the administration of the Republic." For De Tolnay (1963) the snow on the mountains and the flaming volcano are allusions respectively to the season of winter and the element of fire. The exact interpretation of its subject aside, admirable too is the high quality of the composition, which unfurls in linear rhythms that cut across each other along parallel diagonals. Quite unlike the *Bacchus and Ariadne with Venus* (colorplate 32), these figures are treated in foreshortenings that vibrate with a nervous and tense draftsmanship. The Cyclops viewed from the rear virtually projects out of the picture plane. The impression of uninterrupted movement is accentuated by the sudden flaring up of the azure, orange, carmine, and white of the loincloths within a color range otherwise restricted to the uniform registers of the amber yellow of the flesh and the pale greens and blues of the landscape. With great subtlety of pictorial invention the artist has caught the reflections of light on the breastplates and pieces of armor scattered on the ground.

The treatment of color in the four mythological paintings for the Atrio Quadrato only apparently recalls that of Paolo Veronese. Whereas Veronese was loath to indulge in any play with light, instead steeping his entire chromatic range in an internal luminosity, Tintoretto stakes everything on the dynamic exploitation of light, making it glide and refract in scintillation along the surfaces of his colors.

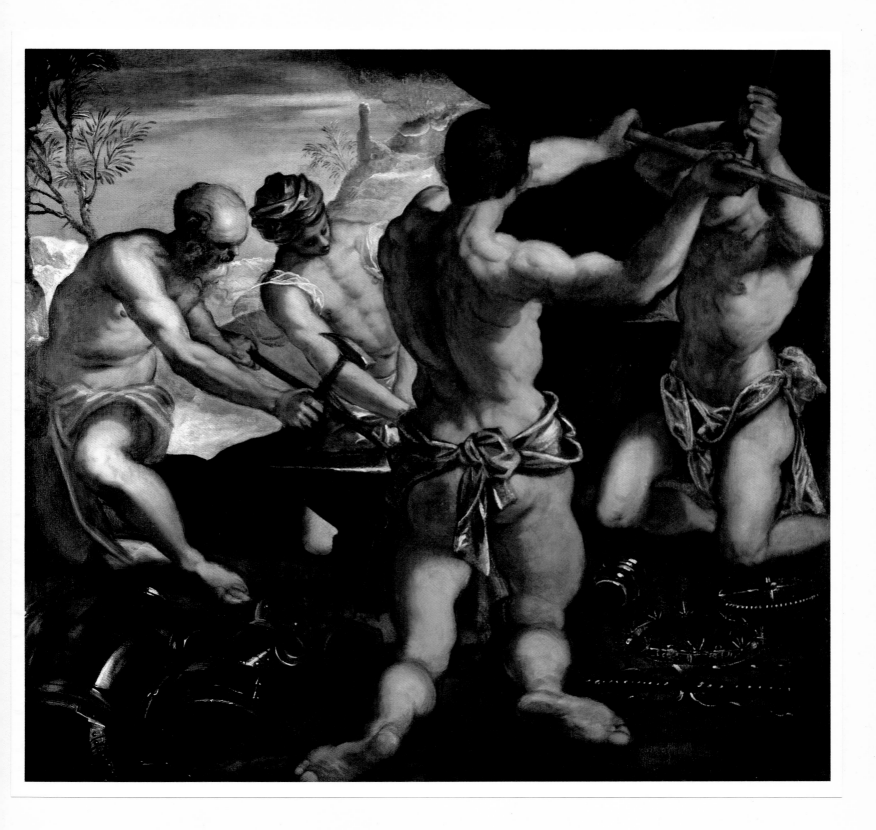

ELIJAH FED BY THE ANGEL

1577–78
Oil on canvas, 12'2" × 8'8"
Sala Grande, Scuola Grande di San Rocco, Venice

At the altar end of the Sala Grande in the Scuola Grande di San Rocco (see fig. 57) the oval pictures of Elisha and Elijah on either side of the ceiling (thus flanking the large *Gathering of Manna*) as well as the two corner paintings on the walls below—the *Multiplication of the Loaves and Fishes* (fig. 60) and the *Last Supper* (colorplate 41)—have as their common theme the spiritual bread of the Eucharist. At the same time they refer to the obligation of the confraternity members to relieve the hunger of the poor. Perhaps the most memorable oval is this *Elijah Fed by the Angel*, for its felicitous invention and its intensely lyrical color. From the left the divine winged messenger—for which a preparatory drawing exists (fig. 92)—sweeps down as if shot from a bow toward the sleeping Elijah huddled on the ground. Here the emotional charge is entrusted to the movement and disposition of the bodies rather than to facial expressions, both faces being half-concealed though possessed of a certain subtle intimacy. The expressive quality of the composition is heightened by the contrast between the deep tonalities of the bright-red garment of the Prophet, the dark-green landscape around him, and the varied combinations of colors in the tunic and wings of the angel pervaded with pearly reflections. The two figures are compressed with difficulty into the shape of the oval, whose form indeed helps to determine theirs. Despite the monumentality of the figures, the refined gamut of colors and their reflections confer on the scene a memorable impression of resigned surrender to the divine will. This presentation is wholly in accord with the biblical passage that recounts Elijah's journey to Horeb: "And as he lay and slept under a juniper tree, behold, then an angel touched him, and said unto him, Arise *and* eat" (I Kings 19:5).

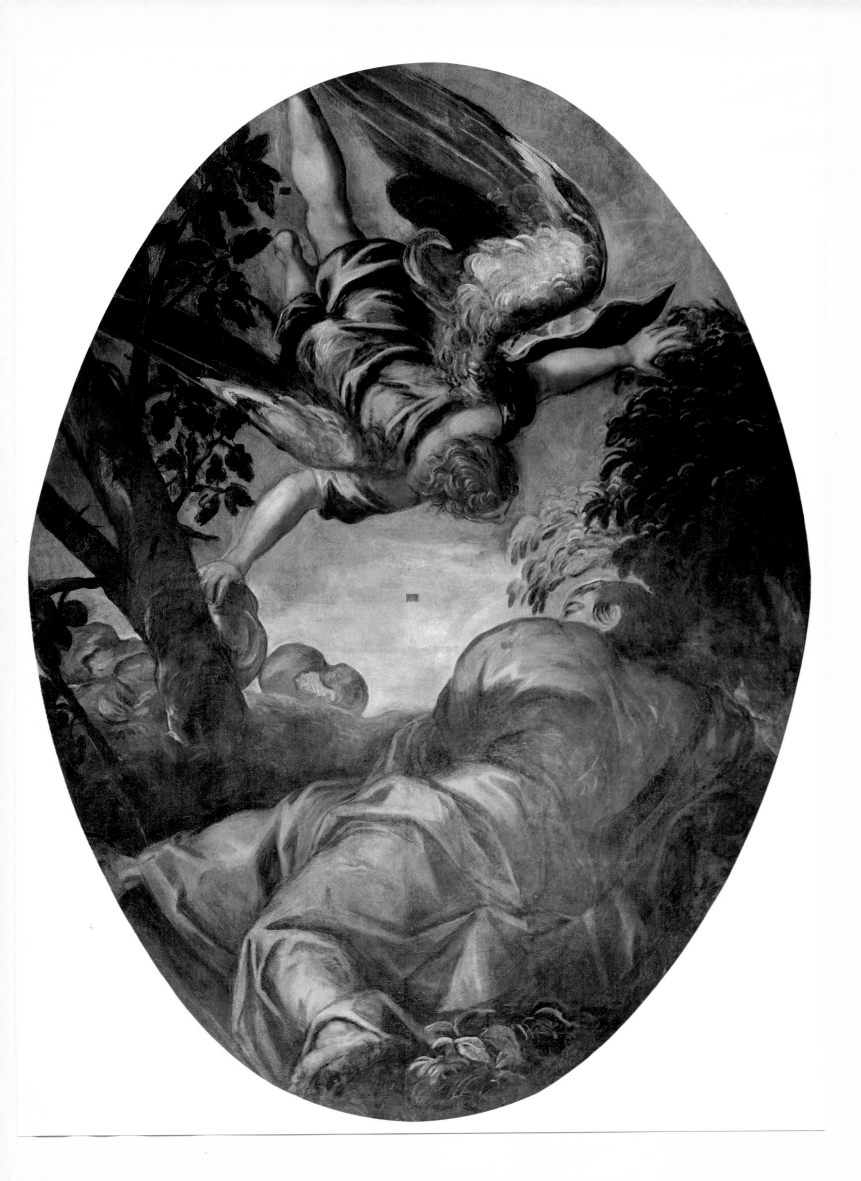

PORTRAIT OF A MAN

c. 1578

Oil on canvas, 23 ¼ × 17 ¾"

Gemäldegalerie, Staatliche Museen Preussischer Kulturbesitz, Berlin–Dahlem

It has been suggested that the subject of this portrait may be Giovanni Mocenigo because the face resembles that person (there younger in age) in the *Madonna Adored by Doge Alvise Mocenigo and His Family* (The National Gallery of Art, Washington, D.C.) as well as the older man in *Doge Alvise Mocenigo Presented by Saint Mark to the Redeemer* (fig. 64) in the Doges' Palace.

Here the old man, in almost three-quarter profile, directs a sharp and unflinching gaze that seems to engage the viewer in immediate dialogue. The pictorial elements are sketched with admirable concision. The dark-colored garment and mantle are simple statements about social position, but the painter dwells more closely on the face, in which no concessions are made to the ravages of age: bloodless lips, thinning hair and beard, ears wrinkled as parchment, skin so dry and tightly stretched that the cheekbones and pulsing veins stand out dramatically. Each facial plane has its part in the realistic rendering of character, and this due especially to the synthesis brought about by the play of light. While Titian constructed his late portraits by breaking down forms into pure entities of color and light, conferring on them something of his own nostalgia for the past, Tintoretto continued to seek out individual physical and psychological traits in his sitters. He found the most congenial means of expressing these through a luminism that anticipated that of Rembrandt.

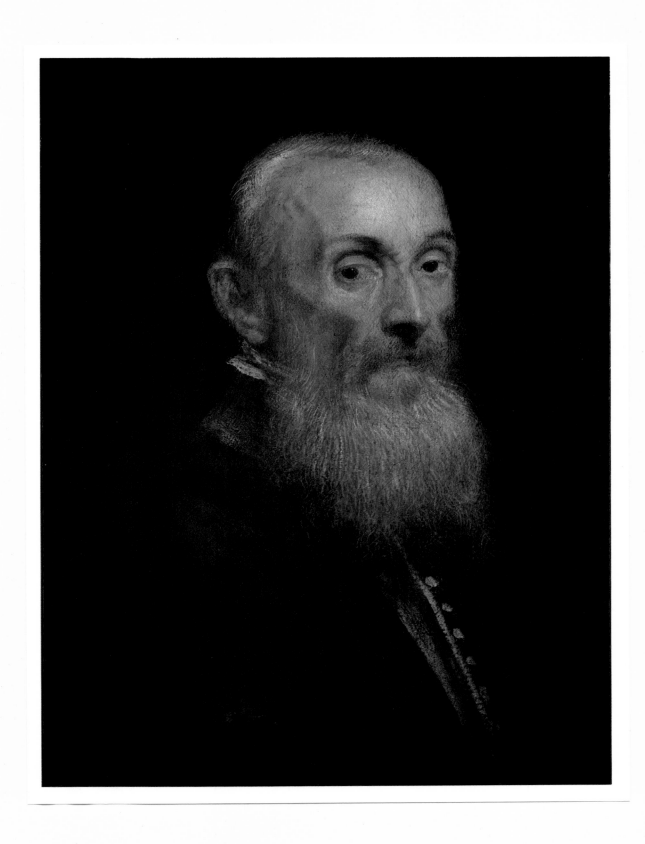

THE CAPTURE OF PARMA

1579–80

Oil on canvas, 7' × 9'1"
Alte Pinakothek, Munich

For the court of Mantua Tintoretto produced two cycles of four canvases each, cele-brating the deeds and great men of the Gonzaga family. The series was known as the *"Fasti gonzagheschi"* (best rendered, perhaps, as "Deeds of the Gonzaga"). The first cycle was commissioned by Duke Guglielmo Gonzaga in 1579 to adorn the chief apartment of his Mantuan castle; the second was ordered by Count Teodoro Sangiorgio, a Mantuan nobleman, on October 1 of that year, the date on the count's letter of commission to Monsignor Paolo Moro, Duke Guglielmo's representative in Venice. The second cycle of four paintings were to depict certain outstanding deeds of Duke Federico Gonzaga as pre-cisely specified in the commission, and were to be delivered by December 25, 1579. Tin-toretto, however, did not complete them until May 1580 (fig. 67), and the following Sep-tember, at the invitation of the duke, he traveled with his wife to Mantua to supervise the placing of the paintings (see Eikemeier, 1969).

Even if the intervention of the workshop is all too evident in the sometimes opaque and hasty realization of the paintings in both series, Tintoretto was responsible for the com-plete conception, including the details, working them out in numerous drawings of indi-vidual figures (figs. 93, 94). In all particulars he conformed strictly to the historical guide-lines laid down in the commission.

Among the most fascinating of the *"Fasti gonzagheschi"* is this painting illustrating the capture of Parma in 1520. The forestage is articulated by the large figure of the warrior in gleaming armor and by the horseman thrown to the ground, reminiscent of the sublime ideas of El Greco. Just behind, reaching to the upper-right corner, the virtually heraldic form of Duke Federico on his battle steed makes the rear distances seem even more remote as the swarms of besiegers march on the walls of Parma in ever more compact ranks and clamber up fantastically tall ladders to overtake the city. The foreplanes are firm and static; yet in the grandiose panorama of the assault on the city the composition acquires an excite-ment of exaggerated rhythms. These agitated rhythms are repeated and follow swiftly one on the other; feverishly oppressive, they convey the grievous significance of inevitable atrocity attendant on any warlike action.

THE BAPTISM OF CHRIST

c. 1580
Oil on canvas, 9'3" × 5'4"
San Silvestro, Venice

When the interior of San Silvestro was rebuilt about 1840, this painting (cited by Borghini in 1584) was added to on all four sides and "retouched" to fit above a new altar. Restored in 1937 to its original dimensions and liberated from the crude repainting, it proved to be one of the most poetic of its artist's later works.

Preparatory drawings exist for the two figures (fig. 96), but it was in their translation into paint that the imagination of Tintoretto became clarified in all its lyrical force. The Baptist in inky shadow and the Christ in full light take their places in an impressive landscape surrounding the slow-moving waters of the Jordan. The two bodies, stark and massive in the immediate foreground and calibrated in the accentuated diagonals of their poses and gestures, echo the silvery reflections of the gray-green tonalities of the wooded setting. The pervading moistness is almost palpable.

Here, as in other works painted by Tintoretto directly after Titian had died, he drew closer to the world of that master. But the chromatic magic of the late Titian, in which light exalts color to join in one cosmic vision of man and nature, was something forever alien to Tintoretto. He was inclined to give more importance to colors of local value, subordinated first to the plastic consistency of his images and then to their luministic rendering, thereby endowing his inventions with essentially narrative significances quite beyond academic conventions in the approach to subject matter.

Much of the fascinating concentration of image in this unusual creation is missing in a version of the theme now in the Cleveland Museum of Art, done at the same time but enhanced, for better or worse, by the addition of two angels at one side and one in the center; this painting was in large part due to the workshop. There are three more versions—in the Prado, and in the churches of San Pietro Martire in Murano and of San Giorgio in Braida in Verona—all entirely the work of Tintoretto's assistants.

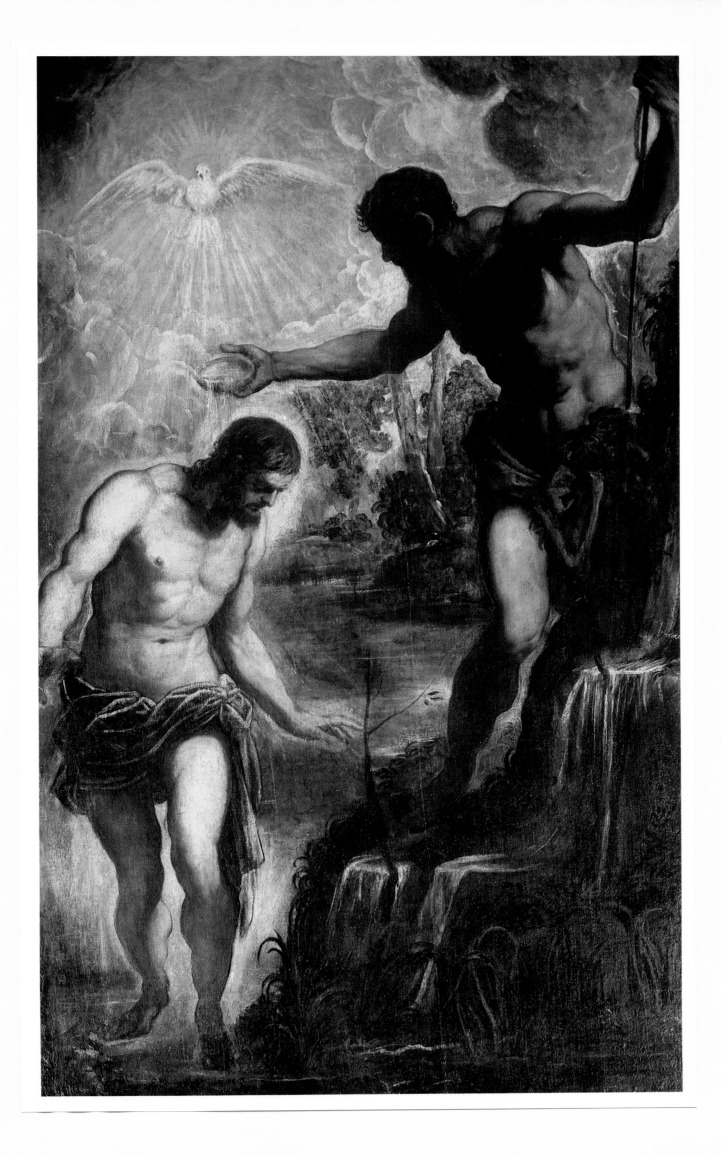

THE ORIGIN OF THE MILKY WAY

c. 1580

Oil on canvas, 4'10" × 5'5"
National Gallery, London

In 1640 Ridolfi mentions this picture among the set of four mythological subjects that Tintoretto painted for Rudolf II of Hapsburg, Holy Roman Emperor since 1576, which perhaps were ordered through the good offices of Ottavio Strada, the celebrated Venetian antiquary portrayed by both Titian and Tintoretto. As we know from two drawings—one probably by Domenico Tintoretto (Accademia, Venice), the other by Joris Hoefnagel (Kupferstichkabinett, Staatliche Museen, Berlin–Dahlem)—there was originally an entire section at the bottom of this painting in which a nude woman was stretched out among lilies. Klára Garas (*Bulletin du Musée Hongrois des Beaux-Arts* 30 [1967]) has suggested that the composition was apparently inspired by a passage in the epic *Ercole* of Giovanni Battista Giraldi, published in Modena in 1557. According to Giraldi's narration, Jupiter attempted to guarantee the immortality of the son he had by the mortal Alcmene by holding up the infant Hercules to drink from the breast of the sleeping Juno, who, waking suddenly, instead spilled her milk in two streams, one giving rise to the Milky Way in the heavens and the other to lilies on the earth.

Later in date than the four mythological pictures for the Atrio Quadrato in the Doges' Palace (colorplates 32, 33, figs. 54, 55), this profane subject still has all the refinement of their compositional invention and the transparency of their colors. The subtle intellectual implications of the subject and its various details seem to have stimulated the artist to a more controlled taste in form and to a use of color still akin to that of Veronese.

Along the curving horizon of the earth the beautiful and seemingly weightless Juno starts up from her bed on a cloud. Her naked flesh changes color under the transparent shadows and impalpable reflections, which also lend their varying tints to the hovering figure of Jupiter, to the winged cherubs around her, and to the birds that are the gods' attributes. The whole array of images appears to be inlaid in the azure of a sky pierced by the new stars. Rarely did Tintoretto sing so wholeheartedly of the enchantments of pagan felicity.

A work of the highest quality, the painting simply cannot be attributed to Domenico Tintoretto as Hans Tietze implied in 1948, nor can it be included among Tintoretto's youthful works as Henry Thode in 1901 would have it. It has an undeniable affinity of conception and style with works from the end of the 1570s, not only with the four mythological pictures for the Atrio Quadrato but also with the now-destroyed *Luna and the Hours* (fig. 68) that was painted about 1580 for the hall of the Fondaco dei Tedeschi, the German trading center in Venice.

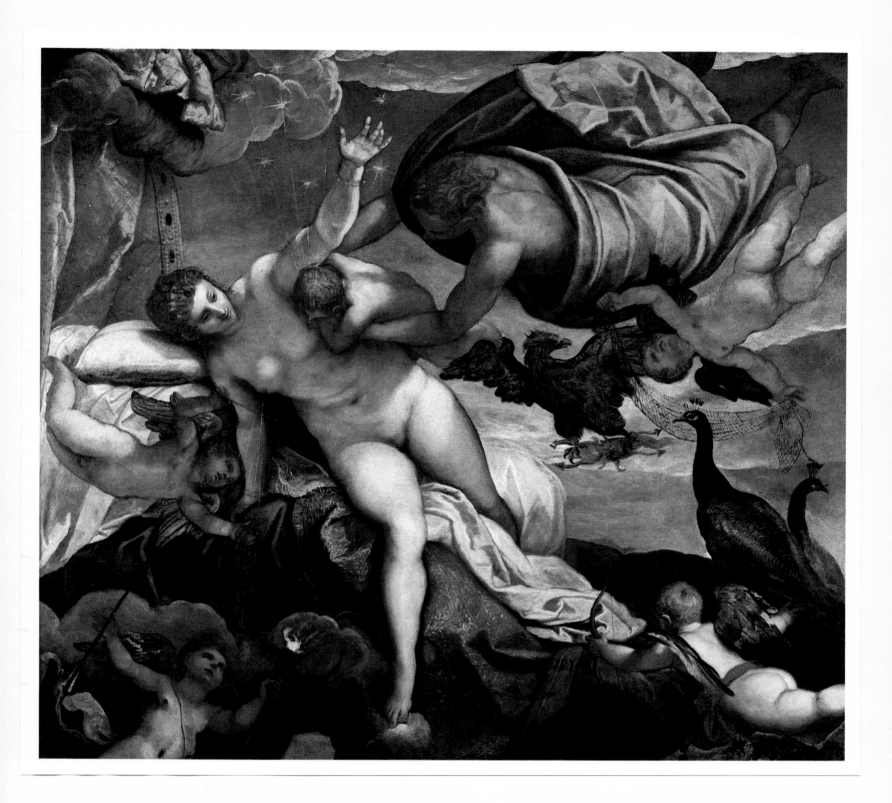

THE ADORATION OF THE SHEPHERDS

1579–81

Oil on canvas, 17'9" × 14'11"

Sala Grande, Scuola Grande di San Rocco, Venice

Even before he had finished the paintings for the ceiling of the upper hall in the Scuola Grande, Tintoretto came forward, on November 27, 1577, with the proposal to paint the altarpiece and ten canvases to go on the walls, pledging himself to deliver three works each year on the feast day of Saint Roch. He declared himself disposed, for an annual compensation of a hundred ducats, to give his services as long as he lived for whatever embellishment the Scuola Grande might wish, desiring thereby to give proof of his "great love" for that "venerated confraternity by devotion . . . to the glorious Messer Saint Roch." Having accepted the proposal on December 2, 1577, with forty-five favorable votes, the heads of the confraternity on February 24 of the following year set up a committee of three members to inspect and approve the annual consignment of paintings pledged by their fellow member. Tintoretto kept his word, and the ten large pictures for the walls were completed between 1579 and July 1581, although the altarpiece was not completed until 1588.

The first canvas on the west wall of the Sala Grande is this *Adoration of the Shepherds*, with its obvious reminiscence of the engraving of that subject in the "Small Passion" series by Dürer. The division into two episodes by means of the hayloft floor makes the most notable comparison in the two works, though Tintoretto's scenographic illusionism is vastly more free and flexible than that of his model. Below, counterpointed by the shadows and light from an exterior source, the shepherds offer their gifts with broad gestures. Above, almost blinded by the heavenly light flooding through the openwork trestles of the ruined roof, the sacred actors reveal in their movements their willing participation in the divine event. The two different emotional situations have a common vehicle of expression in the quality of the color. Somewhat agitated in the lower half with its continual alternation of refractions and reflections, paint is laid on to give material reality to the humble utensils and the animals in the stall. The broad fields of color of the upper half are calmer, although imbued with vitality by sudden flares of light.

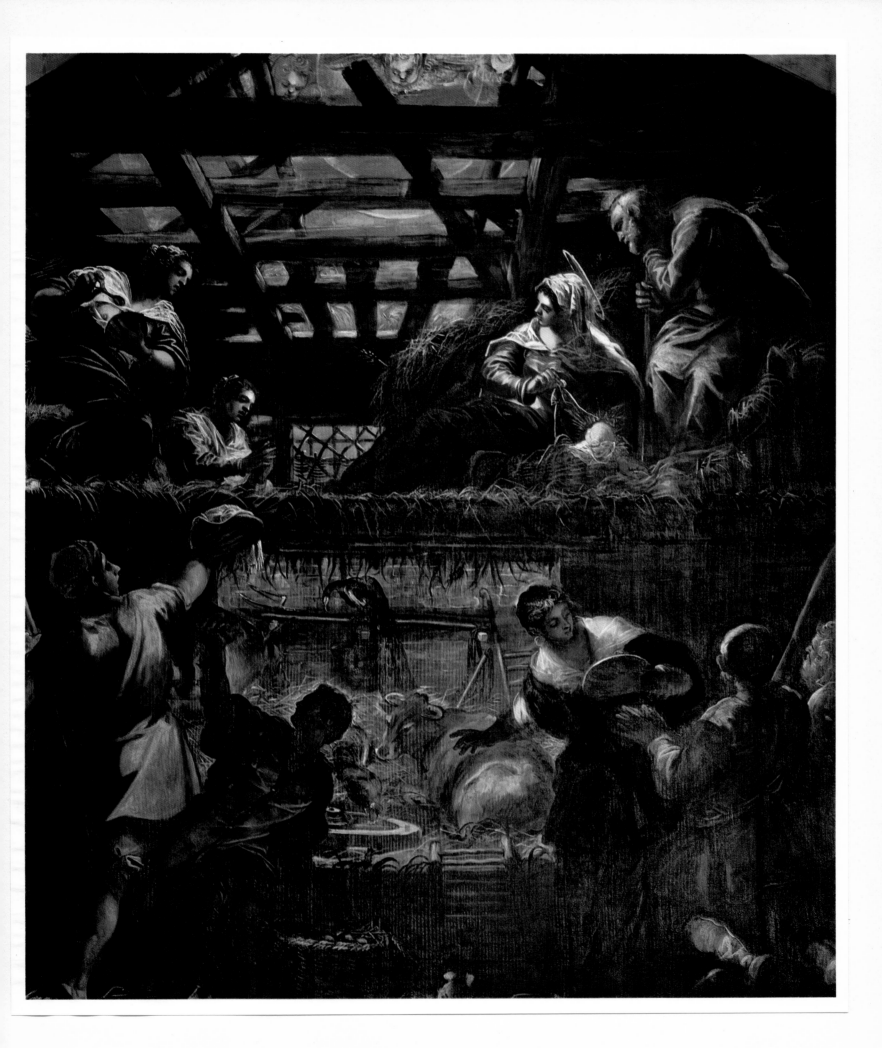

THE BAPTISM OF CHRIST

1579–81

Oil on canvas, 17'8" × 15'3"

Sala Grande, Scuola Grande di San Rocco, Venice

In the sequence of canvases on the walls of the upper hall of the Scuola Grande, the *Baptism* immediately follows the *Adoration of the Shepherds* (colorplate 39), and their juxtaposition emphasizes even more dramatically the radical differences between these two pictures in their compositional treatment. Here the central event is given no special prominence—nor is it brought directly to the foreground, as in the *Baptism* altarpiece at San Silvestro (colorplate 37). The composition's forcefulness comes rather from the ray of light that falls on the back of Jesus, from his face plunged in deep shadow, and from the shoulders and face of the Baptist leaning forward to perform his prophetic act. All around them there is space, a broad area delimited on the right by the steeply rising rocky embankment in front of which are glimpsed, somewhat indistinctly, figures removing their clothes beneath the gaze of the confraternity member deep in prayer. At the rear this space is defined by a long line of candidates for baptism, a sparkling clump of figures evoked by amazingly fleet brushwork. Their procession seems to wind uninterruptedly along the broad sickle-shaped bank of the Jordan beneath a blanket of threatening clouds. The spatial interconnections and the highly mobile rhythms of light create a vortex that compellingly draws the viewer emotionally into the scene.

In this canvas, as in the others for this confraternity headquarters, the astounding inventive freedom with which Tintoretto brought new life to religious iconographic formulas, to even the most traditional among them, is his most striking achievement. It shows the impulse of a simple faith, which, though close in time to the conclusion of the Council of Trent in 1563, gave little evidence of the prescriptions and pietism of the Counter Reformation instituted there.

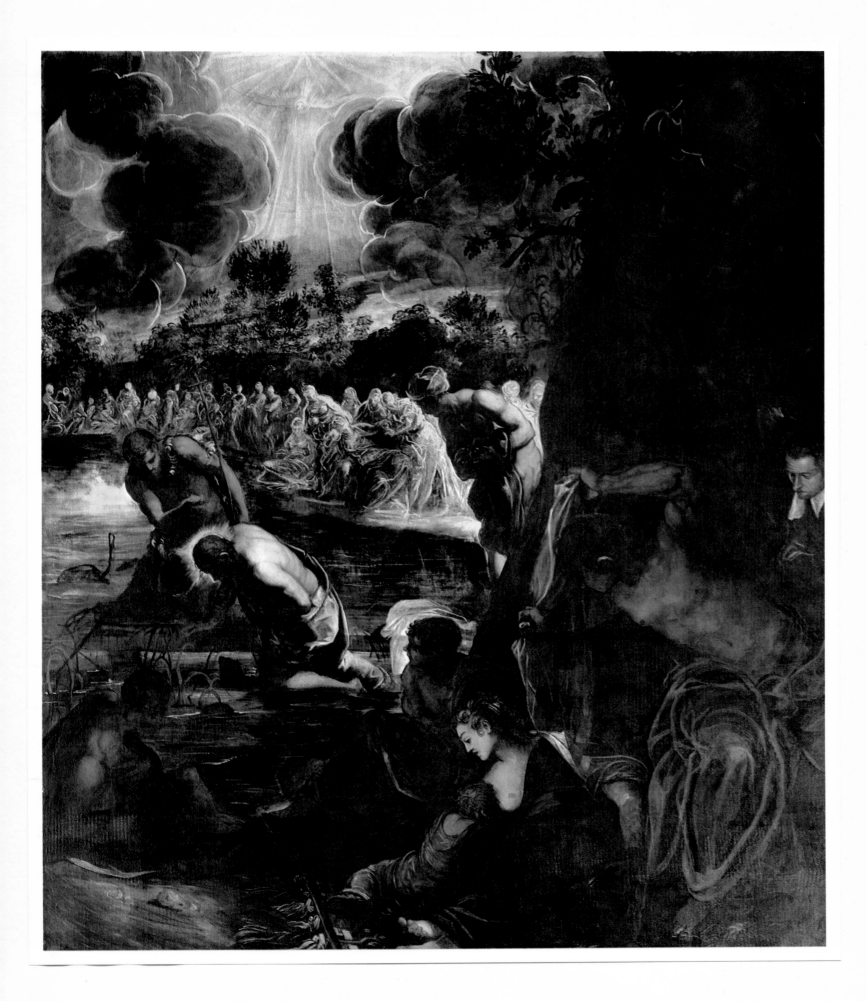

THE LAST SUPPER

1579–81

Oil on canvas, 17'8" × 16'

Sala Grande, Scuola Grande di San Rocco, Venice

As in the *Baptism of Christ* (colorplate 40), the *Last Supper* is set in a space whose ingeniously conceived expanse can only be symbolic. Once the eye goes beyond the forestage frame, created by the two poor persons crouched on the steps along with an agitated dog, one senses that every element of the composition contributes to an effect of great depth: the large room delimited diagonally on the right by a wall in shadow from which the fireplace hood projects prominently, the marble checkerboard of the steeply rising floor, the long table placed obliquely with the surrounding figures decreasing rapidly in size, the kitchen areas in the distance described in every detail in a unified vision. Illuminated from a double source—through an undefined opening in the foreground and through the corridor at the rear—the tumult of the poses and emotions of the Apostles makes an excited jagged progression along both sides of the table in a chiaroscuro phrasing of heightened drama. The intensity of movement around the table comes to rest finally in the figure of Christ—minute in size but singled out by the dazzling aureole around his head—who is in the act of offering communion to an Apostle while embraced by the beloved disciple John.

It is the light that makes every detail take on the aspect of a vision through the force of its dynamic definition and the urgent rhythm with which it bursts forth from all sides. However rapid the expressive means and however much the luminous and chromatic episodes may be woven into a fabric of transfiguring imagination, nothing is sacrificed of the truthfulness of the figures' poses. The quality of this work, especially congenial to his own pictorial approach, did not pass unnoticed by Velázquez, and during his visit of 1649 he made a copy of it as a gift for Philip IV of Spain.

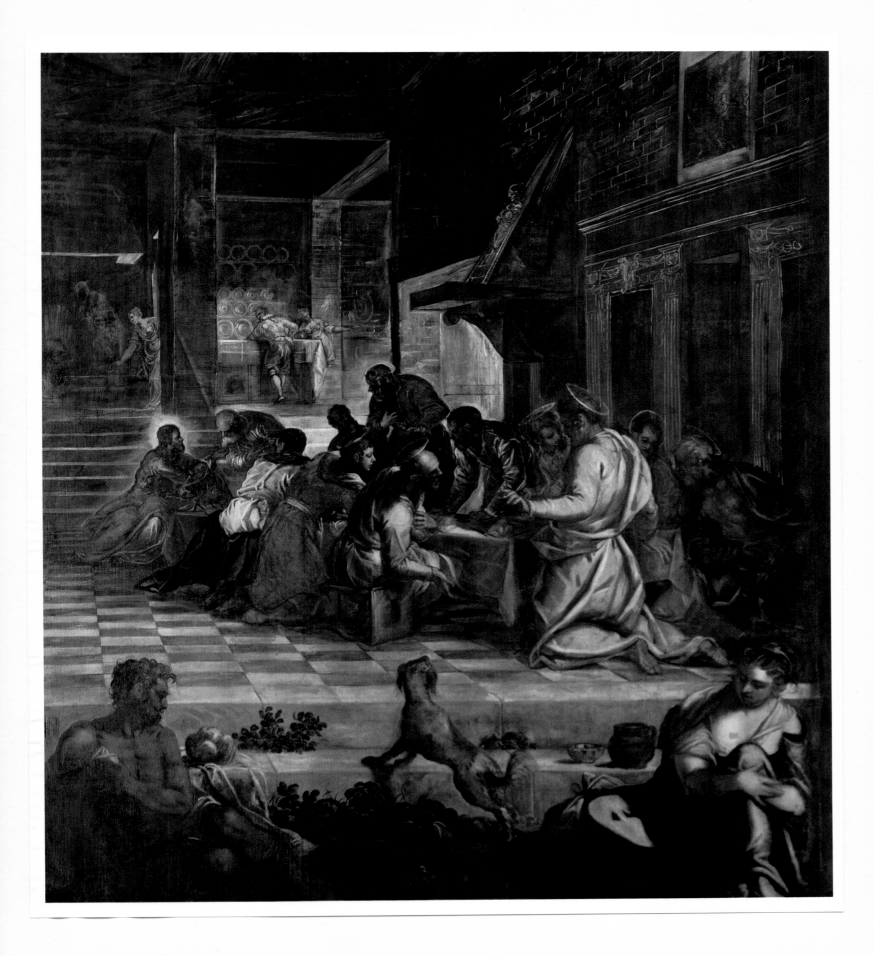

THE ASCENSION

1579–81

Oil on canvas, 17'8" × 10'8"

Sala Grande, Scuola Grande di San Rocco, Venice

In perhaps no other painting in the upper hall of the Scuola Grande did the artist achieve such success in his unremitting striving for effects of light that would not sacrifice the vivid range of color. In the midst of a quivering beating of angelic wings and the festive jubilation of palm fronds and olive branches the risen Christ soars to heaven on a smoky bank of storm clouds with such élan as almost to sweep beyond the upper border of the canvas. With its whirlpool of chiaroscuro and the highly charged splendor of its palette, the sudden apparition seems to shoot out toward the viewer. Beneath that looming presence an Apostle at the right, his pose reused and enlarged at the left, is amazed by the shock of the explosion of light. His fellow disciples, grouped around the rustic table, look upward while in the center midground Moses and Elijah, engaging in disputation, appear as ephemeral yellow and rose filaments. As if kneaded with light, these two figures are laid on with evanescent paint almost at one with the yellow tone of the sun-drenched plain.

This poetic climate is maintained in the *Resurrection* (fig. 58), on the opposite wall, in which the Christ, shining within the darting lights and shadows, dominates all other formal compositional elements in his violent catapulting into space; the effect is rendered with a melodramatic artifice that, without sinking into banal theatricality, evokes the suspense of miracle with a convincing immediacy. With such conceptions as revealed in these two canvases it is clear that the art of Tintoretto was at its most natural and most expressively forceful when he could render biblical episodes in formulas that involved spectacular figurative solutions, which in particular excited the imagination of the humble and rustic population. Anna Pallucchini was doubtless right in her monograph of 1969 when she insisted on the affinity between the emotions evoked in the painting of Tintoretto and a particular form of mysticism prevalent among the populace of Venice in the late sixteenth century.

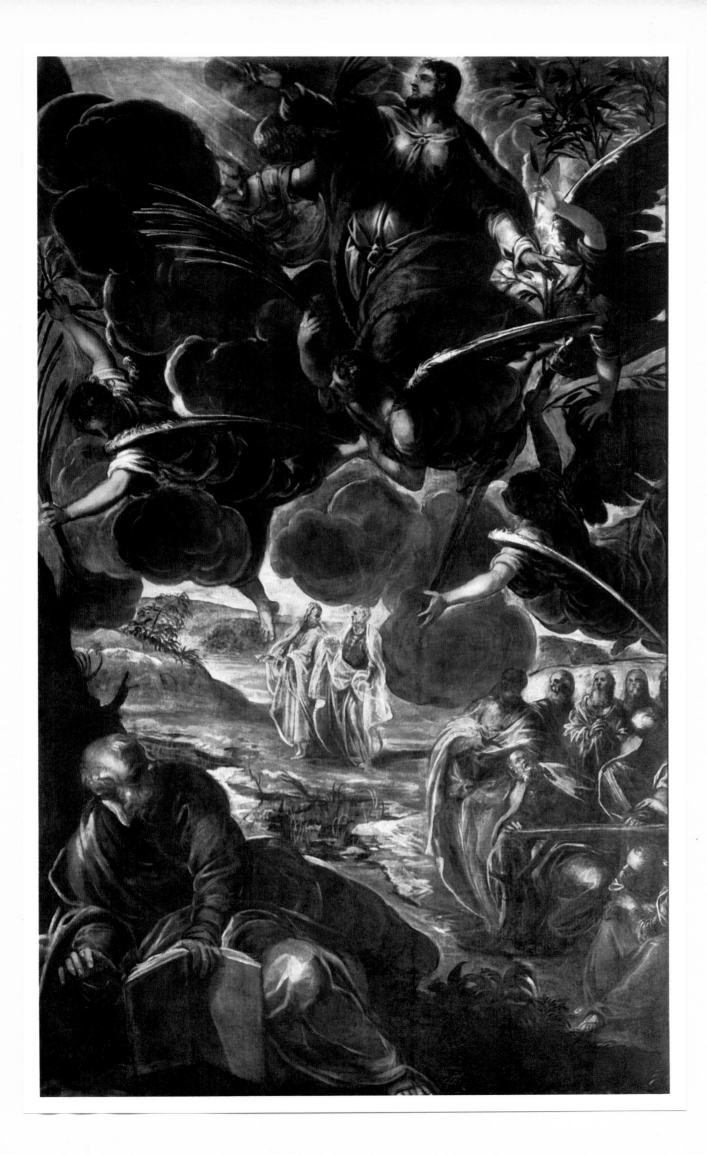

THE ADORATION OF THE MAGI

1583–87

Oil on canvas, 13'11" × 17'10"

Sala Terrena, Scuola Grande di San Rocco, Venice

After an intermission of a little more than a year Tintoretto returned to the decoration of the Scuola Grande di San Rocco, and with no less passionate enthusiasm. In just over four years, between July 1583 and August 1587, he completed eight large canvases for the hall on the ground floor. Recent restoration suggests that in only one of these, the *Circumcision*, did the workshop play an important part. In the other seven there can be no doubt that the artist gave of himself fully, in proud solitude and with a deeply felt spiritual attitude toward his subjects, drawn from the lives of the Virgin and of the infant Jesus.

For this *Adoration of the Magi* Tintoretto returned with no less imaginative vigor to the compositional plan he had established in the *Adoration of the Shepherds* (colorplate 39), although with greater sobriety in the treatment of the setting and with even more accent on luminous values, choosing a time just before nightfall. At the right, in the dense twilight dusk broken only by gleams from heaven, appears the cortege of the Magi transmuted into phosphorescent phantoms riding slowly from their remote Eastern lands, guided by the star to the manger in which the Son of God has been born. Presented frontally in pyramidal form, the central episode is lit by a direct overhead illumination that emphasizes even more sharply the physical and spiritual traits of the three kings—especially the handsome Moor with a turban glowing like a variegated gem in the indistinct penumbra behind him. In this carefully orchestrated polyphony of sudden gleams of light and subdued scintillations the forms drained of plastic relief lose their corporeal weight. The colors, fused into a harmonic structure, are also resolved into separate notes within a continual arabesque-like movement.

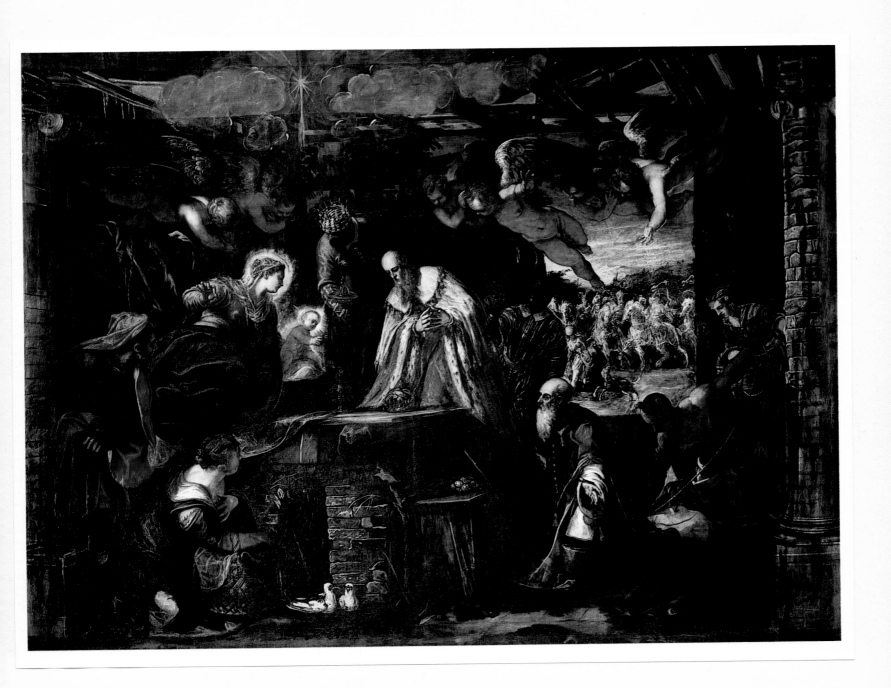

THE FLIGHT INTO EGYPT

1583–87
Oil on canvas, 13'10" × 19'
Sala Terrena, Scuola Grande di San Rocco, Venice

In their flight from the violence of Herod, Joseph and Mary, with the infant Jesus clasped to her breast, hold to wooded spots, giving a wide berth to any inhabited areas. Their feelings of apprehension and fear have their counterpart in the vast landscape given over to the quiet life of the fields, to the hills and snowcapped mountains beneath the azure of an even vaster sky raveled by clouds streaked with red and pink refractions. Again the light with its violent and repeated flashes in all directions recomposes into an intense unity, the many details still visible in the dense atmosphere of the last hour of daylight. The fugitives are revealed with terse concreteness in every aspect of form and color within the single-toned fabric of greens, browns, and whites of an expansive landscape that is conjured up with a rapidity of touch in its most picturesque and unquiet aspects. Like suffused filaments, the profiles of the branches and tall tree-trunks seem to light up, and the clumps of vegetation also shiver with illumination. The rippling pond shines under the movement of the late-afternoon breeze, and the walls of the rustic cabin take on a golden luminosity. In this virtually impressionistic rendering, the landscape proves anything but monochromatic and in the extraordinary fullness of the color and the incessant play of lights it seems to breathe as if regulated by a cosmic pressure from within. For the felicitous manner in which every motif of reality is transfigured by the force of imagination, this landscape is one of the most memorable in Venetian painting and in line with a tradition running back through Titian and, indeed, to Giorgione.

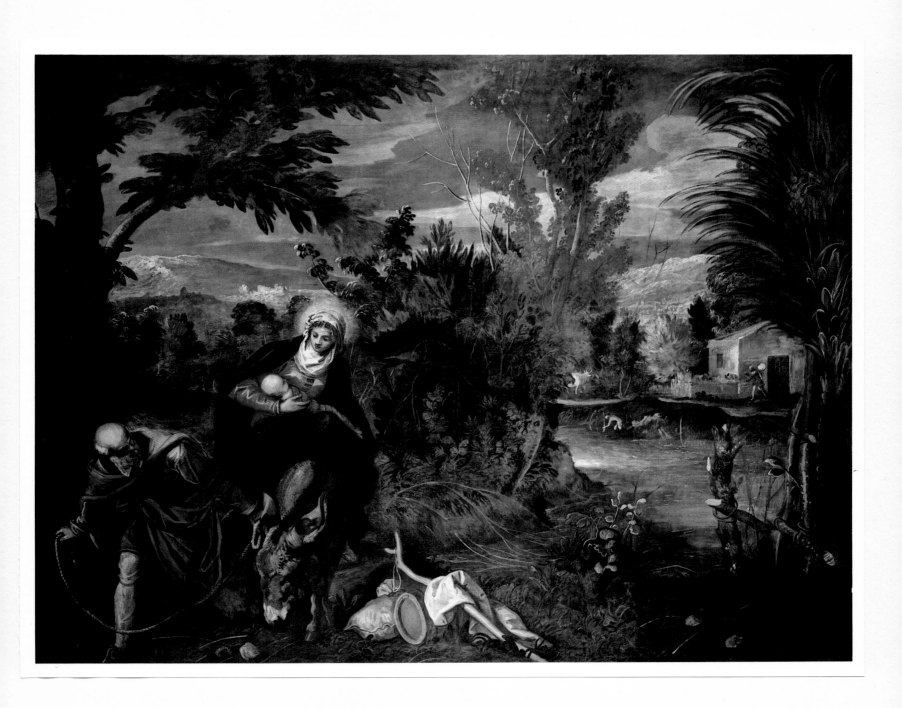

THE MASSACRE OF THE INNOCENTS

1583–87

Oil on canvas, 13' 10" × 19'

Sala Terrena, Scuola Grande di San Rocco, Venice

The calm yet disquieting atmosphere of the *Flight into Egypt* (colorplate 44) gives way here to an extraordinary tension created by swarming forms within the sharp interplay of lights, exacerbating the horror of a cruel and bloody scene. In the tangled groups, reminiscences of Michelangelo, Raphael, and such mannerist sculptors as Giovanni Bologna have been recognized, but as always with Tintoretto every borrowing was transformed by his personal vein of dramatic fantasy. Constructed of great crossbeams of shadow and light and executed with lightning-swift brio, episodes of unprecedented ferocity alternate in an unending succession of zigzags between the stage wings of masonry walls, which block all escape on the left and only in the far background lead to a loggia that opens on a wooded landscape.

In this violent representation one can isolate moments of particular expressiveness. In the left foreground a mother with despondent gesture holds back the blade with which she herself is about to deliver the death blow to her own child, and above her another woman hangs over the wall straining every sinew to draw up the lifeless body of her child. In the background desperate but vain attempts to escape are ominously contrasted by sparse strands of colors striated by shadow. Yet it is the totality of the many anguished episodes—amalgamated by the interrupted movement of penetrating lights and by the tightly woven fabric of the predominant reddish tonalities—that creates an atmosphere of epic grandeur without the taint of theatrical fiction.

In this painting there is no doubt about the spiritual distance that separates Tintoretto from Michelangelo. The Tuscan artist experienced personally, and with sorrow, all the tragic uncertainty of man's destiny. In Tintoretto, religious faith gave rise to no such quandaries; rather it impelled him to fuse fantasy and reality in the concreteness of dramatic conceptions in which the slightest occurrence is intensified in its profound striving for moral significance.

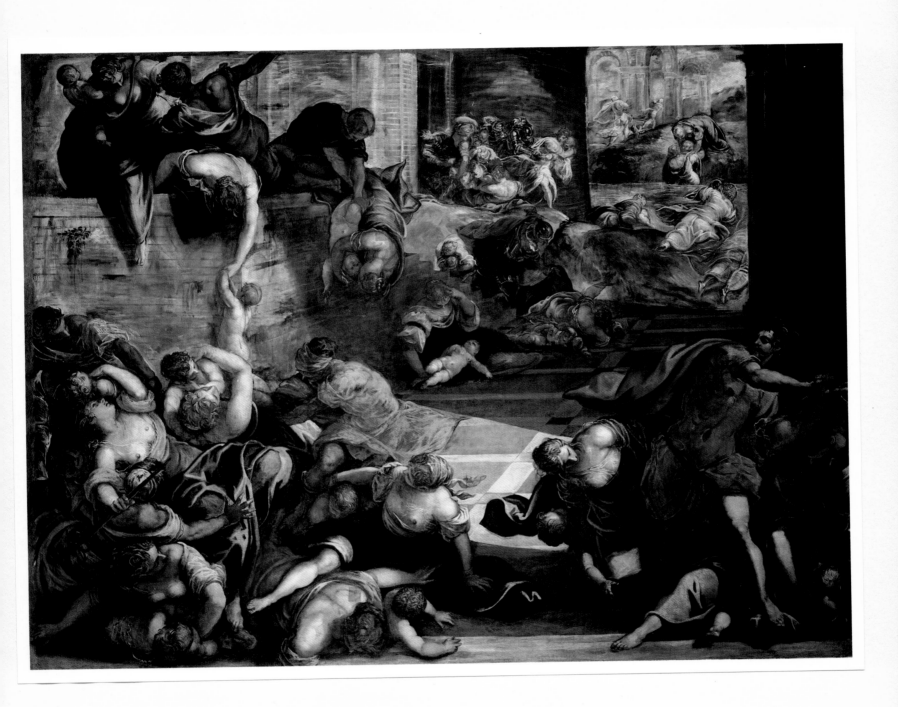

SAINT MARY MAGDALEN

1583–87

Oil on canvas, 13'11" × 6'11"
Sala Terrena, Scuola Grande di San Rocco, Venice

In the cycle for the ground-floor hall of the Scuola Grande two pictures are unrelated to episodes from the life of the Virgin and the infant Jesus. The two paintings, this *Saint Mary Magdalen* and *Saint Mary the Egyptian* (fig. 71), were the last to be installed there, hung facing each other on the main walls. The hypothesis of Hans Tietze (*Arte Veneta* 5 [1951]), that they were not originally intended for this cycle, would seem to be contradicted by the fact that they are identical in height with the other canvases in the hall. What is even more significant is the intense spirituality pervading them and their stylistic treatment, in which the painter pushed to the utmost the notions of landscape he had expressed in the *Flight into Egypt* (colorplate 44).

Minute in proportions, within the silhouette of luminous filaments surrounding their bodies, the figures seem to integrate elements of the vast landscapes; they are part of the breathing atmosphere of forest scenes rendered mysterious by the shadows palpitating with infinite reflections and by luminescences set ablaze with the coming of evening. The Magdalen is immersed in her reading by the light of the last rays of the sun that pour over the trunk and branches of the great tree, which is the true protagonist of this apparition of a nature revealed for one last fleeting instant in the outlines of undulating flatlands, distant hills beneath a foreboding sky, and a rustic cabin. In the magical use of light, which here attains an unmatched intensity, the color is consumed in a palette of almost monochromatic burnt tones.

Approaching the end of his life, Tintoretto concluded with these two paintings the extraordinary serial narration he began in the Scuola Grande di San Rocco in 1564, over twenty years before. The series was developed with an undeviating vision that proved itself original and independent within the context of the great painting not only of Venice but of Europe as a whole in the second half of the sixteenth century. There is a religious fervor that pervades these works, a sentiment that was overtly and unabashedly popular and quite outside the devotional forms laid down by the Counter Reformation. Tintoretto could dispense with those forms precisely because he put the Christian message on his canvases with immediacy, without restrictions of intellectualism interposed between reality and fantasy.

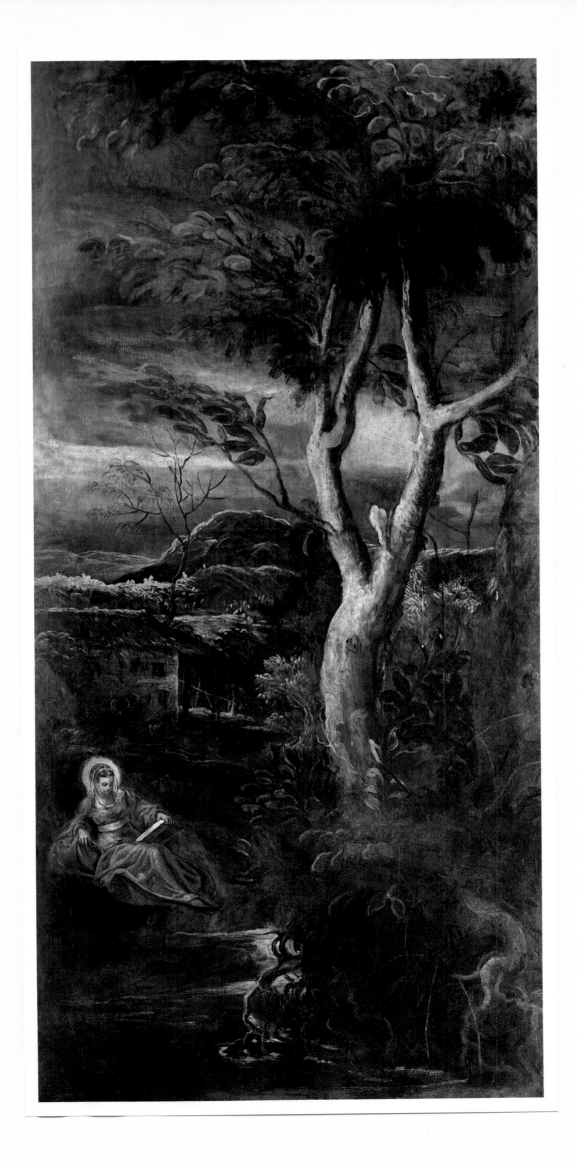

THE ENTOMBMENT OF CHRIST

1592–94
Oil on canvas, 9'5" × 5'5"
San Giorgio Maggiore, Venice

In the later years of his activity Tintoretto more frequently had to resort to the help of collaborators, as is evident in such grandiose undertakings for the Doges' Palace as the *Capture of Zara by the Venetians in 1346* (fig. 72), painted between 1584 and 1587 for the Sala dello Scrutinio, or the immense *Paradise* (fig. 73), for centuries the largest painting in the world, created between 1588 and about 1592 for the rear wall of the Sala del Maggior Consiglio, the assembly hall of the lower house of the Venetian parliament, and preceded by a very fine oil sketch of comparable cosmic power painted more than a decade earlier (fig. 74) and by the model now in the Thyssen-Bornemisza Collection.

But the artist's final and most intimate thoughts were devoted to the paintings for San Giorgio Maggiore, the church designed in 1565 by Andrea Palladio though the chancel was not finished even in 1589. Of the seven paintings for that church that came from the studio of Tintoretto only three were from his own hand, the two vast ones for the chancel (colorplate 48, fig. 76) and this *Entombment*, for which he was paid seventy ducats in 1594 shortly before his death, when it was installed in the Cappella dei Morti (Chapel of the Dead), built and consecrated in 1592.

The virtually theatrical lighting, projected from all directions to bring out the slightest detail with impressive harshness, gives rise to effects of repressed but continuous motion in the three episodes making up the composition: the group of attendants in the front who are sliding the lifeless body wrapped in a bloodstained shroud into the sepulcher, the Virgin overcome in her maternal grief and held up by two bystanders almost swallowed up by shadow, and the place of martyrdom looming indistinctly against the sunset glow. With its three episodes staggered upward and rearward, the picture might appear disjunct and even lacking an order were it not coordinated into a supreme unity by the strong interplay of light. Even the solidity of forms and vivid timbre of the isolated notes of color are subordinated to the light, an effect that evokes the tragic atmosphere of death and devout compassion.

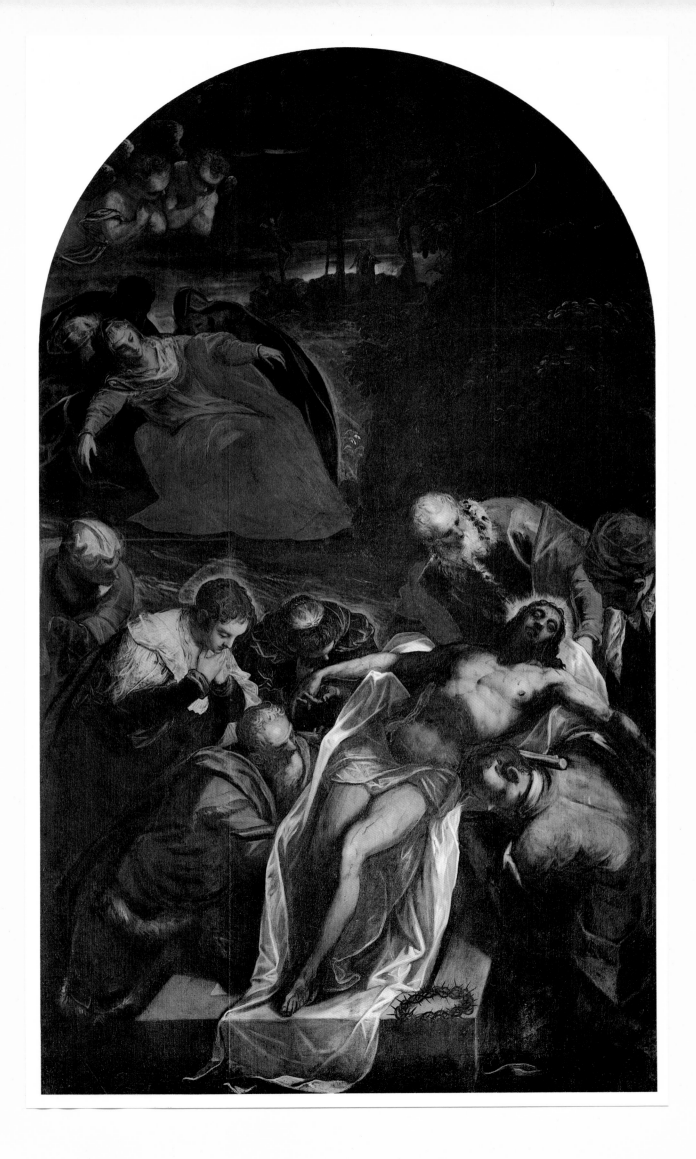

THE LAST SUPPER

1592–94
Oil on canvas, 12' × 18'8"
San Giorgio Maggiore, Venice

In the first months of 1594 Tintoretto continued to work on two huge canvases for the chancel of the Benedictine church of San Giorgio Maggiore: the *Last Supper* and the *Gathering of Manna* (fig. 76). The seventy-five-year-old artist was keeping faith with his commitment to Michele Alabardi, the prior who had devised the iconological program for the chancel: centered on the Eucharist, it comprised, besides the two paintings, wooden reliefs on the singers' tribunes and on the high altar a bronze group of the Holy Trinity upon a globe supported by the four Evangelists. The statue was created between 1592 and 1594 by Girolamo Campagna on designs by Aliense (see Ivanoff, 1975).

The workshop had its part in both canvases, although there can be no doubt that the master himself, now close to the end of his days, devoted his last physical and spiritual resources to the conception and to part of the actual execution. In these paintings he carried to the ultimate his quest for blazing luministic visions and for a seemingly limitless spatial perspective.

The grand theatrical use of perspective is particularly striking in the *Last Supper*, which is yet another version of the theme he had loved and repeated many times. The table, cutting obliquely across the length of the immense interior, continues endlessly into the dense shadow scarcely dispersed by the smoking flames of the hanging oil lamp, although the lamp is not nearly as bright as the aureole of Christ ablaze with divine illumination. The fantastic nature of those two sources of light not only quarries out of the shadow the human figures and the angels—winged evanescent presences—it also imparts to the plates of food and other domestic objects an unprecedented realism.

Again, and for the last time, reality and fantasy were synthesized in the art of Tintoretto, giving form to a world of extraordinary energy and of indisputable moral teaching that was intelligible to all.

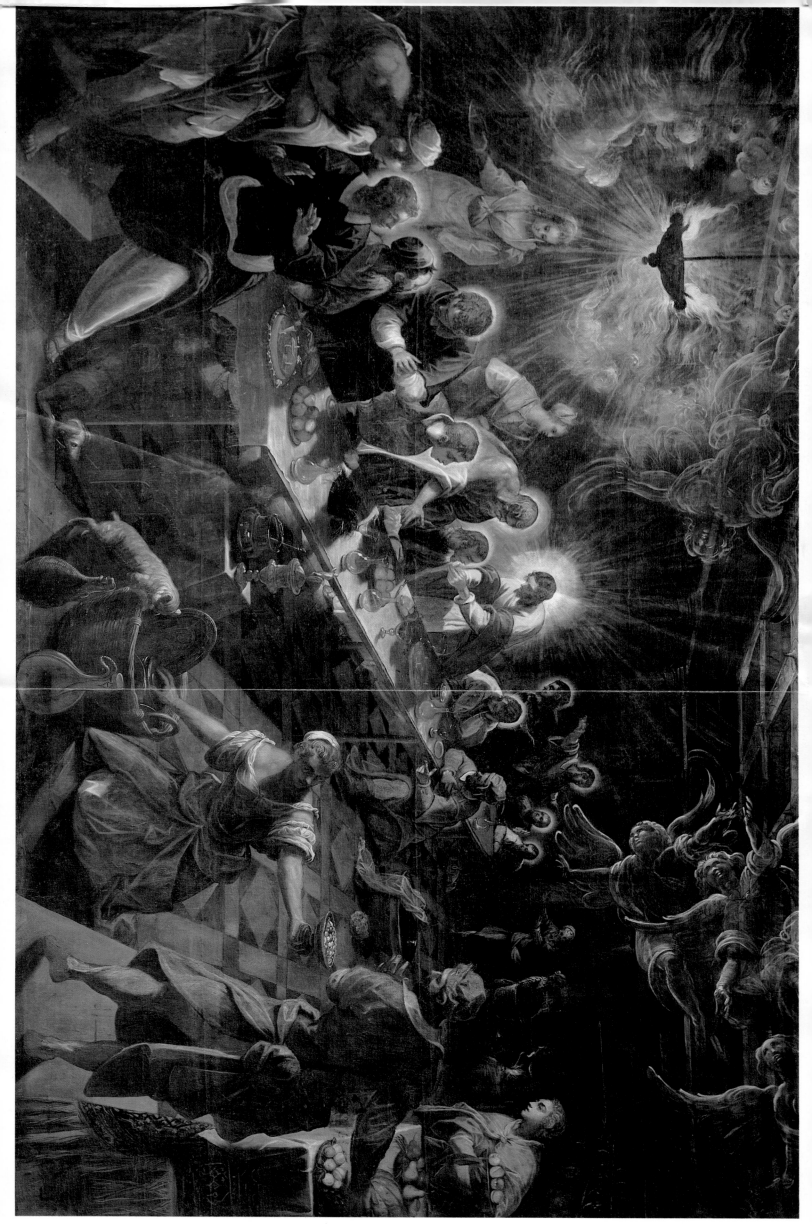

BIBLIOGRAPHY

General Works

ARGAN, GIULIO CARLO. *Storia dell'arté italiana*, Vol. 3, *Il cinquecento, il seicento, il settecento, dal neoclassicismo al futurismo*. Florence: Sansoni, 1968.

BERENSON, BERNARD. *Italian Pictures of the Renaissance: A List of the Principal Artists and Their Works with an Index of Places*. Oxford: Clarendon Press, 1932. Reprint. 2 vols. Rev. ed., illus., with added title, *Venetian School*. London: Phaidon Press, 1957.

————. *The Venetian Painters of the Renaissance, with an Index to Their Works*. 3rd ed. New York: G. P. Putnam's Sons, 1897.

BRIGANTI, GIULIANO. *Il manierismo e Pellegrino Tibaldi*. Rome: Cosmopolità, 1945.

BURCKHARDT, JAKOB. *Der Cicerone: Eine Anleitung zum Genuss der Kunstwerke italiens*. 3 vols. Basel: Schweighauserische Verlagsbuchhandlung, 1855. *The Cicerone: or, Art Guide to Painting in Italy*. Edited by A. von Zahn. Translated by Mrs. A. H. Clough. London: John Murray, 1873.

CHASTEL, ANDRÉ. *L'Art italien*. 2 vols. Paris: Larousse, 1956. *Italian Art*. Translated by Peter and Linda Murray. New York: Thomas Yoseloff, 1963.

DVOŘÁK, MAX. *Geschichte der italienischen Kunst im Zeitalter der Renaissance*. 2 vols. Edited by Johannes Wilde and Karl M. Swoboda. Munich: R. Piper, 1927–29.

FREEDBERG, SYDNEY J. *Painting in Italy, 1500 to 1600*. Pelican History of Art. Harmondsworth, Eng.: Penguin Books, 1971.

GOULD, CECIL. *The Sixteenth-Century Italian Schools*. London: National Gallery, 1975.

HAUSER, ARNOLD. *Der Manierismus: Die Krise der Renaissance und der Ursprung der modernen Kunst*. Munich: Beck, 1964. *Mannerism: The Crisis of the Renaissance and the Origin of Modern Art*. 2 vols. Translated by Eric Mosbacher and Arnold Hauser. New York: Alfred A. Knopf, 1965.

LANZI, LUIGI. *Storia pittorica della Italia*. 3 vols. 2nd ed. Bassano: Remondini de Venezia, 1795–96. Reprint. 3 vols. Edited by Martin Capucci. Florence: Sansoni, 1968–74. *The History of Painting in Italy*. 3 vols. Rev. ed. Translated by Thomas Roscoe. London: Henry G. Bohn, 1847.

LONGHI, ROBERTO. *Viatico per cinque secoli di pittura veneziana*. Florence: Sansoni, 1946.

PALLUCCHINI, RODOLFO. *La pittura veneziana del cinquecento*. 2 vols. Novara: Istituto Geografico De Agostini, 1944.

PALLUCCHINI, RODOLFO, et al. *Da Tiziano al Greco: per la storia del manierismo a Venezia*. Milan: 1981.

PEVSNER, NIKOLAUS. *Die italienische Malerei vom Ende der Renaissance bis zum ausgehenden Rokoko*. Handbuch der Kunstwissenschaft. Wildpark–Potsdam: Akademische Verlagsgesellschaft Athenaion, 1928.

RUSKIN, JOHN. *The Stones of Venice*. 3 vols. London: Smith, Elder and Company, 1851–53.

TAINE, HIPPOLYTE. *Voyage en Italie*. 2 vols. Paris: Hachette, 1866. *Italy: Florence and Venice*. Translated by J. Durand. New York: Leypoldt and Holt, 1869.

TIETZE, HANS, and TIETZE-CONRAT, ERICA. *The Drawings of the Venetian Painters in the Fifteenth and Sixteenth Centuries*. New York: J. J. Augustin, 1944.

VENTURI, ADOLFO. *Storia dell'arte italiana*. Vol. 9, Part 4. Milan: Ulrico Hoepli, 1929. Reprint. Facsimile ed. Nendeln, Liechtenstein: Kraus Reprint, 1967.

VENTURI, LIONELLO. *The Sixteenth Century: From Leonardo to El Greco*. Translated by Stuart Gilbert. Geneva: Albert Skira, 1956.

VENTURI, LIONELLO, and SKIRA-VENTURI, ROSABIANCA. *Italian Painting: The Renaissance*. Translated by Stuart Gilbert. Geneva: Albert Skira, 1951.

WÖLFFLIN, HEINRICH. *Kunstgeschichtliche Grundbegriffe: Das Problem der Stilentwicklung in der Neueren Kunst*. Munich: Bruckmann, 1915. *Principles of Art History: The Problem of the Development of Style in Later Art*. Translated by M. D. Hottinger. London: G. Bell and Sons, 1932. Reprint. New York: Dover Publications, 1950.

ZANETTI, ANTONIO MARIA. *Della pittura veneziana e delle opere pubbliche de' veneziani maestri*. Venice: G. Albrizzi, 1771.

Biographies and Monographs

BARBANTINI, NINO, ed. *La mostra del Tintoretto*. Exhibition catalog, Ca' Pesaro, Venice (1937). Venice: Carlo Ferrari, 1937.

BERCKEN, ERICH VON DER. *Die Gemälde des Jacopo Tintoretto*. Munich: R. Piper, 1942.

BERCKEN, ERICH VON DER, and MAYER, AUGUST L. *Jacopo Tintoretto*. 2 vols. Munich: R. Piper, 1923.

COLETTI, LUIGI. *Il Tintoretto*. 2nd ed. Bergamo: Istituto Italiano d'Arti Grafiche, 1944.

GALLO, RODOLFO. "La famiglia di Jacopo Tintoretto." *Ateneo Veneto* 128, nos. 3–4 (March–April 1941): 73–92.

HADELN, DETLEV VON. *Zeichnungen des Giacomo Tintoretto*. Berlin: P. Cassirer, 1922.

NEWTON, ERIC. *Tintoretto*. London: Longmans Green, 1952.

OSMASTON, FRANCIS. *The Art and Genius of Tintoret*. 2 vols. London: G. Bell and Sons, 1915.

PALLUCCHINI, ANNA, ed. *Tintoretto*. I Diamanti dell'Arte. Florence: Sansoni, 1969. Translated by Pearl Sanders. New York: Grosset and Dunlap, 1971.

PALLUCCHINI, RODOLFO. *La giovinezza del Tintoretto*. Milan: Daria Guarnati, 1950.

————. "Tintoretto." In *Encyclopedia of World Art*, vol. 14, 111–34. New York: McGraw-Hill Book Company, 1967.

PALLUCCHINI, RODOLFO, and ROSSI, PAOLA. *Tintoretto: le opere sacre e profane*. 2 vols. Profili e Sassi de Arte Veneta. Milan: Electa, 1982.

PHILLIPS, EVELYN M. *Tintoretto*. London: Methuen, 1911.

PITTALUGA, MARY. *Il Tintoretto*. Bologna: N. Zanichelli, 1925.

ROSSI, PAOLA. *Jacopo Tintoretto: i ritratti*. Preface by Rodolfo Pallucchini. Venice: Alfieri, 1974.

———, ed. *I disegni di Jacopo Tintoretto*. Corpus Graphicum, edited by Terisio Pignatti, vol. 1. Florence: La Nuova Italia, 1975.

THODE, HENRY. *Tintoretto*. Bielefeld and Leipzig: Velhagen und Klasing, 1901.

TIETZE, HANS. *Tintoretto: The Paintings and Drawings*. New York: Phaidon Press, 1948.

VECCHI, PIERLUIGI DE. *L'opera completa del Tintoretto*. Introduction by Carlo Bernari. Milan: Rizzoli, 1970.

EARLY SOURCES

ARETINO, PIETRO. *Lettere sull'arte*. Vol. 2, *1543–1555*, edited by Ettore Camesasca. Milan: Del Milione, 1957.

BORGHINI, RAFFAELLO. *Il riposo*. Florence: Giorgio Marescotti, 1584. Reprint. 2 vols. Edited by Mario Rosci. Milan: Labor, 1967.

BOSCHINI, MARCO. *La carta del navegar pitoresco*. Venice: Per li Baba, 1660. Reprint. Edited with Introduction by Anna Pallucchini. Venice: Istituto per la Collaborazione Culturale, 1966.

———. *Le ricche minere della pittura veneziana*. 2nd ed., rev. Venice: Francesco Nicolini, 1674.

CALMO, ANDREA. *Il rimanente de le piacevoli et ingeniose littere indrizzate a diversi con bellissime argutie*. Venice: [m.p.], 1548. Reprint. *Le lettere di messer A. Calmo*. Edited by Vittorio Rossi. Turin: E. Loescher, 1888.

CICOGNA, EMMANUELE ANTONIO. *Delle iscrizioni veneziane*. 6 vols. Venice: Orlandelli, 1824–53.

DOLCE, LODOVICO. *Dialogo della pittura intitolato L'Aretino*. Venice: Gabriel Giolito de' Ferrari, 1557. Reprinted in *Trattati d'arte del cinquecento, fra manierismo e controriforma*, edited by Paola Barocchi, vol. 1. Bari: Giuseppe Laterza e Figli, 1960.

LORENZI, GIAMBATTISTA. *Monumenti per servire alla storia del Palazzo Ducale*. Part 1. Venice: Marco Visentini, 1868.

LUDWIG, GUSTAV. *Archivalische Beiträge zur Geschichte der venezianischen Kunst aus dem Nachlass Gustav Ludwigs*. Edited by Wilhelm von Bode, Georg Gronau, and Detlev von Hadeln. Kunsthistorisches Institut in Florenz; *Italienische Forschungen*, vol. 4. Berlin: Bruno Cassirer, 1911.

PALOMINO DE CASTRO Y VELASCO, ANTONIO. *El museo pictórico y escala óptica*. 3 vols. Madrid: L. A. de Bedmar, 1715–24. Reprint (3 vols. in 1). Madrid: Aguilar, 1947.

PINO, PAOLO. *Dialogo di pittura*. Venice: Paolo Gherardo, 1548. Reprinted in *Trattati d'arte del cinquecento, fra manierismo e controriforma*, edited by Paola Barocchi, vol. 1. Bari: Giuseppe Laterza e Figli, 1960. Reprint. Critical ed. with Introduction by Anna Pallucchini. Venice: Daria Guarnati, 1946.

RIDOLFI, CARLO. *Le meraviglie dell'arte*. 2 vols. Venice: G. B. Sgaua, 1648. Reprint. 2 vols. Edited by Detlev von Hadeln. Berlin: G. Grote, 1914–24.

———. *Vita di Giacopo Robusti detto il Tintoretto*. Venice: G. Oddoni, 1642.

SANSOVINO, FRANCESCO. *Dialogo di tutte le cose notabili e belle che sono in Venetia*. Venice: [m.p.], 1556.

———. *Venetia città nobilissima et singolare*. Venice: Iacomo Sansovino, 1581. Reprint. Rev. ed., enl. Edited by Giustiniano Martinioni. Venice: Steffano Curti, 1663. Reprint. Facsimile ed. (1663). 2 vols. Edited by L. Moretti. Venice: Filippi, 1968.

VASARI, GIORGIO. *Le vite de' più eccellenti pittori, scultori ed architettori*. 3 vols. 2nd ed., rev. Florence: Giunti, 1568. Reprint. 9 vols. Critical ed. by Gaetano Milanesi. Florence: Sansoni, 1878–85. *Lives of the Most Eminent Painters, Sculptors, and Architects*. 10 vols. Translated by Gaston Du C. de Vere. London: Macmillan and Company and the Medici Society, 1912–15.

ZANETTI, ANTONIO MARIA. *Varie pitture a fresco de' principali maestri veneziani*. Venice: [m.p.], 1760.

STYLISTIC AND HISTORICAL STUDIES

ARCHANGELI, FRANCESCO. "La 'Disputa' del Tintoretto a Milano." *Paragone* 6, no. 61 (January 1955): 21–35.

BENESCH, OTTO. "Titian and Tintoretto: Study in Comparative Criticism." *Arte Veneta* 12 (1958): 79–90.

BERENSON, BERNARD. "While on Tintoretto." In *Festschrift für Max J. Friedländer zum sechzigsten Geburtstage*, 224–43. Leipzig: E. A. Seemann, 1927.

BERLINER, RUDOLF. "Die Tätigkeit Tintorettos in der Scuola San Rocco." *Kunstchronik und Kunstmarkt* N.F. 31, no. 23 (March 5, 1920): 468–73; no. 24 (March 12, 1920): 492–97.

COFFIN, DAVID R. "Tintoretto and the Medici Tombs." *The Art Bulletin* 33 (June 1951): 119–25.

COLETTI, LUIGI. "La crisi manieristica della pittura veneziana." *Convivium* 13 (1941): 109–26.

DE TOLNAY, CHARLES. "Il 'Paradiso' del Tintoretto: note sull'interpretazione della tela in Palazzo Ducale." *Arte Veneta* 24 (1970): 103–10.

———. "L'interpretazione dei cicli pittorici del Tintoretto nella Scuola di San Rocco." *Critica d'Arte* 7 (1960): 341–76.

———. "Tintoretto's Salotto Dorato in the Doge Palace." In *Scritti di storia dell'arte in onore di Mario Salmi*, edited by Filippa M. Aliberti, vol. 3, 117–31. Rome: De Luca, 1963.

EIKEMEIER, PETER. "Der Gonzaga-Zyklus des Tintoretto in der Alten Pinakothek." *Münchner Jahrbuch der bildenen Kunst* 20 (1969): 75–142.

FORLANI, ANNA. *Mostra dei disegni di Jacopo Tintoretto e della sua scuola*. Exhibition catalog, Galleria degli Uffizi, Florence (1956). Florence: Leo S. Olschki, 1956.

GOULD, CECIL. "Sebastiano Serlio and Venetian Painting." *Journal of the Warburg and Courtauld Institutes* 25, nos. 1–2 (January–June 1962): 56–64.

———. "The Cinquecento at Venice: (I) Two Crises." *Apollo* 95, no. 123 (May 1972): 376–81.

———. "The Cinquecento at Venice: (III) Tintoretto and Space." *Apollo* 96, no. 125 (July 1972): 32–37.

HADELN, DETLEV VON. "Beiträge zur Tintoretto Forschung." *Jahrbuch der Preussischen Kunstsammlungen* 32 (1911): 25–58.

HÜTTINGER, EDUARD. *Die Bilderzyklen Tintorettos in der Scuola di San Rocco zu Venedig.* Zurich: Neuen Zürcher Zeitung, 1962.

IVANOFF, NICOLA. "I cicli allegorici della Libreria e del Palazzo Ducale di Venezia." In *Rinascimento europeo e rinascimento veneziano,* edited by Vittore Branca, 281–97. Florence: Sansoni, 1967.

———. "Il ciclo eucaristico di San Giorgio Maggiore in Venezia." *Notizie da Palazzo Albani* 4, no. 2 (1975): 50–57.

NICCO FASOLA, GIUSTA. "Il manierismo e l'arte veneziana del cinquecento." In *Venezia e l'Europa* (18th International Congress on the History of Art), 291–93. Venice: Arte Veneta, 1956.

PALLUCCHINI, ANNA. "Considerazioni sui grandi teleri del Tintoretto della Madonna dell'Orto." *Arte Veneta* 23 (1969): 54–68.

PALLUCCHINI, RODOLFO. "Tintoretto nella luce della critica." In *Rinascimento europeo e rinascimento veneziano,* edited by Vittore Branca, 233–60. Florence: Sansoni, 1967.

RUDRAUF, LUCIEN. "Vertiges, chutes et ascensions dans l'espace pictural du Tintoret." In *Venezia e l'Europa* (18th International Congress on the History of Art), 279–82. Venice: Arte Veneta, 1956.

SCHULZ, JUERGEN. *Venetian Painted Ceilings of the Renaissance.* Berkeley and Los Angeles: University of California Press, 1968.

THODE, HENRY. "Tintoretto: Kritische Studien über des Meisters Werke (Die Bilden in den Scuolen)." *Repertorium für Kunstwissenschaft* 27 (1904): 24–45.

VIPPER, S. "Tintoretto e il suo tempo." *Rassegna Sovietica* 1, no. 8 (December 1950): 50–57; 2, no. 9 (March 1951): 63–73; 2, no. 10 (April 1951): 52–72; 2, no. 11 (May 1951): 53–60.

INDEX

PHOTOGRAPHIC
CREDITS

The authors and publisher wish to thank the libraries, museums, and private collectors for permitting the reproduction in black-and-white and in color of paintings, prints, and drawings in their collections. Photographs have been supplied by these custodians and owners and in addition by the following, whose courtesy is gratefully acknowledged. Figure numbers in roman type refer to black-and-white illustrations; italic numbers signify colorplates.

MAS, Barcelona: *5, 16*, 34; Jörg P. Anders, Berlin (West): 79; Gabinetto Fotografico, Soprintendenza per i Beni Artistici e Storici, Florence: 94, 96; Soprintendenza alle Gallerie, Florence (courtesy Fototeca Unione, Rome): 83, 84, 86–89, 91, 93, 95, 97; Crown Copyright Reserved, London: 24, 90; John Webb, London: *21, 38;* Mario Carrieri, Milan: *1, 2, 26;* Archivio Fotografico della Galleria Estense, Modena: 15; E. Irving Blomstrann, New Britain, Conn.: 18; Butler Library, Columbia University, New York: 17; Cathedral of St. Nicholas, Newcastle-upon-Tyne: 23; The Governing Body, Christ Church, Oxford: 81; Documentation photographique de la Réunion des musées nationaux, Paris: 82, 85; Service photographique des musées nationaux, Paris: 74; Alinari, Anderson, Brogi, Rome: 4, 8, 13, 14, 20, 30, 37, 38, 40, 47, 48, 50, 55, 58, 59, 61, 65, 69, 73, 76, 98; Ludovico Canali, Rome: *6–8, 10, 12, 14, 17–19, 23, 25, 28–34, 37, 39–48;* De Antonis, Rome: 22; Istituto Centrale per il Catalogo e la Documentazione, Rome: 6; Archivio Fotografico del Museo Correr, Venice: 2; Archivio della Soprintendenza ai Beni Artistici e Storici, Venice: 32, 39, 49, 54, 60, 66, 70, 71; Archivio della Soprintendenza alle Gallerie, Venice: 5, 38, 51; Osvaldo Böhm, Venice: 9, 21, 56, 64; Cameraphoto, Venice: 25, 29, 35, 44, 46, 52, 72, 77; Fiorentini, Venice: 36, 75; Giacomelli, Venice: 10; Foto Rossi, Venice: 3, 5, 78; Photo Meyer, Vienna: *13;* U. F. Sitzenfrey, Vienna: 33.